W9-BUJ-227

SAN ANTONIO
THEN & NOW

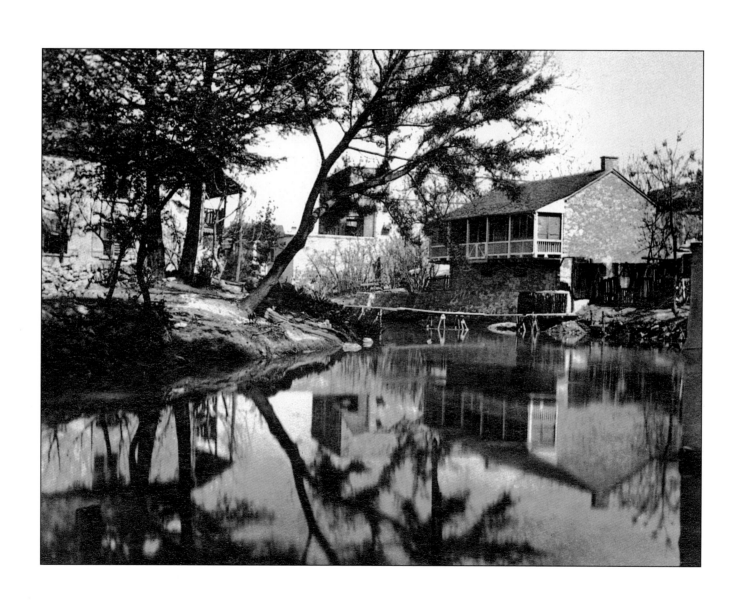

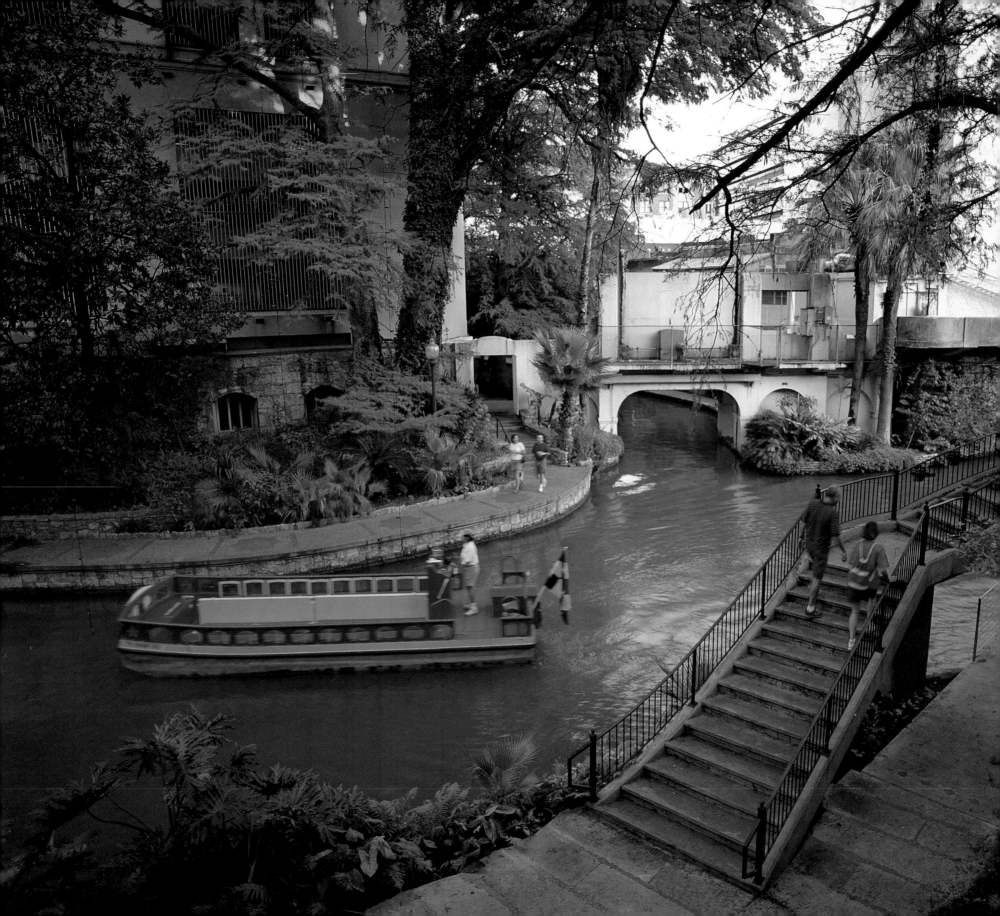

SAN ANTONIO THEN & NOW

PAULA ALLEN

THUNDER BAY
P·R·E·S·S

San Diego, California

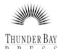

Thunder Bay Press
An imprint of the Advantage Publishers Group
10350 Barnes Canyon Road, San Diego, CA 92121
www.thunderbaybooks.com

Produced by Salamander Books,
an imprint of Anova Books Company Ltd.,
10 Southcombe Street, London W14 0RA, U.K.

"Then and Now" is a registered trademark of Anova Books Ltd.

© 2005 PRC Publishing

Copyright under International, Pan American, and Universal Copyright Conventions.
All rights reserved. No part of this book may be reproduced or transmitted in any form
or by any means, electronic or mechanical, including photocopying, recording, or by any
information storage-and-retrieval system, without written permission from the copyright
holder. Brief passages (not to exceed 1,000 words) may be quoted for reviews.

"Thunder Bay" is a registered trademark of Baker & Taylor. All rights reserved.

All notations of errors or omissions should be addressed to Thunder Bay Press,
Editorial Department, at the above address. All other correspondence (author
inquiries, permissions) concerning the content of this book should be addressed to
Salamander Books, 10 Southcombe Street, London W14 0RA, U.K.

ISBN-13: 978-1-59223-407-3
ISBN-10: 1-59223-407-0

Library of Congress Cataloging-in-Publication Data

Allen, Paula.
 San Antonio then & now/ Paula Allen.
 p. cm.
 Includes index.
 ISBN 1-59223-407-0
 1. San Antonio (Tex.)-Pictorial works. 2. San Antonio (Tex.)-History-Pictorial works.
I. Title: San Antonio then and now. II. Title.

F394.S21143A44 2005
976.4'351'00222-dc22

2005043731

Printed and bound in China

4 5 6 7 8 12 11 10 09 08

ACKNOWLEDGMENTS:

Tom Shelton, who has a near-photographic recall of the three-million-plus images in the Institute of Texan Cultures
Library, was an enthusiastic guide to its San Antonio collections and helped match many long-gone sights with present
views. San Antonio Conservation Society librarian Beth Standifird contributed insight and efficiency in researching
hard-to-find photos. Thanks also are due to local historians Ed Gaida, Theresa Gold, Patsy Light, and Maria Watson
Pfeiffer for sharing details on places pictured in this book; to Cathy Passmore, for information on the Smith-Young Tower
from her father's construction diaries; to Hugh Hemphill, manager and historian of the Texas Transportation Museum;
Brother Ed Loch, archivist of the Catholic Archdiocese of San Antonio; John Manguso, director of Fort Sam Houston
Museum; Rosalind Rock, historian at the San Antonio Missions National Historical Park; Frank Faulkner, manager, and
Matt DeWaelsche, archivist, and the other staff of the Texana/Genealogy room of the San Antonio Public Library; to the
San Antonio Express-News, for providing space for readers to recall our city's past, and to author Frank Jennings, compadre
to this and countless other projects on San Antonio history.

The following sources were used in the writing of this book: *The Alamo: A Cultural History*, by Frank Thompson; *The
Archaeology of the Alamo*, by Herbert G. Uecker; *Bronchos to Spurs: Sports in San Antonio since 1888*, by Chris Foltz;
Courthouses of Bexar County, by Sylvia Ann Santos; *Crown Jewel of Texas: The Story of San Antonio's River*, by Lewis F.
Fisher; *Fort Sam: The Story of Fort Sam Houston, Texas*, by Eldon Cagle Jr.; *The German Texans*, by Glen E. Lich; *A Guide
to San Antonio Architecture*, by the San Antonio chapter, American Institute of Architects; *Handbook of Texas*, Texas State
Historical Association; *HemisFair '68 and the Transformation of San Antonio*, by Sterlin Holmesly; *The History and Mystery
of the Menger Hotel*, by Docia Schultz Williams; *The History of San Antonio's Market Square*, by Mary Ann Noonan Guerra;
The King William Area: A History and Guide to the Houses, by Mary V. Burkholder; *Literary San Antonio: A Look Back*, by
Paul McQuien; *The Post at San Antonio: 1845–1879*, a publication of the Fort Sam Houston Museum; *Place Names of San
Antonio*, by David P. Green; *San Antonio: A Historical and Pictorial Guide*, by Charles Ramsdell; *San Antonio: St. Anthony's
Town*, by Leah Carter Johnston; *San Antonio: The Story of an Enchanted City*, by Frank W. Jennings; *San Antonio
Uncovered*, by Mark Louis Rybczyk; *San Pedro Springs: A Scrapbook*, by Albert F. Grimm III; *Saving San Antonio: The
Precarious Preservation of a Heritage*, by Lewis F. Fisher; *School by the River: Ursuline Academy to Southwest School of Art and
Craft*, by Maria Watson Pfeiffer; *Sesquicentennial: St. Mary's University, 1852–2002*; and *The Spanish Acequias of San
Antonio*, by I. Waynne Cox.

PICTURE CREDITS:

The publisher wishes to thank the following for kindly supplying the photographs that appear in this book:

Then Photographs:
Courtesy of the Catholic Archdiocese of San Antonio, Catholic Archives at San Antonio: 92
© Daughters of the Republic of Texas Library: 6
Courtesy of the San Antonio Conservation Society Foundation: 104, 112, 116, 130
UT Institute of Texan Cultures at San Antonio: 44 [No. 078-0107], 58 [No. 081-0073], 96 [No. 088-0616], 122 [No. 093-
0518], 140 [No. 104-0087]
Courtesy of Ann Russell: 10 [No. 083-0505], 32 [No. 083-0538], 64 [No. 083-1099]
Courtesy of Amanda H. Ochse: 102 [No. 071-0527]. Courtesy of Beulah Margaret; 46 [No. 081-0037]
Courtesy of Douglas Steadman and HDR/Simpson: 48 [No. 099-0481], 68 [No. 099-0525]
Courtesy of Elizabeth Filtsch: 100 [No. 081-0232]
Courtesy of Ellie Lamb: 28 [No.101-0054]
Courtesy of Evelyn and Ray Nell Batot: 80 [No. 104-0672]
Courtesy of Florence Ayres: 30 [No. 083-0656], 50 [No. 083-0737], 86 [No. 086-0070]
Courtesy of Jimmy Gause: 70 [No. 082-0394]
Courtesy of John K. Kight: 128 [No. 086-0097]
Courtesy of Kelly Mitcham: 90 [No. 102-0607]
Courtesy of Madeline F. O'Connor: 120 [No. 098-1250]
Courtesy of Mary Ann Guerra and Wandita Ford Turner: 1 & 74 [No. 093-0378], 62 [No. 093-0372],
72 [No. 093-0379]
Courtesy of Maurice G. Steele: 16 [No. 073-1683]
Courtesy of Pioneer Flour Mills: 18 [No. 082-0651], 114 [No. 082-0654]
Courtesy of San Antonio City Public Service Company: 118, 124 [No. 092-0170], 36 [No. 092-0150]
Courtesy San Antonio Express-News: 38 [No. 069-8404], 40 [No. 069-8423], 60 [No. 069-8744],
126 [No. 069-8716], 136 [No. 069-8492], 138 [No. 069-8696], 142 [No. 069-8685]
San Antonio Light Collection, Courtesy of the Hearst Corporation: 8 [No. L-0342-A], 22 [No. L-0513-A], 34 [No. L-
0083-G], 66 [No. L-0236-F], 78 [No. L-0010-A], 82 [No. L-1435-B], 84 [No. L-1049-D],
88 [No. L-2956-A], 98 [No. L-1112-C], 132 [No. L-1093-J]
The Belgin Collection, Courtesy of Patricia E. Zinsmeyer: 25
The Zintgraff Collection, Courtesy of John and Dela White: 12 [No. Z-42], 20 [No. Z-1276],
42 [No. Z-1217-A], 52 [No. Z-114], 54 [No. Z-1215-B], 56 [No. Z-51], 76 [No. Z-2126-G],
94 [No. Z-1386-A], 108 [No. Z-2126-Q], 106 [No. Z-2272], 110 [No. Z-2126.001], 134 [No. Z-738]
Courtesy of Virginia Essington: 14 [No. 101-0104], 26 [No. 101-0083]

Now Photographs:
All now photographs were taken by Simon Clay (© Anova Image Library)

INTRODUCTION

Nearing its fourth century of recorded settlement, San Antonio (established 1718) has seen almost every change a city could endure. The city's population has waned and boomed, while immigrants have arrived and shared their cultures. Formerly wild brushland has been sold as suburban tracts, while the city's eponymous river has swelled with devastating floods and been tamed into a lucrative tourist attraction.

Through it all, San Antonians needed shelter from semitropical extremes of climate. Moving from stone missions to simple adobe houses to ornate Gothic Revival skyscrapers, the citizenry kept putting up increasingly ambitious buildings in which they could do business, deal with government, go to school, worship, have fun, or stay overnight.

Now the ninth-largest city in the United States, San Antonio was often the largest city in Texas, a distinction it wrested back and forth from other contenders such as Galveston, Dallas, and Houston. Always big enough and important enough to attract photographers, San Antonio has been blessed with abundant documentation.

The historical photos in this book show public places that were important to the city's story and were accessible to most people of their time. Many are of downtown sites, from the days when the city's center was nearly everyone's second neighborhood. Whether they shopped in dime stores or department stores, sat in the front rows or the balconies of theaters, came by public transportation or private cars, San Antonians met and mingled on the streets of their downtown.

Most interesting, the unseen relationships between many of these places show what a small town San Antonio always was, even as its population climbed toward the hundred thousands and then to the millions. The sites show links to some of the key elements in the city's history—such as its Spanish colonial past, the Texas Revolution, and immigration from Germany and Mexico. Many of the buildings were designed by the same influential local architects or are made of materials from the same limestone quarries. During the twentieth century, streetcar lines extended and unified San Antonio, the "City Beautiful" and preservation movements improved its aesthetic, and air conditioning made it livable.

Historic ties connect many of the places in this book. For instance, start with the Milam Building, the nation's first centrally cooled skyscraper. It was designed by George Willis, whose office was in the Smith-Young Tower (now Tower-Life Building), built on the former Bowen's Island, named for an early postmaster. The tower's site was chosen for proximity to the Bexar County Courthouse, which was designed by James Riely Gordon, construction supervisor of the post office built in 1890. It was demolished to build the present downtown post office, which contains WPA murals depicting events in San Antonio history, including the Battle of the Alamo. A cannon was found on its grounds and recast into a bell for St Mark's Episcopal Church, which was built on former mission farmland donated by Texas Declaration of Independence signer Samuel Maverick. He is depicted on doors of the Scottish Rite Cathedral, a Masonic hall used by Alamo Masonic Lodge, founded at the Alamo's Long Barrack.

Part of San Antonio's persistent small-town aspect is evident in the oldest photos of the city. They show a lot of open spaces, dogs, mules, and horses. People are not thick on the hard-packed ground, and those who appear are dressed for wrangling beasts, fording a debris-strewn river or picking their way across muddy streets. By the turn of the last century, though, men of means have put on jackets and donned businesslike derbies, the hard hats of white-collar workers. When the twentieth century arrives, the airspace above increasingly paved streets is crisscrossed with black wires—power lines for streetcars, telegraph, and telephones. At first, buggies and horseless carriages park side by side; as time passes, horses yield to cars and streetcars, which give way to buses. Main streets downtown are crowded not only with vehicles but pedestrians, filling the sidewalks to get to work, buy necessities, or stir up some excitement.

For a while, the buildings get taller and taller. Even those of modest height show high ambition with columns, turrets, and towers that evoke grand civilizations. Just past the twenty-first century mark, our cars have thinned out, corralled into high-rise parking garages until their owners drive off into the suburban sunset. Glass boxes and other hulking towers rear their heads on the skyline—often with simplified references to earlier design—and yet, San Antonio still looks like nothing but itself.

Mission references still abound, and plenty of examples of Victorian solidity and 1920s think-big optimism still meet our municipal gaze. The San Antonio River has been channeled and extended, but its winding course is still an inescapable part of many-bridged downtown. An unusual willingness to compromise is shown in the number of historic buildings that have been moved out of the way of progress into spots where they can be of adaptive reuse.

Over the last 125 years or so, San Antonio gets a new look every couple of decades —after centuries of what must have been windswept plainness. The city's first inhabitants used its land and water lightly; what marks they left were temporary, long-buried, or still undiscovered. Since the first Spanish colonial structure proclaimed human intentions for this space, more than once, the people of San Antonio have changed dreams for the place they called home.

Through photographs, we are able to follow those shifts in desire, from colonial outpost to sleepy villita, frontier trade center, booster's tourist paradise, and contemporary metropolis on the brink of still more change. These images show us San Antonio as a series of temporary realizations—and remind us that our present is another past in the making.

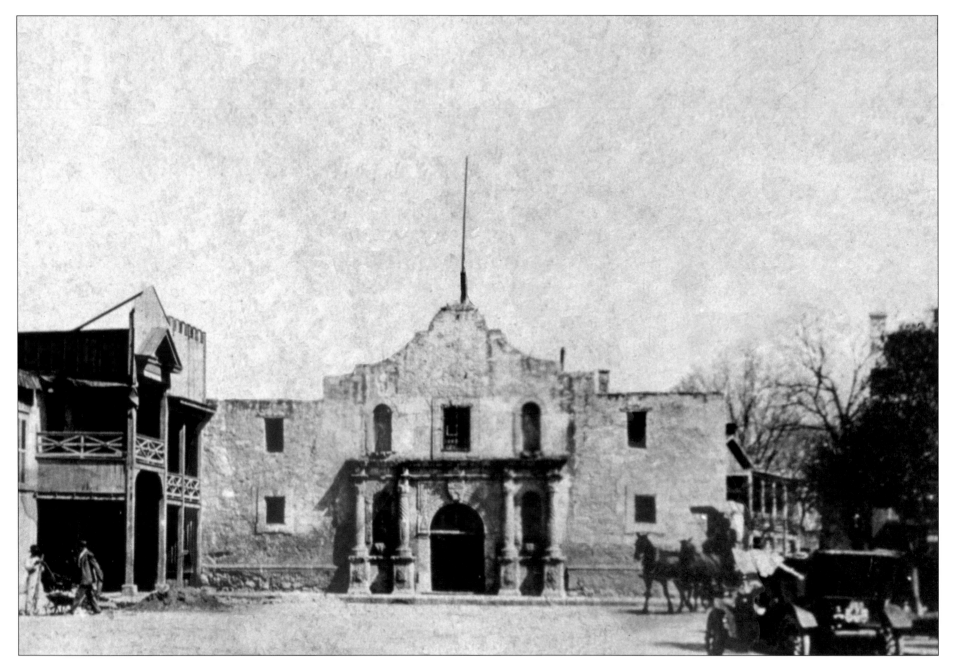

The Alamo—more properly, the church building built for Mission San Antonio de Valero—is everywhere in San Antonio. The restored building (with the memorable roofline added during U.S. Army occupation) is a central feature of downtown, but the Alamo is also present in the shape or details of other buildings, business names, and logos. As the Alamo passed from mission to garrison, fort to storehouse, the building was often vacant and badly deteriorated. Niche statuary from its facade disappeared during the 1840s; citizens took stones from the ruin for their own building projects. Commercial development (such as a proposed hotel and skating rink) threatened to encroach even further on the grounds, which were already much reduced from the original mission lands.

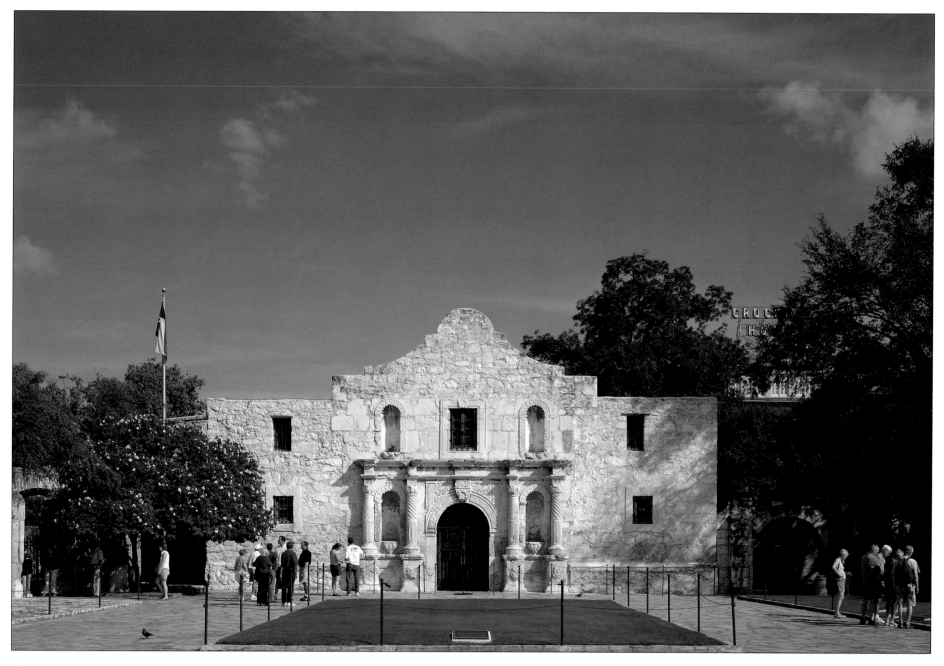

The Alamo has been a historical site longer than it was used for any earlier purpose. It is owned by the State of Texas, with the Daughters of the Republic of Texas (DRT) acting as custodians since 1905. Adjoining land was purchased to create Alamo Park around the church and convent, also called the Long Barracks. Alamo Hall, used for meetings, is a former city fire station.

A Sales Museum was added in 1936, and the DRT Library was dedicated in 1950. The site's changes are traced in exhibits in the Long Barracks Museum and on the Wall of History. Belongings of the Alamo defenders are displayed in the church. The Alamo is the top tourist attraction in Texas; admission remains free.

The 1910s and 1920s were a time of growth for San Antonio, with an emphasis on attracting out-of-towners for tourism and new business. A publicist of the period dubbed the city the "Old-New Pearl of the Continent"; better remembered is the slogan "Where the Sunshine Spends the Winter." The improved Alamo attracted more visitors to Alamo Plaza, which became a lively center for trade and entertainment. Where the ruined Alamo, a meat market, outdoor chili stands and the first demonstration of barbed wire (1876) once had set the city's frontier tone, this beautified Alamo Plaza had been civilized with paving and landscaping that matched the parklike setting within the developing Alamo compound.

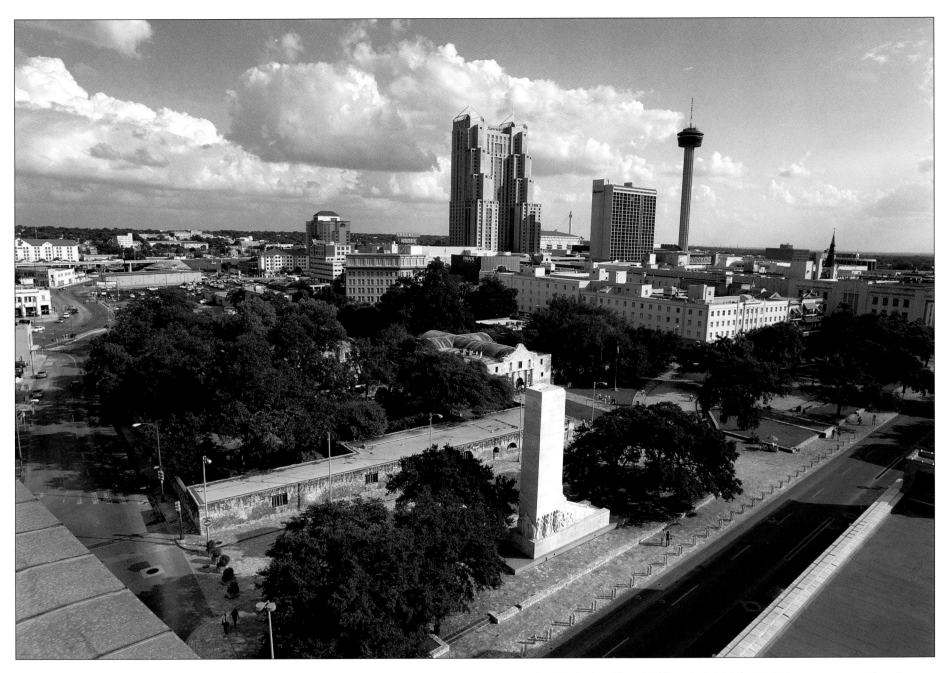

San Antonio is still an "old-new" city. The eighteenth-century mission church, whose cornerstone was laid in 1744, remains at the center of newer structures, some of which have become historic themselves: the Alamo Cenotaph (completed in 1940), Menger Hotel (1859, with many additions), Tower of the Americas (theme structure of HemisFair '68), and the spire of St. Joseph's Catholic Church (founded 1868). A skyline punctuated with hotels built for HemisFair '68, the Alamodome (opened in 1993), and Rivercenter Mall (1988) shows how important tourism has become to San Antonio's economy.

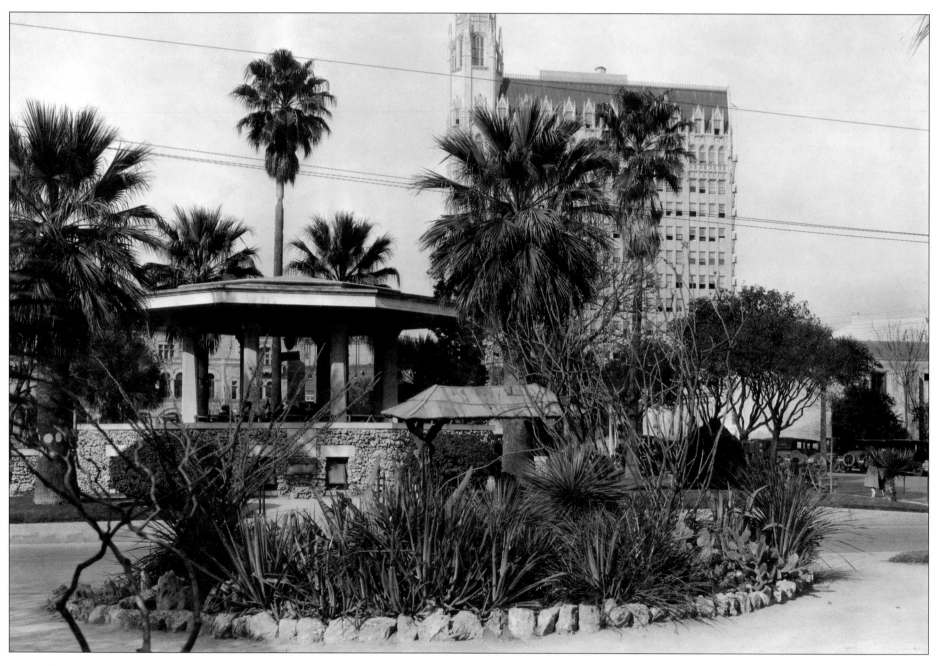

Variously called gazebos and kiosks, shaded structures like these have dotted San Antonio parks since their late-nineteenth-century heyday. This bandstand in Alamo Plaza, shown here in the early 1930s, most likely was the third of an eventual four, all built on approximately the same site. The first stone bandstand was donated in the 1890s by Billy Reuter, who sponsored band concerts to draw customers to his nearby saloon. Next came a "Prussian helmet" bandstand, most likely moved during early-1900s street repair. This concrete-and-stone bandstand, built around 1915, had a hidden purpose: a set of restrooms beneath its performance stage. The shaded "concrete wood" bench at right, by sculptor Dionicio Rodriguez, may have been moved to Brackenridge Park.

A Victorian-style replica of the bandstands once located in Alamo Plaza and San Pedro Park, this wooden structure has been in place since it was installed as part of San Antonio's observance of the U.S. Bicentennial in 1976. The previous bandstand was torn down, and no restrooms were built into its replacement. This bandstand is of similar design to the one formerly on Alamo Plaza around the turn of the twentieth century, but has a wider roof. The "old-new" Alamo Plaza bandstand has been used for holiday and festival performances, as well as lunchtime concerts.

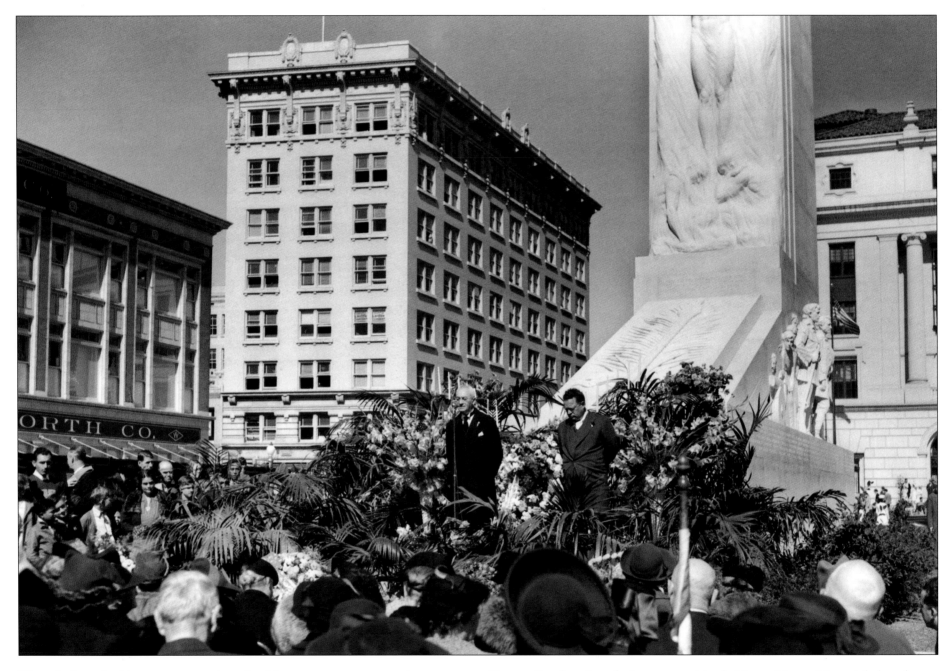

Though there had been previous plans for Alamo monuments, starting in the late nineteenth century, the Alamo Cenotaph was the first such erected in San Antonio. (An Austin monument, studded with grim skulls, was lost in a Capitol fire.) During the 1936 Texas Sesquicentennial celebration, the state provided $100,000 for the monument, commissioned from local sculptor Pompeo Coppini (who bested Mount Rushmore sculptor Gutzon Borglum in a design competition). Mayor Maury Maverick (on the platform at right) presided over the dedication ceremony, November 11, 1940. Titled *Spirit of Sacrifice*, the marble-and-granite monument incorporates half-reliefs of the spirits of sacrifice and Texas, images of the Alamo garrison leaders, and names of known Alamo defenders.

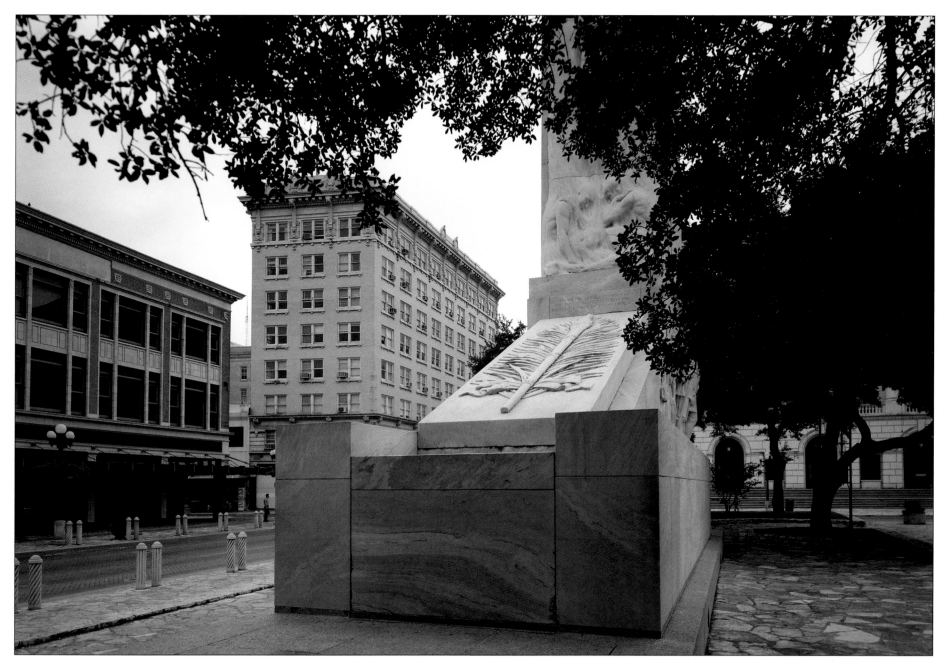

The paved island on which the Cenotaph stands is now a favorite meeting place for walking-tour groups and a safe vantage point for photographing the Alamo facade. Not everybody likes the Cenotaph, which partially obstructs the eastward-looking view of the Alamo compound. During the mid-1980s, a proposal to move the monument a few blocks south was quashed by DRT members and others who believed the Cenotaph belongs near the Alamo. In 1995, the Alamo Wells Project (a hunt for legendary buried silver in conjunction with an archaeological dig) tore up the street between the Cenotaph's island and the Alamo walls. Replacement flagstones can still be discerned near the south end of the Long Barracks.

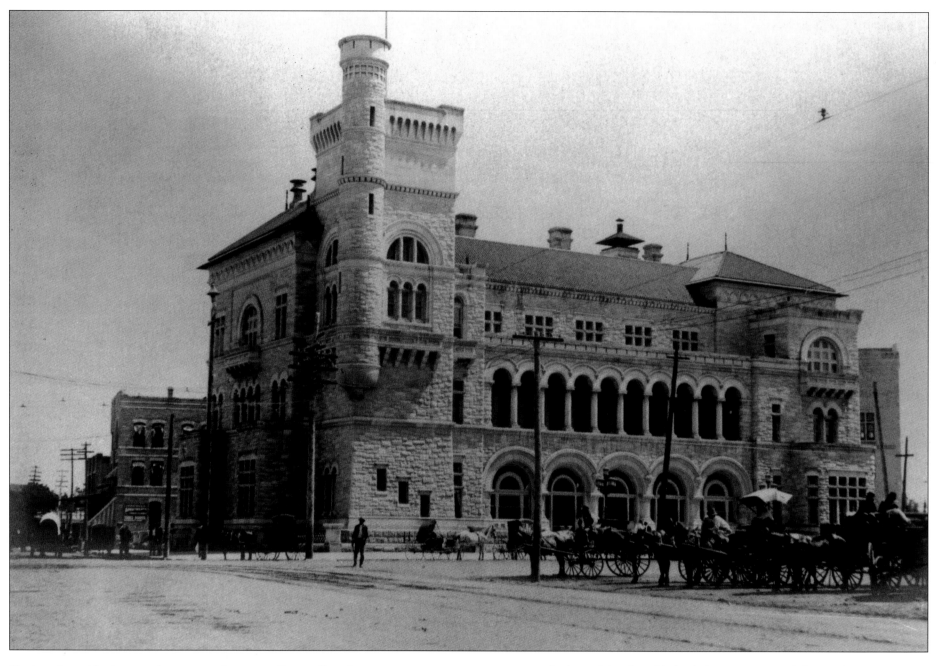

During the mid-nineteenth century, the post office at San Antonio was in the northwest corner of postmaster John Bowen's house off Main Plaza. A modest two-story post office followed, but by the time this Federal Building and Post Office opened in 1890, the city demanded not only more space but also more gravitas from its public buildings (such as City Hall, then under construction). A guidebook published that year praised the exuberantly styled new post office as "a beautiful medieval dream in Richardsonian Romanesque with a touch . . . of Lombardy and the south of France." This observation point was later closed to the public after pranksters pulled increasingly risky stunts from its windows.

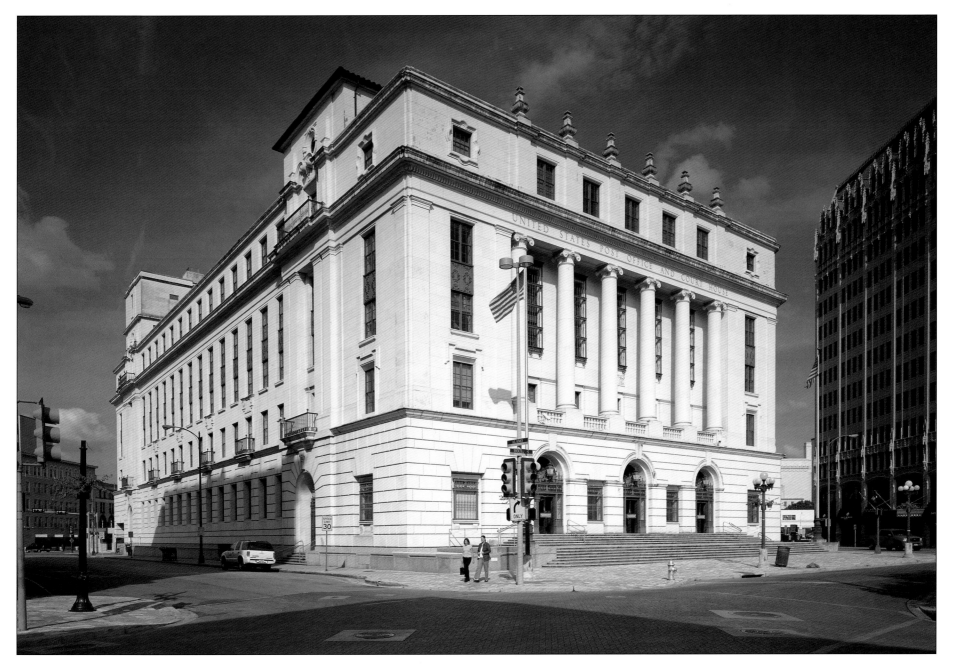

A growing population and more federal services offered during the New Deal era required a larger federal building. This downtown post office, in a more austere, neoclassical style, was finished in 1937. Inside the entrance lobby, the frescoes *The Importance of San Antonio in Texas History* glow with color. Restored in 1999, the murals were painted by magazine illustrator Howard

Cook, who researched historical scenes and used some local people as models. Cook worked on the project for nearly two years, as offices moved in and schoolchildren were brought to watch him at work. A kiosk in the lobby details his lengthy process. Many federal offices have relocated, and the city's main post office is now in northeast San Antonio.

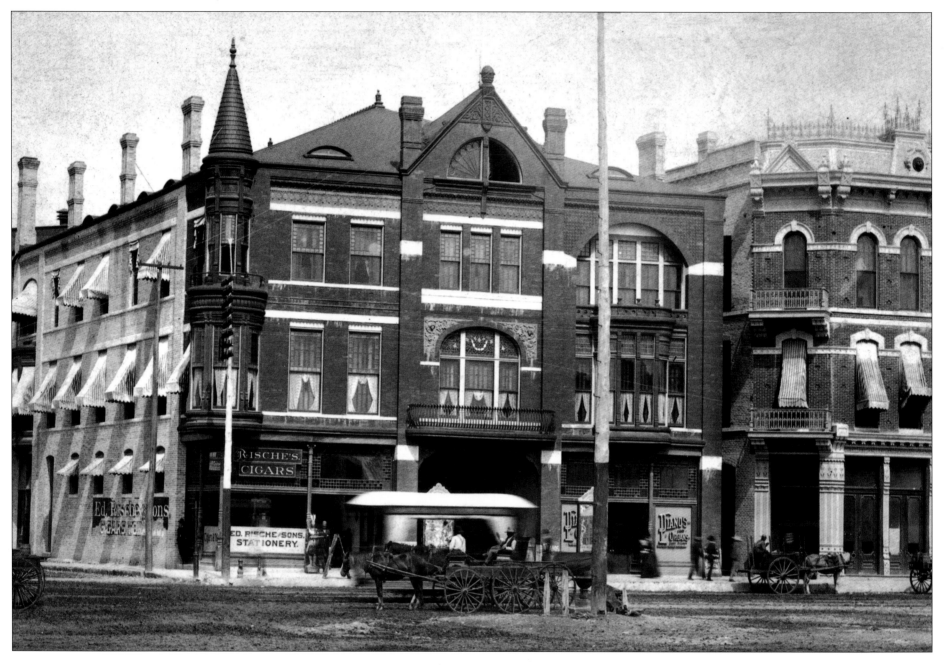

San Antonio theater went upmarket when the Grand Opera House opened in 1886 on the east side of Alamo Plaza. Most public places of entertainment (such as the neighboring Dingle-Dangle Theater) had catered to cowboy tastes. After the railroad came in 1877, touring companies found San Antonio more accessible. To accommodate them, local investors built an opera house with a private club upstairs. The modern-Renaissance building had the city's first fire escape. Furnishings were luxurious: mohair seats, crystal chandeliers, and a fresco portrait of Shakespeare. Visiting artists such as actor Edwin Booth, pianist Ignace Paderewski, and singer Lily Langtry brought art and glamour to its stage, but offerings devolved to sports events, "leg shows," and early movie screenings.

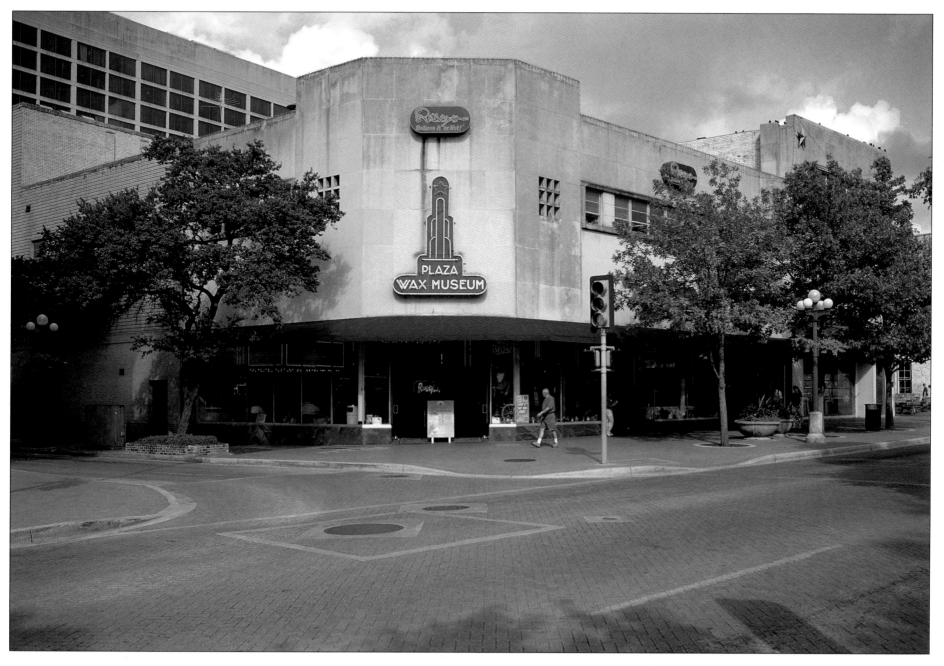

From 1925 onward, the Grand Opera House was no longer a theater. After renovations, the building housed stores and offices before being torn down in the late 1940s. The building that replaced it was the H. L. Greene Variety Store, from 1951 through the late 1980s. Entertainment came back to the site in the early 1990s with the Plaza Wax Museum/Ripley's Believe It or Not.

Visitors may tour a collection of 250 wax figures, representing movie stars, historical figures, and Texans such as the Alamo defenders, President George W. Bush, and former Dallas Cowboy Tom Landry. Artifacts from the collection of cartoonist Robert Ripley are also on display, including the world's smallest pool table and the *Junk Art Man* folk sculpture.

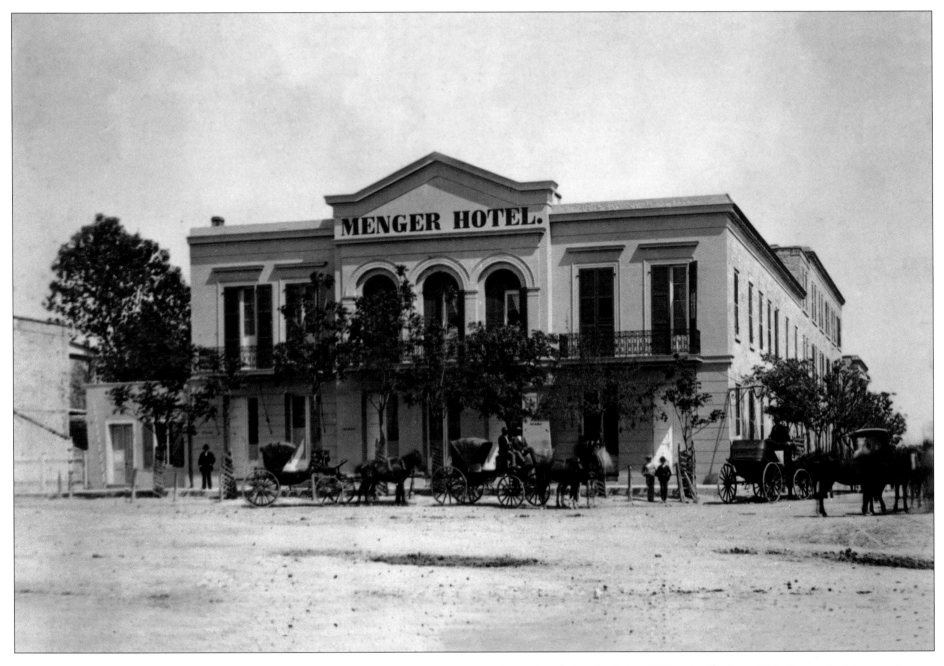

The city's first first-class hotel opened in 1859, with accommodations advertised by owner William Menger as "at least equal to those of any hotel in the West." To keep this promise, German-born Menger operated an adjacent brewery, hired European chefs, and bought antique furnishings abroad. His hotel became the San Antonio stopping place for the rich and famous, including cattle kings and touring celebrities such as Oscar Wilde and Sarah Bernhardt. After William's death in 1871, his wife, Mary, and their sons ran the hotel, expanding it in 1875 and selling it to the original contractor in 1881. Temperance activist Carrie Nation—famous for smashing up saloons with her hatchet—paid a visit to the Menger Bar in the 1880s, handing out small souvenir hatchets to surprised patrons.

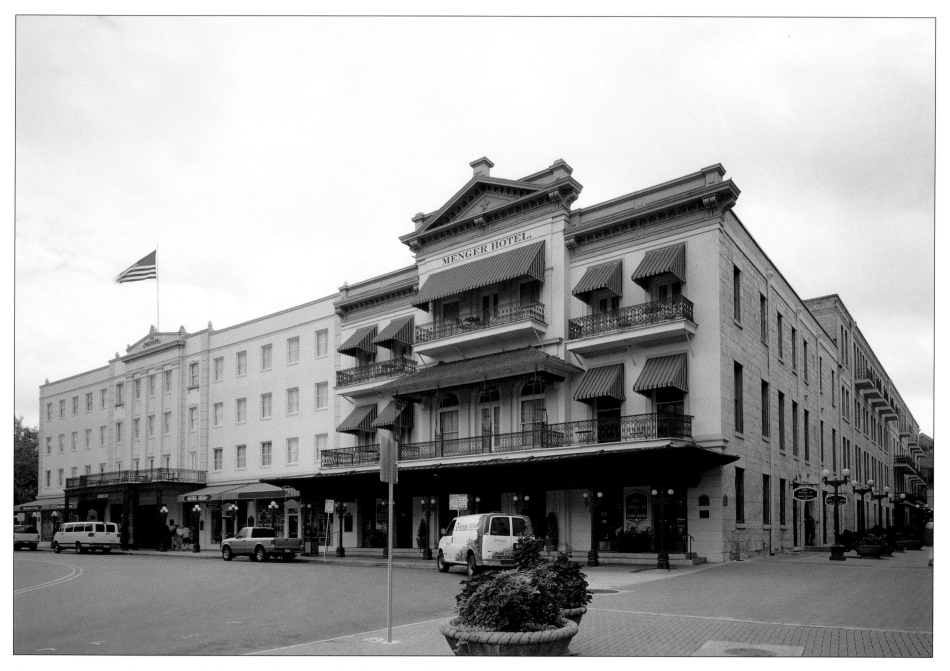

Further expansions (including a "motor hotel" addition for HemisFair '68) spread the Menger to cover a good chunk of its block, with retail stores on part of its ground floor. It's now one of the closest hotels to the Alamo and to Rivercenter Mall. The old lobby in the original hotel at right is decorated with furniture and artwork acquired by the Menger family and later owners, including Mary Menger's grand piano. One of the historic Menger's more unusual quirks is the many ghost tales that have been told about it. Phantoms thought to be Alamo defenders, former guests, and employees are said to haunt the hotel; guests may request rooms with or without a ghost.

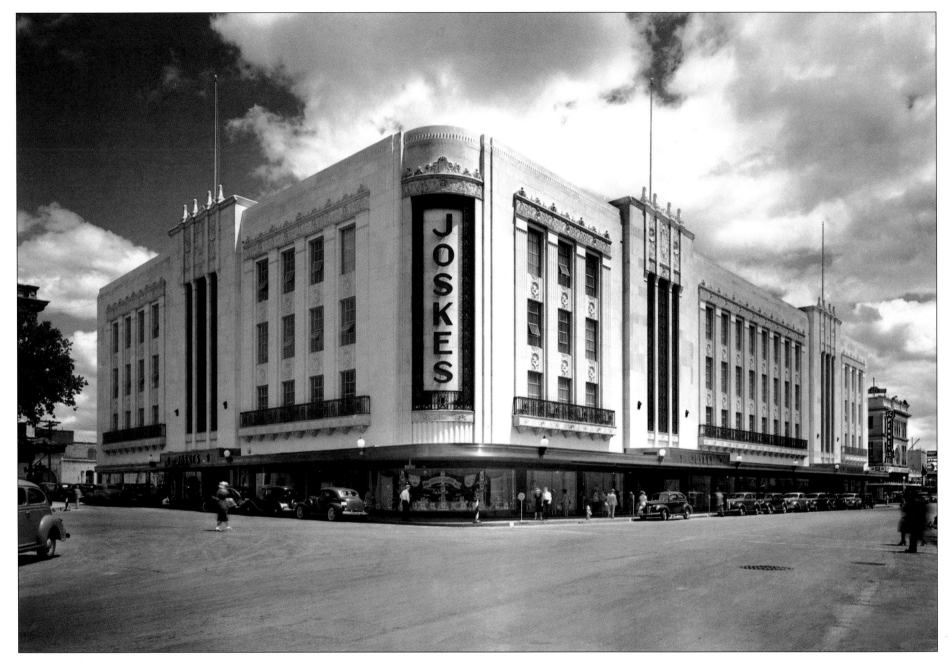

On Alamo Plaza since 1888, Joske's of Texas was "the biggest store in the biggest state." This downtown flagship was known as "the Big Store," among an eventual total of seven branches in malls and other cities. In 1936, Joske's became the first fully air-conditioned store in Texas, with departments including spurs and saddles, appliances, books, and toys. After a 1939 expansion (as shown here), the Big Store boasted San Antonio's first escalators. Founded by a German immigrant, Joske's passed from family hands in 1928, but continued to grow, with additions built whenever property became available. St. Joseph's Catholic Church (behind store at right) refused to sell; hemmed in on three sides, it was nicknamed "St. Joske's."

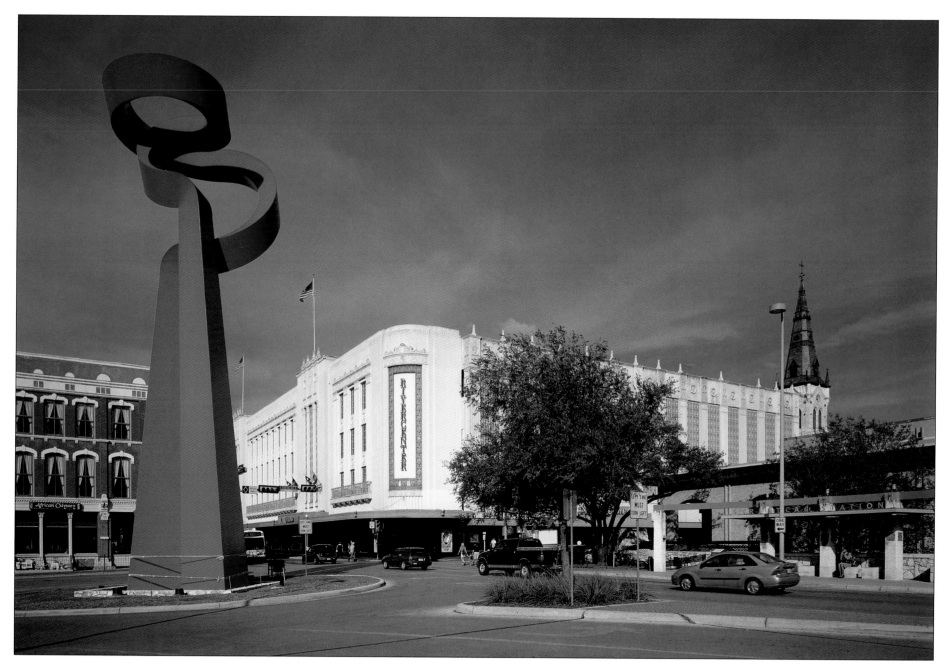

Joske's was sold while closed for renovations in 1987. The Big Store, once a shopping center in itself, is now Dillard's, an anchor tenant of Rivercenter, the multilevel, glass-walled mall that straddles an extension of the San Antonio River. The letters in the Joske's sign were donated to public-television station KLRN and auctioned off in a fund-raising event. Dillard's has preserved the eye-level display windows, modeled after the rose window in the church at Mission San Jose, from Joske's 1939 renovation. This intersection of Alamo Plaza, South Alamo, and Losoya streets is now Convention Plaza. The sixty-five-foot *Torch of Friendship*, by Mexican sculptor Sebastian, was donated in 2002 by leaders of the Mexican community in San Antonio.

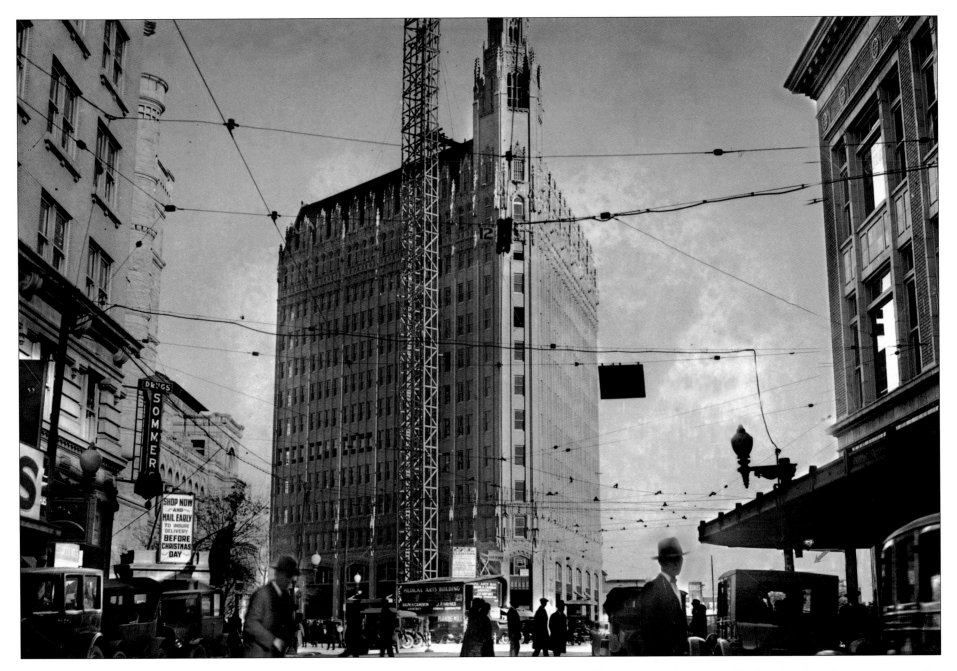

For nearly five decades, the Medical Arts Building was "the place to practice medicine in the Southwest," as announced when the thirteen-story medical center opened in 1926. A wedge-shaped site dictated its design, which thrusts out into Alamo Plaza. At mezzanine level, pained faces in terra-cotta relief advertised the building's original purpose. Inside, ultrafast elevators swooped patients to doctors' or dentists' offices, or to the small hospital on the top floor. Development of the South Texas Medical Center during the late 1960s drew tenants to newer office buildings in northwest San Antonio.

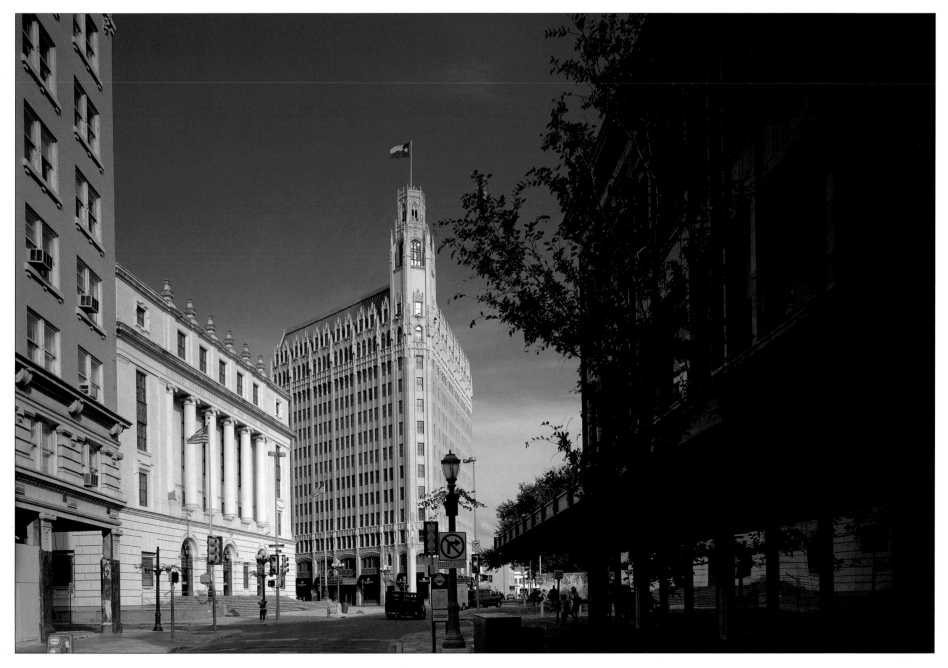

Sold in 1975, the former Medical Arts Building was reopened the next year with a bicentennial theme, including a lobby eagle sculpture whose less-than-eternal flame was lit in ceremony by a visiting British consular official. As the Landmark Building, it was sold again in 1982 to be converted into the Emily Morgan Hotel. This name caused some controversy with its reference to the legend of an enslaved woman who distracted Mexican general Santa Anna during the climactic battle of the Texas Revolution. Briefly renamed the Alamo Plaza Hotel, the Emily Morgan name was restored because of its ties with Texas history.

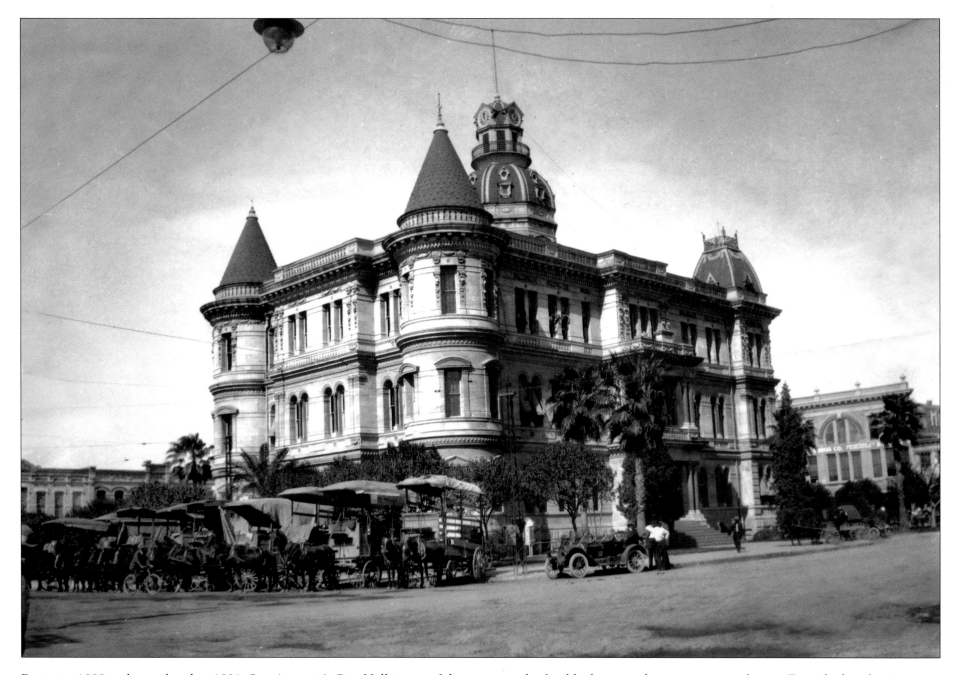

Begun in 1888 and completed in 1891, San Antonio's City Hall is one of the nation's oldest buildings in continual use. Before it was built, Military Plaza was an open square used as a marketplace, where vendors sold produce and the nineteenth-century equivalent of fast food from wagons and tables. Chili was most popular, sold far into the night. The market and its nighthawks moved a few blocks west when construction began. Described at the time as Renaissance, the design included conical and mansard towers, as well as a central octagonal tower with a clock that struck the hour. To keep the clock going, its tender had to turn a crank 160 times, once a week.

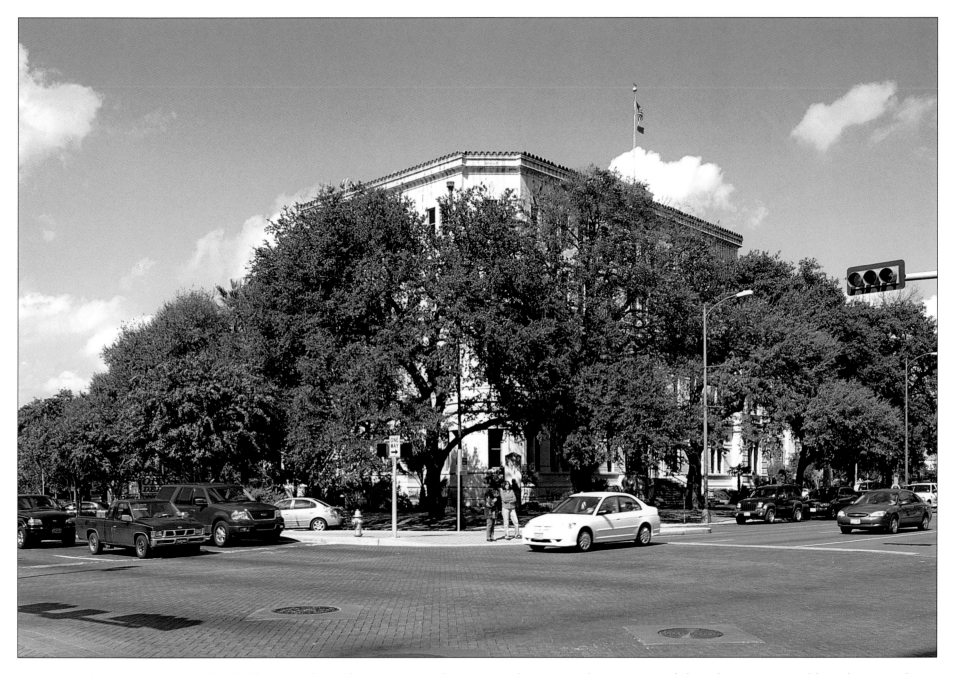

As municipal government grew, City Hall grew with it. The assortment of towers that graced its roof had to be sheared off with other architectural flourishes when a fourth floor was added in 1927. (Damaged beyond use in removal, the tower clock had to be scrapped.) While many city departments are located now in other buildings, offices of the mayor and city council members remain here. Its grounds have become a veritable sculpture garden, with a heroic statue of colonist Moses Austin at the rear, a bust of Franklin D. Roosevelt, and a sculpture of Mexican and U.S. eagles near the front entrance. A rock commemorating the Caminos Reales (Spanish Colonial Highways) is on the northeast side.

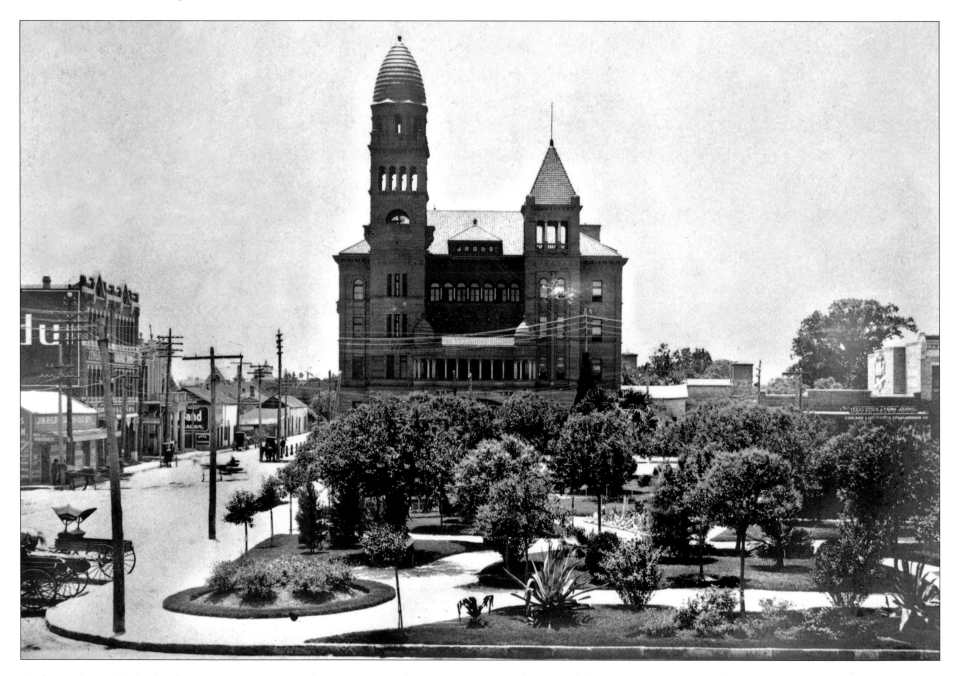

Architect James Riely Gordon was no stranger to skinny turrets and repeating arches when he submitted the winning design for a new Bexar County Courthouse. Gordon, who supervised construction of San Antonio's 1890 federal building, was a twenty-seven-year-old local architect when he won a first prize of $1,000 for his Romanesque Revival plan. The four-story seat of county government had ventilation features suited to San Antonio's "peculiarities of climate." Construction (in native Texas granite and red sandstone) began with a December 1892 cornerstone ceremony, accompanied by Masonic honors and an army band. Cost overruns and contracting disputes plagued the building process, even after the December 1895 move-in. The courthouse was finished in late 1896, with plumbing, heating, and electrical repairs.

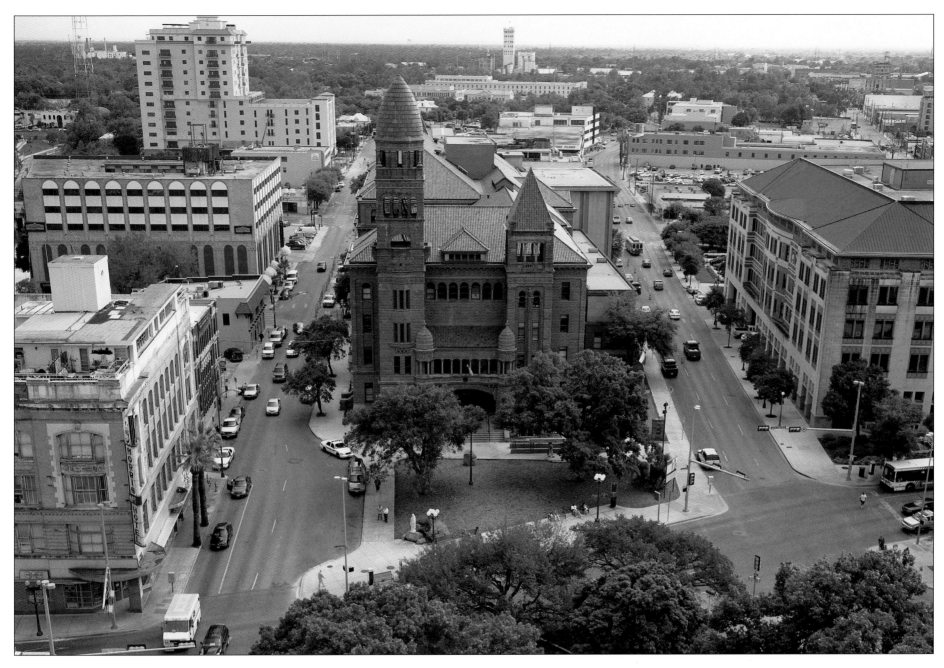

Now the largest historic courthouse in Texas, Bexar County's headquarters is one of only eighty built before the turn of the last century. An exterior restoration project, begun in late 2001 with funds from the Texas Historic Courthouse Preservation Program, cleaned the building's stone and terra-cotta, repaired the roof, and replaced iron railings. Surrounded by scaffolding custom-designed to prevent pressure on clay roof tiles, the courthouse remained open throughout the project and was rededicated on April 4, 2003. At right, the Bexar County Justice Center is a courthouse expansion, which was completed in 1990, with materials similar to those used in the 1890s building. Construction revealed a portion of a Spanish acequia (waterway), left open to view on the building's north side.

In a sense, this adobe building was the first capitol of Texas. Begun in 1722, the commandancia (home and headquarters of the Spanish garrison commander) was completed in 1749. As the seat of Spanish and later Mexican government in the province of Tejas, the Governor's Palace was a social, as well as a government center, with a ballroom that doubled as council chambers. The building became a private home until the Military Plaza marketplace turned the neighborhood into a commercial district. From the 1860s, the former "palace" was used as a school, then divided into business premises that sold shoes, second-hand clothing, and "all you can drink for 10 cents" at El Palacio saloon. The stones in front were used for a City Hall addition.

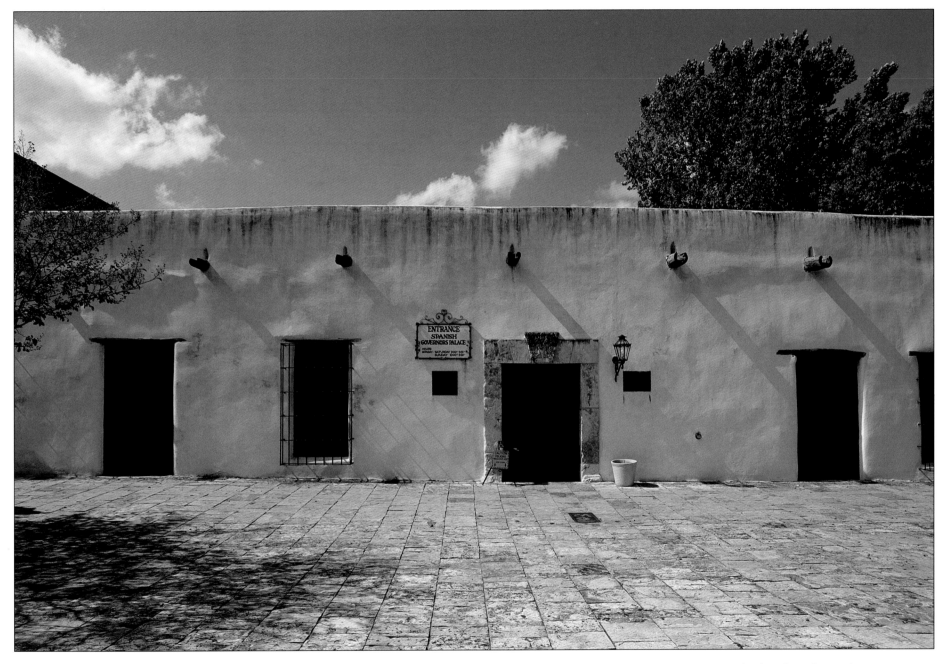

Behind present-day City Hall, the Spanish Governor's Palace is now a museum, as the city's only surviving example of an aristocratic colonial home. After the city purchased the dilapidated building, telephone poles were used to prop the ceiling while a tin roof was replaced. Supervising architect Harvey P. Smith traveled to Santa Fe to study the Spanish Governor's Palace there, so rooms could be reconfigured to resemble the original plan. Restoration was completed in 1931, and the house was furnished with eighteenth-century artifacts and reproduction pieces. In recent years, historical reenactors have portrayed soldiers from La Compania de Cavalleria del Real Presidio de Bexar (Calvary Company of the Royal Garrison of Bexar) at the Governor's Palace, just steps away from the former drill ground of the Military Plaza.

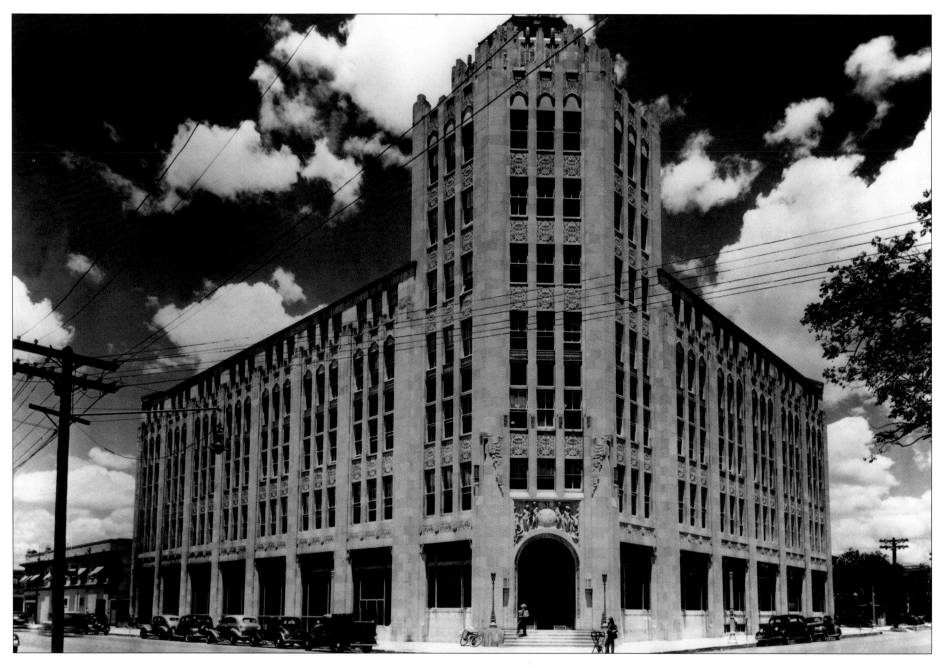

Completed days before the stock market crash of 1929, this is the third headquarters of the San Antonio Express Publishing Co. Its *San Antonio Express* first appeared in 1865, making it one of the oldest continuously published newspapers in Texas. The newspaper and printing company announced that it would move to this nine-story building to "widen its scope of service and usefulness." Pompeo Coppini's bas-relief over the entrance depicts that scope with allegorical figures of Knowledge, Education and Enlightenment, as well as carved-stone telegraph wires linking Texas with the rest of the globe. The staff got new ceiling fans and drinking fountains "to promote and speed them at their task," while the public was invited to lectures in the 850-seat auditorium.

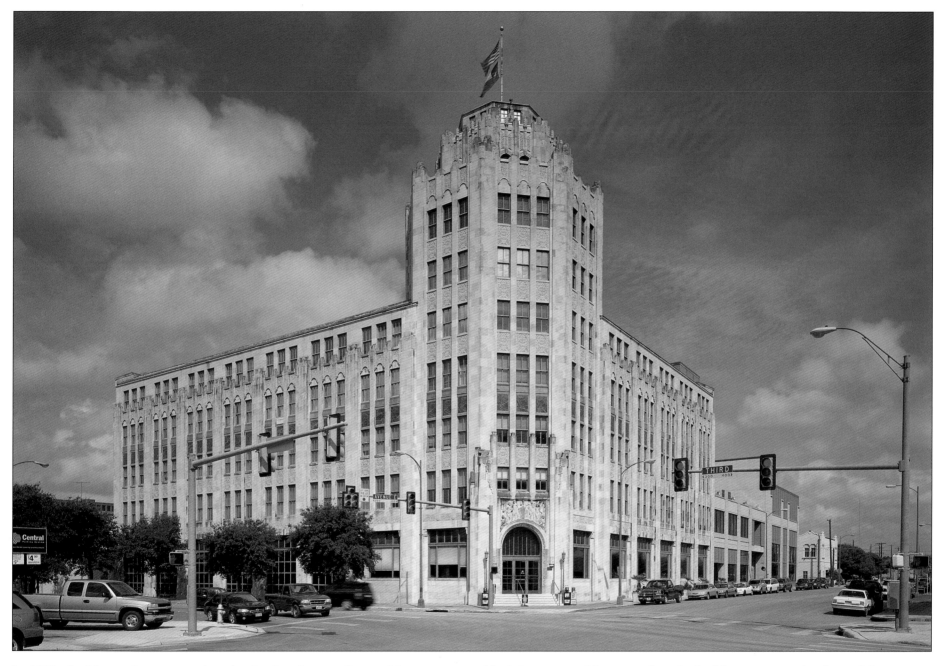

In 1993, the Hearst Corporation bought the *San Antonio Express-News* (renamed in a merger with its own evening paper) and closed the *San Antonio Light*, ending a rivalry that began with the *Light*'s first publication in 1881. The *Express-News* moved some departments to the Light Building on Broadway, but kept most news staff in the 1929 building. A Lone Star of black Persian marble, original to the building, is set in the floor of the octagonal lobby, shaped by the tower at the confluence of Avenue E and Third Street. The tower, usually illuminated in blue at night, is a familiar feature of the city's skyline.

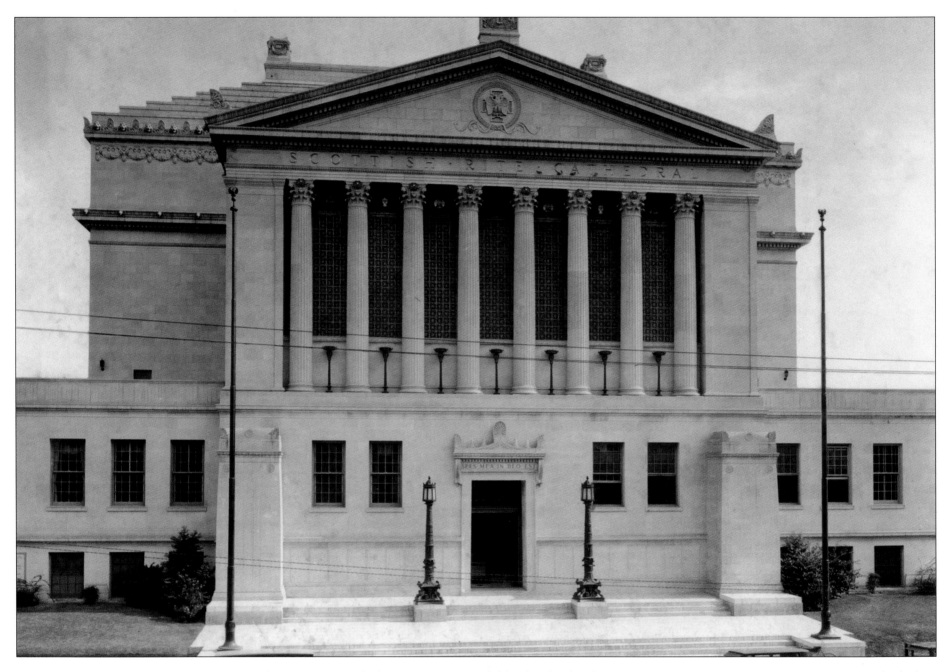

Masons were among the first American settlers in Texas, including many heroes of the Texas Revolution. Alamo Lodge No. 44—founded in 1847 by U.S. soldiers in the Alamo's Long Barrack—was the first in San Antonio and the sixth in the state. Built in 1924, the Scottish Rite Cathedral was planned for ceremonial use by area Masonic lodges. Ritual is important in Freemasonry, and the Scottish Rite is said to make use of plays depicting biblical and other lessons. San Antonio's imposing Scottish Rite Cathedral is a tribute to "the Craft" (the practice of Freemasonry), with a neoclassical facade incorporating Masonic symbols and splendid interiors with vaulted ceilings, marble floors, and gilt-trimmed ceilings. An upper-floor auditorium was designed to have nearly perfect acoustics.

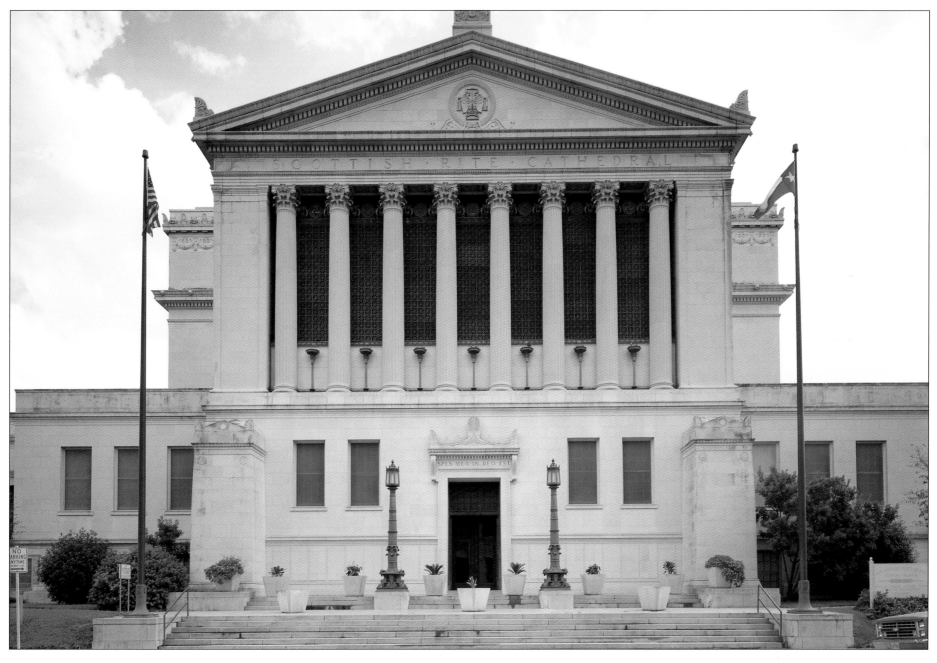

Solid-bronze doors were installed in 1926 at the front and south entrances of the building. Reliefs by Pompeo Coppini (later, the sculptor of the Express-News entrance frieze and Alamo Cenotaph) represent contributions of Freemasonry to U.S. and Texas governments with portraits and Masonic iconography. Figures of George Washington and Sam Houston (both heads of state) flank the front doors, while Sam Maverick and Lorenzo de Zavala (both important to the Texas Revolution and Republic of Texas) are featured on the south doors. Lodges and affiliated organizations still use the building, which houses a Masonic library and museum. Open to the public for tours, the building's auditorium, ballroom, and Ladies' Parlor are popular venues for weddings, concerts, and meetings.

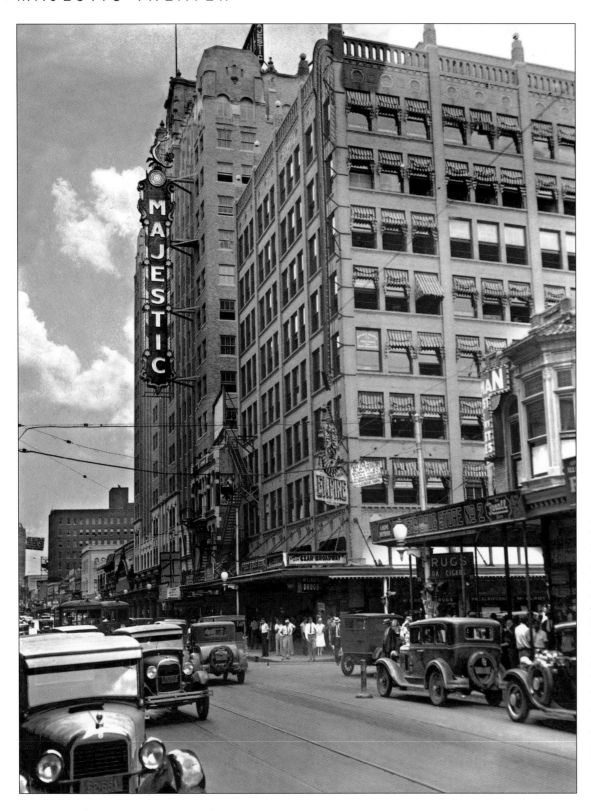

Living up to its name, the Majestic Building occupies a major chunk of its Houston Street block. Far surpassing the old Majestic—a vaudeville house (later the State movie theater) a few blocks west—the new Majestic, opening on June 14, 1929, rose to fourteen floors and had office space above the theater, one of the city's grandest movie palaces. The showpiece of the "atmospheric theater"—designed by genre master John Eberson—was its 3,700-seat auditorium, modeled after a Spanish Colonial courtyard. A ceiling "sky" was painted and lit to mimic day-into-night, while faux balconies, tiled towers, and plaster peacocks were constructed to suggest a cathedral and castlelike atmosphere. Hollywood royalty, such as Mae West and Bob Hope, often appeared in stage shows here.

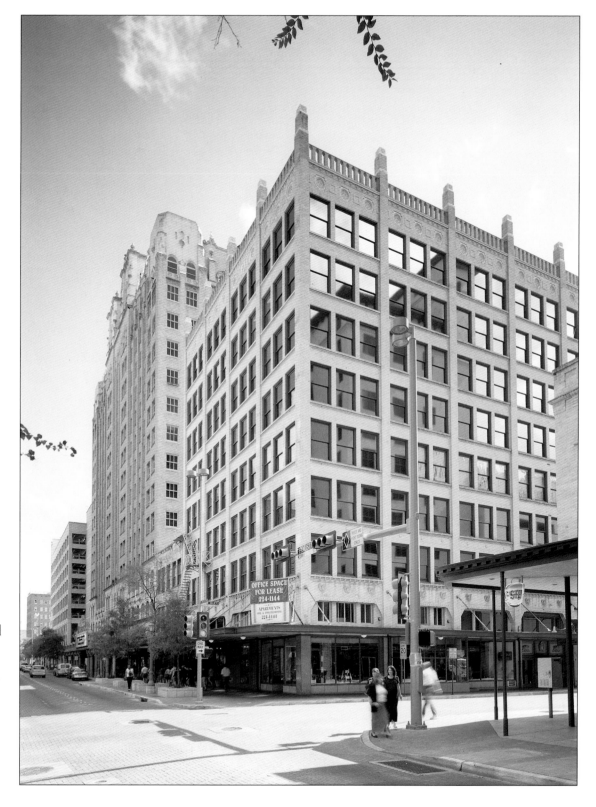

The post–World War II trend toward neighborhood theaters (then suburban multiplexes) gradually turned downtown's huge, elaborate movie palaces into unprofitable, decaying caverns. The Majestic—the largest and the last built before the Depression—closed in 1974 and reopened a few years later as the short-lived Majestic Music Hall. In 1988, the city bought the theater and leased it (for $1 a year) to Las Casas Foundation, a nonprofit group that raised funds for its $10 million restoration into a legitimate theater. Meanwhile, an independent Majestic Development Company renovated upper floors of the building into an eighty-nine-unit apartment tower. Since reopening, the theater has been home to the San Antonio Symphony and presents a yearly season of Broadway musicals and other touring shows.

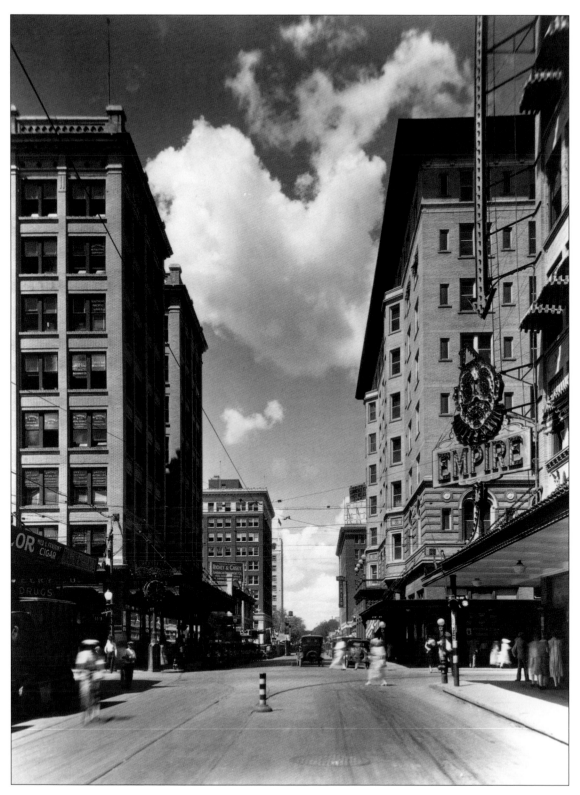

San Antonio's earliest movie theaters were modest affairs, from nickelodeons to storefronts with bedsheet screens. By the time the Empire Theater opened on December 14, 1914, the movies were here to stay and the theater had acquired a glamour reflected in what a local newspaper called "one of the most beautiful [theaters] in the entire South." The Empire boasted a lobby fountain, exotic plants, and rays of recessed blue lighting in the auditorium. A decade later, the theater acquired further gloss with a mahogany ticket booth, Japanese silk curtains, and Italian marble decorations. Empire staff often worked in costumes keyed to the theme of films on the program, and the theater's stage shows featured stars such as singing cowboy Gene Autry.

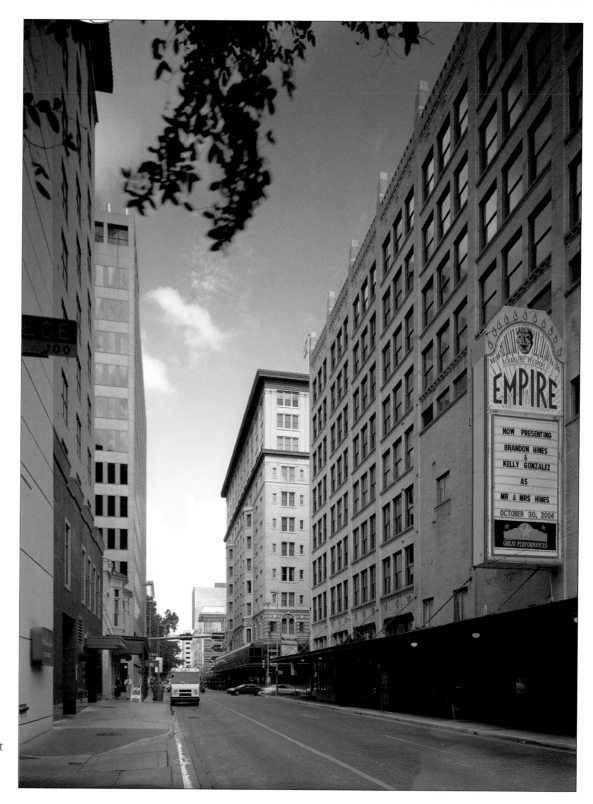

Another victim of downtown decline, the Empire slipped to showing second runs and then unsavory fare before closing in 1978. The Las Casas Foundation took up the Empire's cause, raising $3.5 million for renovation of the smaller theater, which shares some facilities with the nearby Majestic. (A $1 million gift from a board member and her husband—Charline and B. J. "Red" McCombs—facilitated completion of the project in 1998.) The showiest aspect of the aesthetic and technical restoration was the regilding of heavily overpainted ornamental plasterwork. This 800-seat "jewel box" of a theater is used for smaller, simpler productions. Described at its opening as "at the very hub of the city," the Empire is now a centerpiece of the revitalized Cultural Arts District.

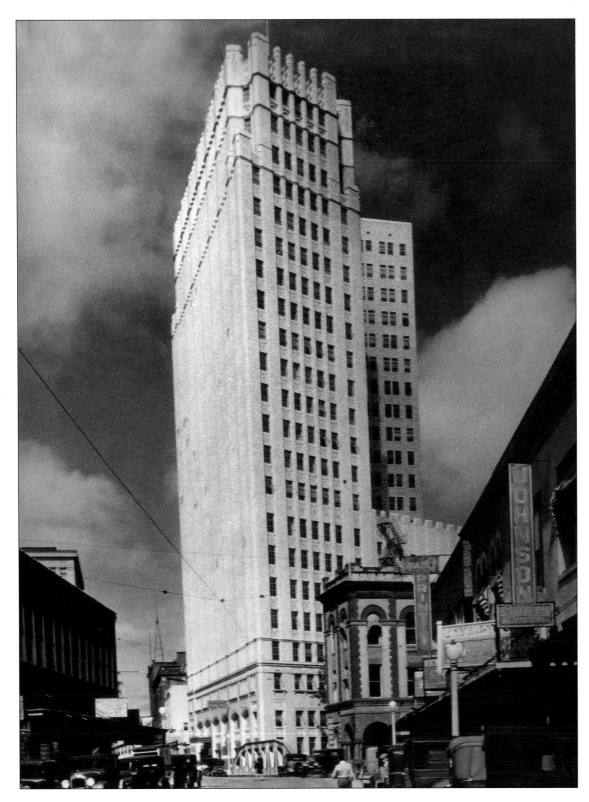

Developer J. M. Nix (also involved with the Majestic Theater building) put his name on San Antonio's first full-service, for-profit hospital. The Nix was the first hospital to be housed in a skyscraper when it opened in November 1930. As a medical complex, the Nix was an advance on the earlier Medical Arts building in several ways. Even more massively Gothic, the twenty-four-story building alongside the San Antonio River was much taller than its Alamo Plaza counterpart. It also had a parking garage—initially, on the first eight floors of the building, then later just on the first three (a conversion in response to demand for more office space). A frieze of ornamental faces at mezzanine level depicts not only suffering patients but also classical and historic healers.

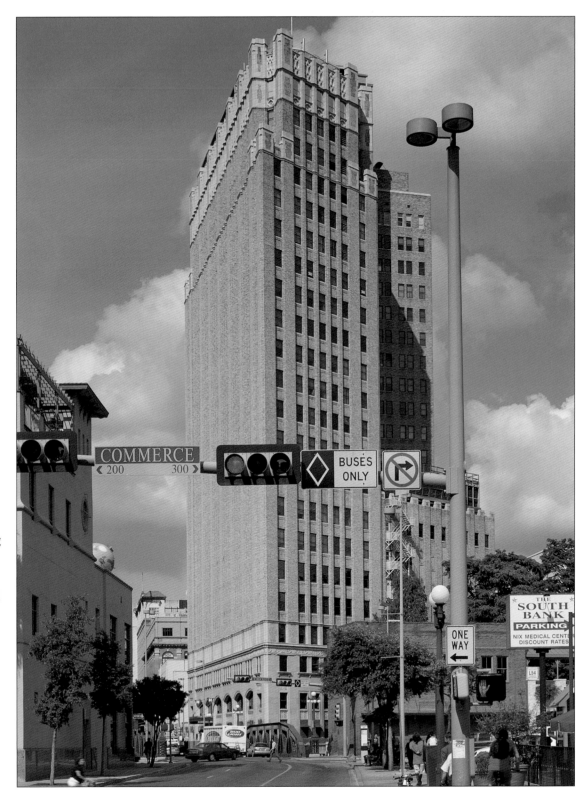

The former Nix General Hospital/Nix Professional Building is now the Nix Medical Center, headquarters of the Nix Health Care System. Many San Antonians were born in the original downtown facility, including Carol Burnett and former San Antonio Mayor Henry Cisneros. Known for its personal touch, the Nix continued to employ an elevator operator far into the age of self-service. The parking garage was remarkable for its wash-and-wax service and the open "man-lift" elevator for valets retrieving cars. The Nix was the city's first hospital to offer radiation therapy, bone scans, and other new medical technologies. The system now operates two other centers, as well as the hospital in the downtown building, linked to the River Walk by a lower-level restaurant.

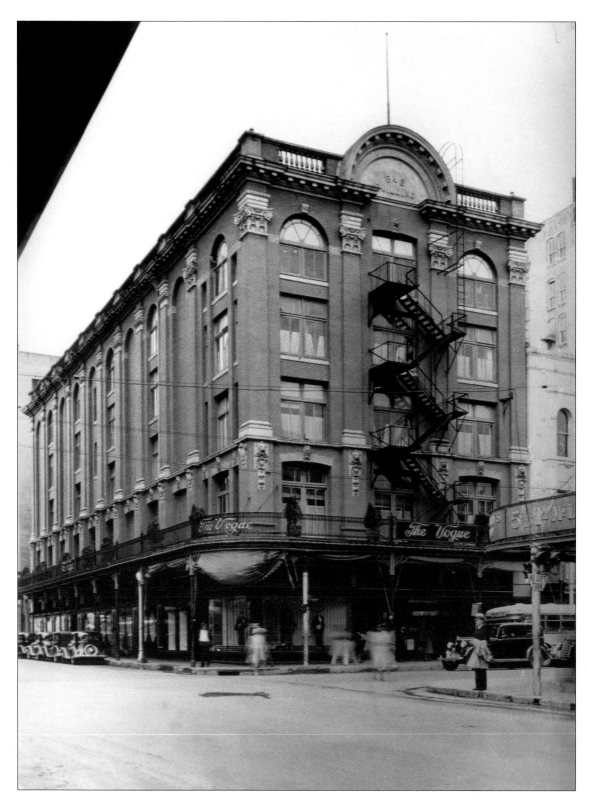

During the early- to mid-twentieth century, Houston Street was the place to see and be seen—a larger, livelier, open-air version of today's shopping malls. From Alamo Plaza westward to the river, Houston Street was home to many of the city's best-known stores, restaurants, and movie theaters. Known to cruising teenagers as "the Drag," the street was a magnet for people in search of goods or good times. Street photographers snapped pictures of well-dressed shoppers promenading along trade routes anchored by department stores such as the Vogue. In the Peck Building (home of Peck's Furniture during the 1910s), the Vogue concentrated on high-fashion women's apparel, conveniently close to competitor Frost Bros., the popular Manhattan Restaurant, and first-run movies at the Majestic.

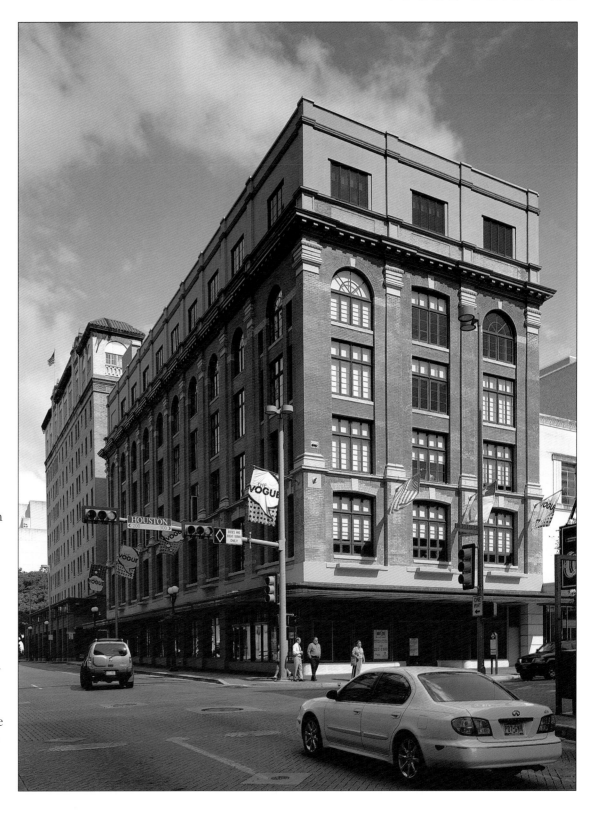

As suburban development shifted San Antonio's population away from the center city, department stores such as the Vogue, Frost Bros., and others moved out to the malls or closed their doors. Since the late 1980s, much downtown redevelopment has centered around a growing Cultural Arts District that links two refurbished theaters on and just off Houston Street with new attractions, such as the San Antonio Children's Museum, opened in 1995 in the previously empty W. T. Grant store next door to the Vogue. Now known as the Vogue Building, the former store was cleaned, restored to a streamlined version of its original exterior, and eventually converted into office space. Despite a top-floor addition and several previous renovations, a few exuberant architectural flourishes survive.

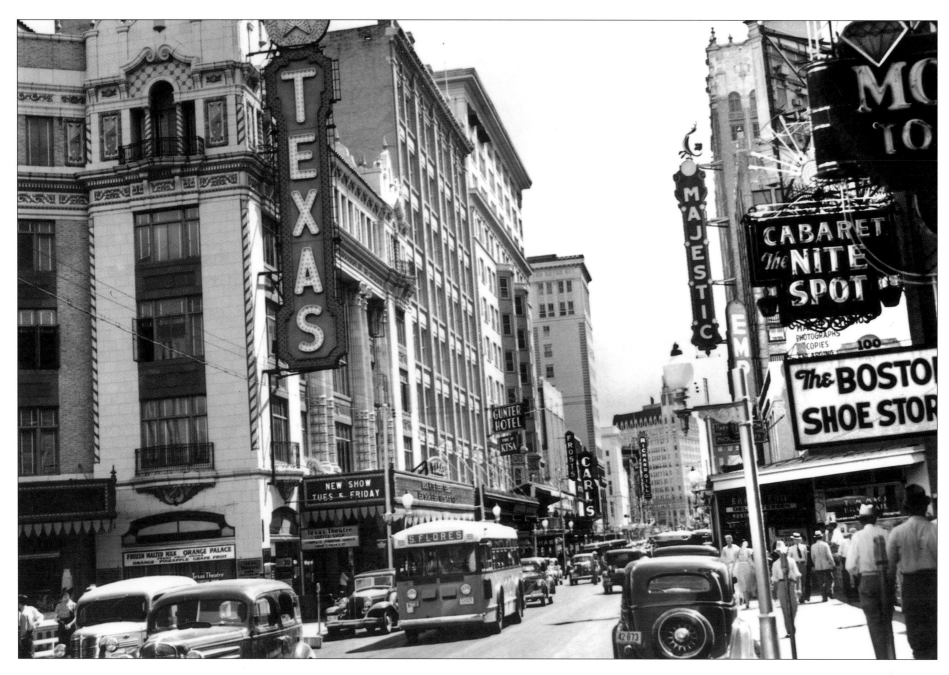

From this Houston Street vantage point, moviegoers could scan marquees of the Texas, Majestic, Empire, and State theaters (just west of the river). The 2,700-seat Texas opened December 1926 and was host next year for the premiere of *Wings*—a World War I drama with scenes filmed in San Antonio and winner of the first Academy Award for Best Picture. Noted local architect O'Neil Ford later called it "a mishmash of Italian-Spanish stuff,"

like many other fantasy theaters of the period. On the exuberant, angled facade of "San Antonio's Two-Million Dollar Showplace," barber-pole stripes mix with other multicolored or gilded Spanish Colonial and rococo motifs. A canopy led to a patio-style entrance; murals inside were painted by Spanish-born artist José Arpa.

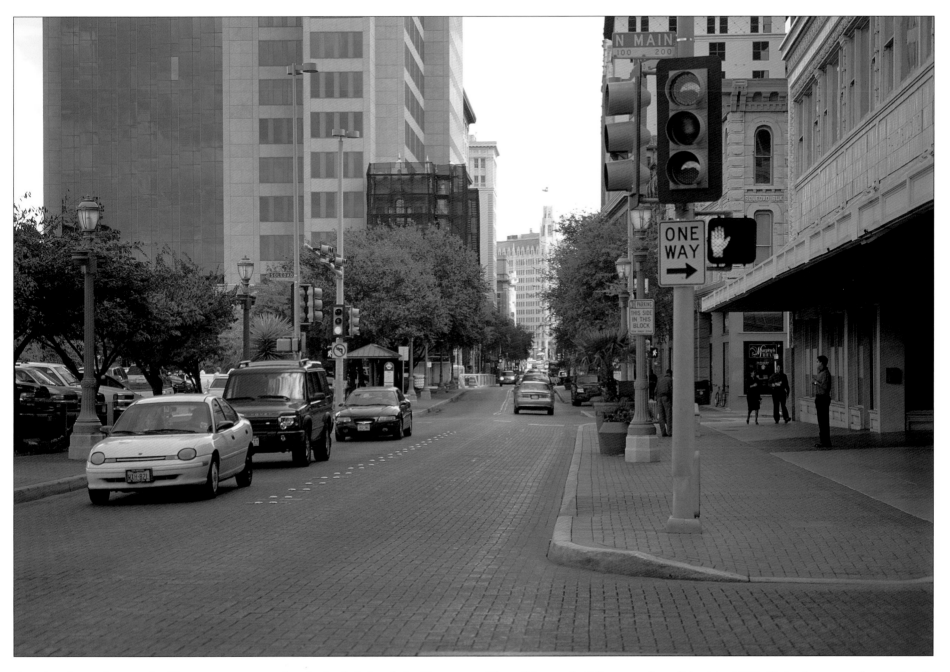

Another large theater, the Travis, was supposed to be built behind the Texas, but the Depression chilled further theater development. Like neighboring theaters, the Texas closed in the 1970s. When a Dallas-based bank announced plans to destroy the theater to build an office complex, the San Antonio Conservation Society protested and offered alternate plans, which were rejected. After years of mediation and counterproposals, most of the

Texas Theater building was demolished in 1983. Only the street-front side of the ornamental facade was saved and incorporated into a new, thirteen-story office building. The bank eventually failed, and the foreclosed property was leased in 1992 by Southwestern Bell (now AT&T), which has restored and preserved the facade decorations and ticket booth.

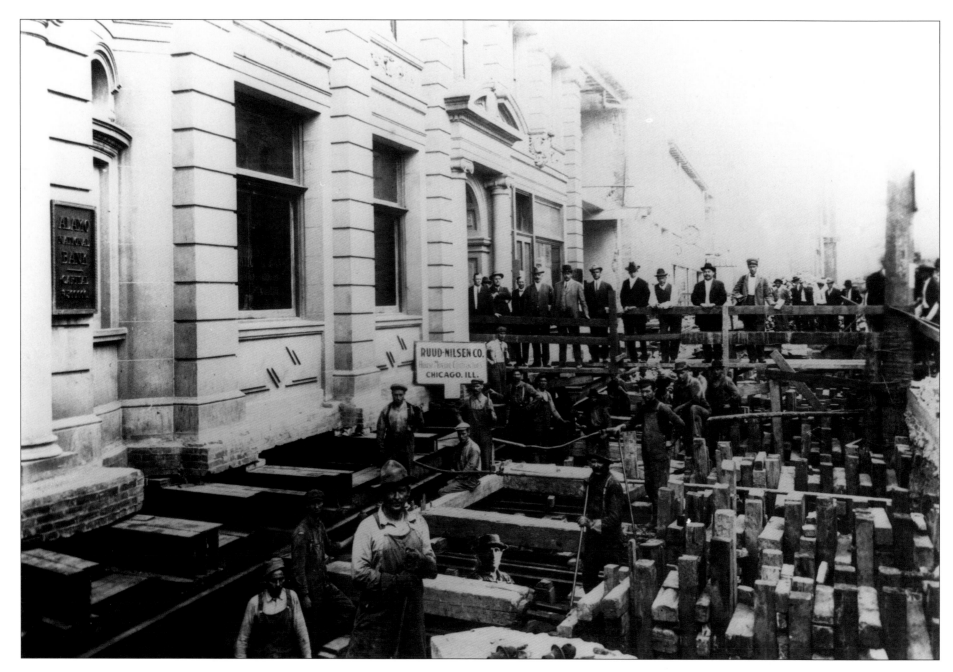

Too snooty for streetcars (clanking mule harnesses might disrupt mercantile trains of thought), the lords of "business houses" on Commerce Street were being left in the dust by faster-tracked Houston Street. They capitulated to progress after a survey showed that two-thirds of downtown retail traffic was brought by public transportation (by then electrified). From 1913 to 1914, a street-widening project made way for tracks. Many buildings had facades sheared off, but the five-story Alamo National Bank building was moved back almost seventeen feet. Workers dug trenches around the 8,000-ton building, then jacked it up onto a wooden platform on steel rollers. Pushed by crews in lines of ten, the building was resettled by January 1915, remaining open for business throughout the move.

After the move that preserved its distinctive arched and recessed corner entrance—and thus, the integrity of facades on both Commerce and Presa streets—the Alamo National Bank Building received an addition of three upper stories in 1916. Renaissance Revival detail preserved by the 1914–1915 move was maintained in the renovation, and the original, pressed-steel cornice recapped the new top floor. Designed by local architect James

Wahrenberger and completed in 1902, the massive, steel-framed, granite-trimmed building remains a solid presence on Commerce Street, where it is still home to business offices. The streetcars are long gone, but the street is still important, especially as a gateway to the River Walk stores and restaurants.

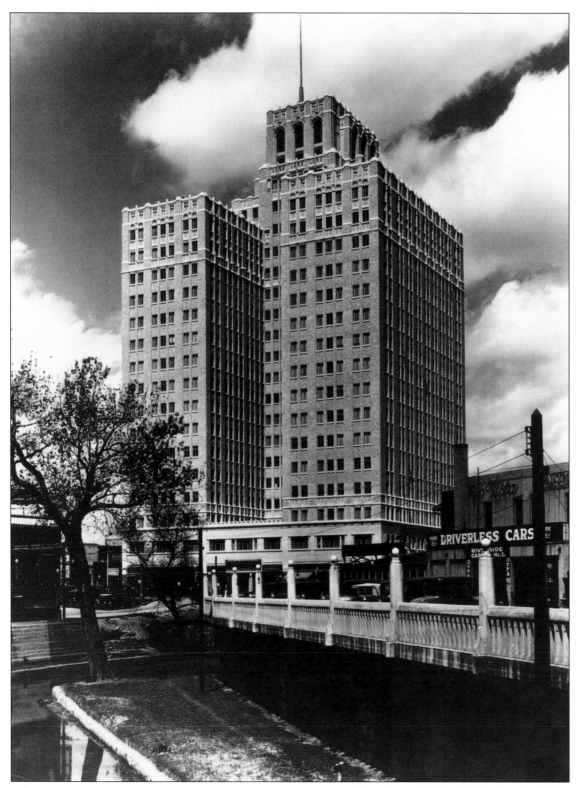

Named for nearby Milam Park, the Milam Building was the largest all-concrete structure in the United States when it opened in 1928. At twenty-one stories (not counting the missing thirteenth floor), it was also the world's first all air-conditioned skyscraper, completed the same year neighboring Frost Bank became the city's first air-conditioned bank. The new technology would have anything but a chilling effect on the economy of the Southwest. Early tenants liked being able to keep their windows closed, shutting out traffic noise and paper-rattling breezes. Among the building's occupants were offices of petroleum giants such as Humble, Mobil, and Shell (all later headquartered in Houston). Lesser oilmen did business in the booths of the Milam's restaurant, nicknamed the Linoleum Club.

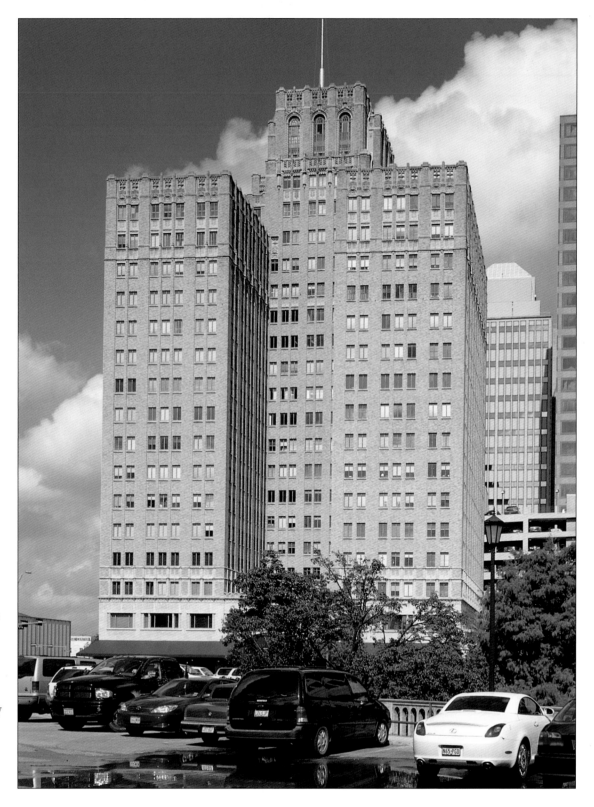

For a time in the mid-twentieth century, the Milam Building's flagpole alternated among the six flags that have flown over Texas. Though a taller tower was built in 1987 on the site of the former parking garage, the Milam is still neighbor to several banks and has preserved its high-ceilinged, tiled lobby. Like a northeastern city building, the Milam is host to business-support tenants (such as a postal substation, travel agency, office supply store, and printing company) on its broad ground floor. Most famous of these is the Milam Café, a diner-style restaurant that serves up specials and malted milks without regard to passing culinary fashions. Though the pioneering air-conditioning system has been updated, office windows still open—just in case.

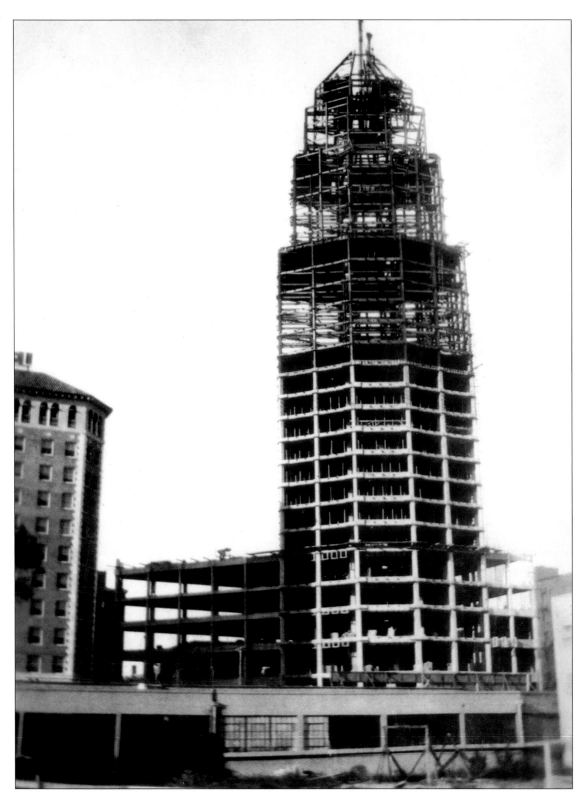

Smith Bros. Properties Co. was a high-flying firm of real-estate developers when principals J. H. and F. H. Smith (with partner/lawyer J. W. Young) decided to build this then-extreme, high-rise building convenient to the Bexar County Courthouse, City Hall, and many banks. At the time, its thirty-two stories made it the tallest building in Texas, a title it held until the early 1950s. Ornaments in its late–Gothic Revival style included gargoyles visible from the street and near the top. At the grand opening, June 1, 1929, San Antonio's mayor congratulated the tower's go-getter builders for "waking up" the city's less visionary "Rip Van Winkles." Though Smith Bros. planned further area development, the Depression put the brakes on large commercial construction.

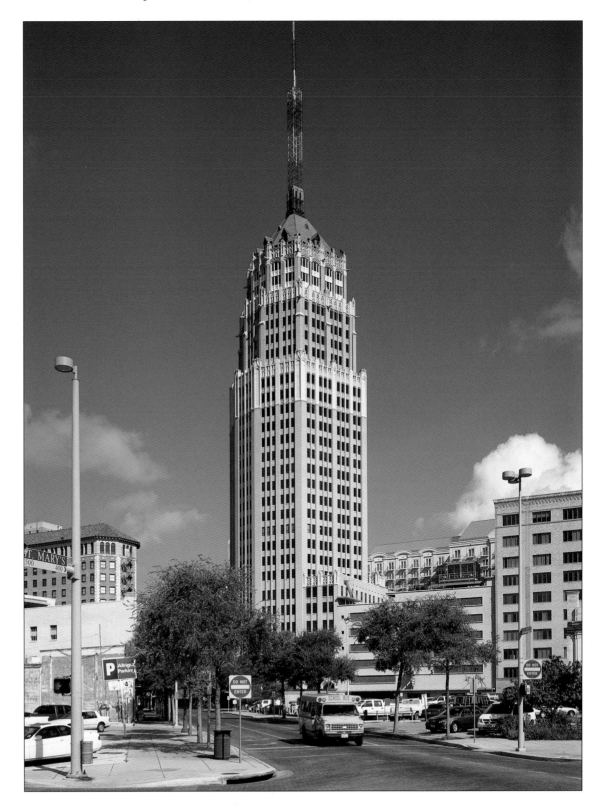

Some of the city's most prominent architects, lawyers, and artists have been tenants in the Smith-Young Tower (renamed the Tower-Life Building, after its principal tenant, Tower-Life Insurance). For years it was also a tourist attraction, with a twenty-five-cent admission to the tower's observation floor—reported in a 1930s guidebook. An antenna has replaced the flagpole at the top (under which construction workers left twenty cents and a Masonic coin piece), but the tradition of lighting the building at night (a mellow gold or some seasonal variation) continues. The observation deck is now closed to the public, although building tenants may have access. An exhibit of photographs and newspaper accounts traces the history of the building and its setting.

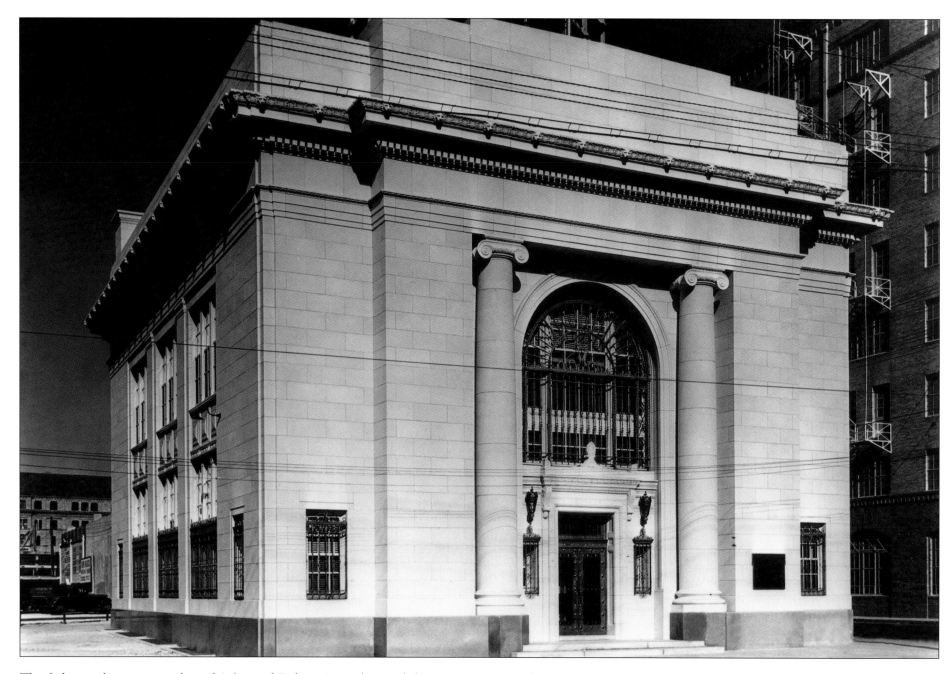

The father-and-son partnership of Atlee and Robert Ayres designed this elegantly simple building for the local branch of the Federal Reserve Bank, completed in 1928. Its smooth concrete walls and restrained neoclassical detail resemble community banks of its era. At right is the Plaza Hotel (now the Granada Homes for senior citizens), finished earlier that year. Both were across the street from the Smith-Young Tower (now Tower-Life Building), and all three structures were built on the former Bowen's Island, a peninsula in the San Antonio River. With the surrounding bend of the river filled in, the area drew the interest of developers. A "large store building" and apartment hotel were planned but never built after the stock-market crash of 1929.

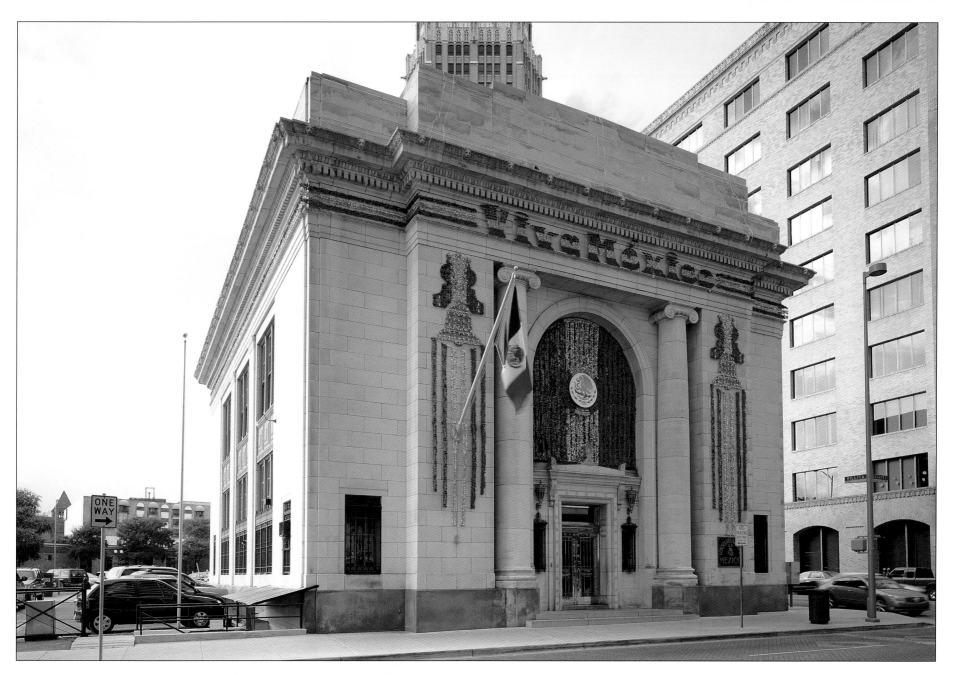

Many Mexican nationals live and work in San Antonio, especially since the North American Free Trade Agreement of 1994, and the city is a favorite tourist destination for Mexicans from border states. Since 1861, there has been a Mexican Consular Office in San Antonio. This location dates from 1957, when the Mexican government acquired the former Federal Reserve Bank Building. The Consulate General of Mexico provides identification documents to Mexican nationals and facilitates the official end of visits to Mexico by U.S. and other citizens. This San Antonio office serves twenty-six counties in central and south Texas. Under its auspices, a government-sponsored Mexican Cultural Institute in HemisFair Park brings contemporary Mexican art and cultural programming to San Antonio.

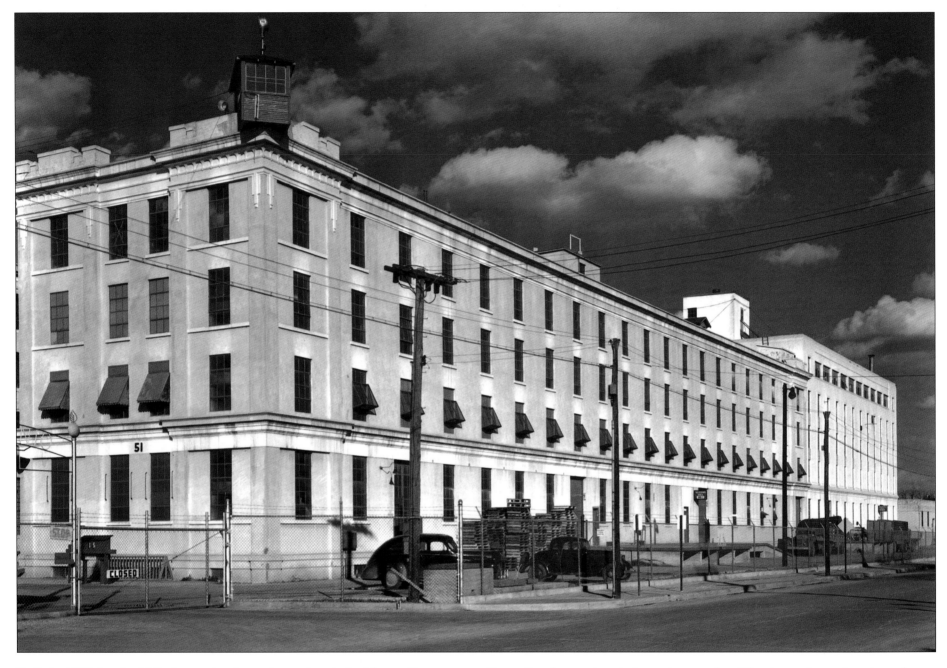

Built in 1858 for the U.S. Army, the Arsenal was the city's oldest military installation in continuous use. With a riverside location chosen because of its distance from town, the closed compound was used for manufacture and repair of ordnance equipment (including firearms, artillery, and even cavalry saddles and tack). By World War I, the Arsenal was used also for ammunitions storage, a potentially hazardous function that was moved to Camp Stanley on the city's northwest edge. The Arsenal was deactivated in 1947, and the city acquired part of the property a few years later (with buildings still used for Naval and Marine reserve training through the early 1980s). The Commander's House was deeded to the city in 1972 and is now a senior citizens' center.

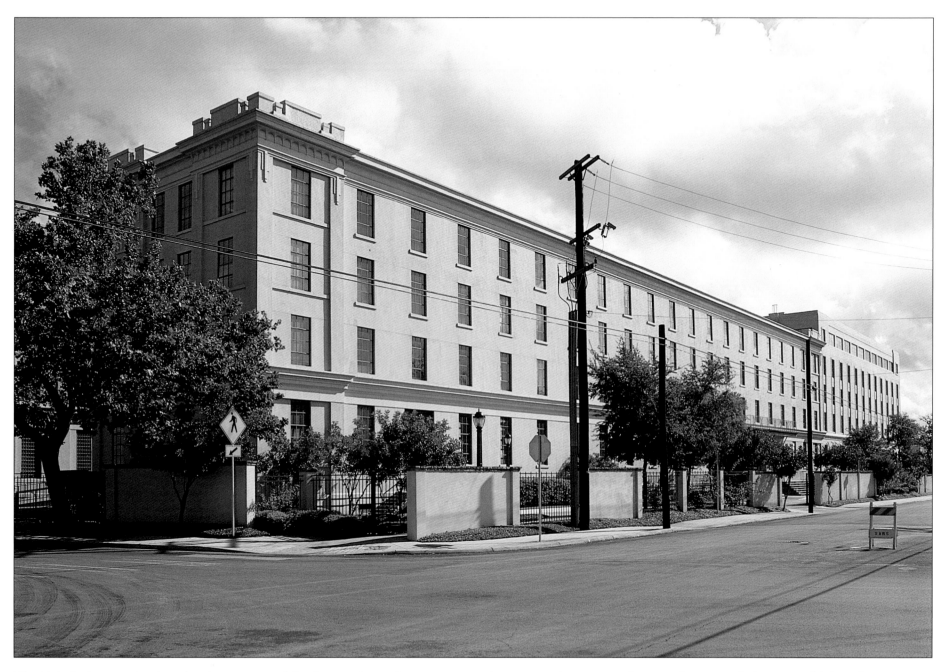

The H-E-B Grocery Co. bought eleven acres of the former Arsenal property in 1982 and moved its corporate headquarters there in 1985. Reusing two nineteenth-century stone buildings and warehouses built in 1916, the campus includes one new building that houses executive offices. Founded in 1905 in Kerrville, the grocery chain came to San Antonio in 1942, the same year it introduced frozen foods and air-conditioning to its stores. H-E-B pioneered the supermarket concept here, with in-store bakeries, and fish and meat markets. In accordance with a founder's religious principles, beer and wine were not carried until the 1970s. In 1997, H-E-B expanded into Mexico but still concentrates on its Texas business. The company currently has nearly 300 stores and 55,000 employees.

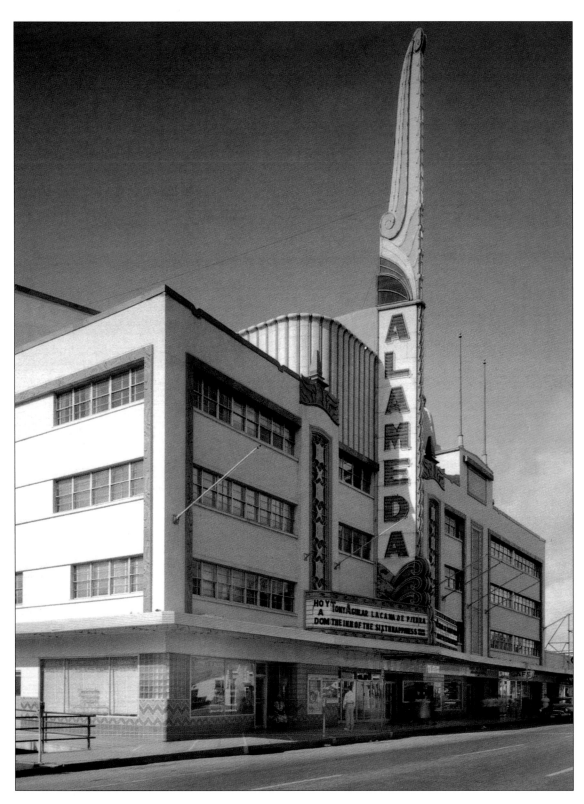

When it opened on West Houston Street in 1949, the Alameda Theater was in the heart of a thriving Mexican American retail community. It was part of the Casa de Mexico International Building—home, for a while, to the Mexican Consulate—and its neighbors included Spanish-language book and record stores, whose customers were likely to favor the mostly Mexican films shown at what turned out to be the city's last great movie palace. The style was Streamline Art Moderne, a swoopy postwar mix of brightly colored tile, etched Plexiglas, and aluminum details. Outside, an eighty-four-foot "waterfall" sign beckoned customers to enter the theater. Inside, black-light murals represented events in Texas history on either side of the stage, where Mexican film stars made live appearances.

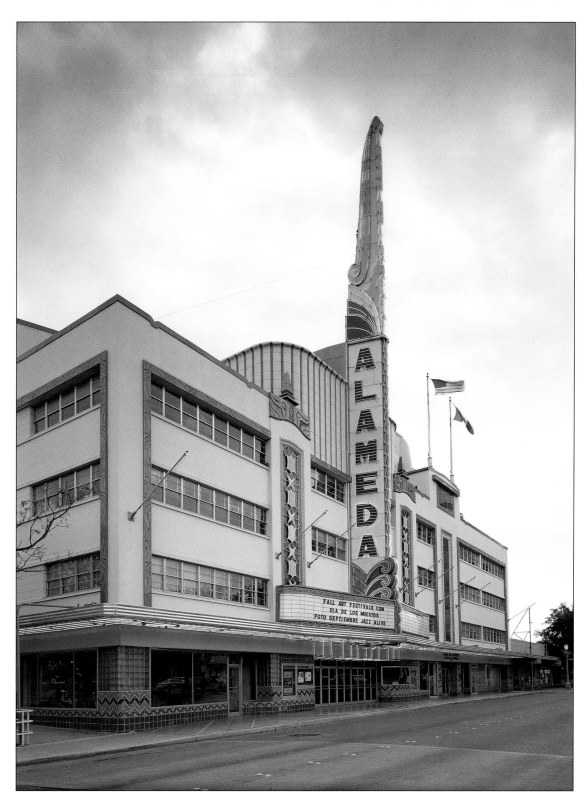

Converted into a three-screen theater, the formerly 2,400-seat Alameda struggled to stay alive during the 1970s and beyond, as the growing availability of Spanish-language television and videos shrank its audience. The theater closed in 1990 and continued to deteriorate until the city bought the Casa de Mexico International Building in 1994. Since 1995, a group of Hispanic community leaders has been working with the city to restore the water-damaged building as a performing-arts center. An agreement with the John F. Kennedy Center in Washington D.C. was signed in 2001, creating a partnership to present major Latin artists on the Alameda's stage. A nearby Museo Americano, affiliated with the Smithsonian Institution, will showcase achievements of Hispanic Americans.

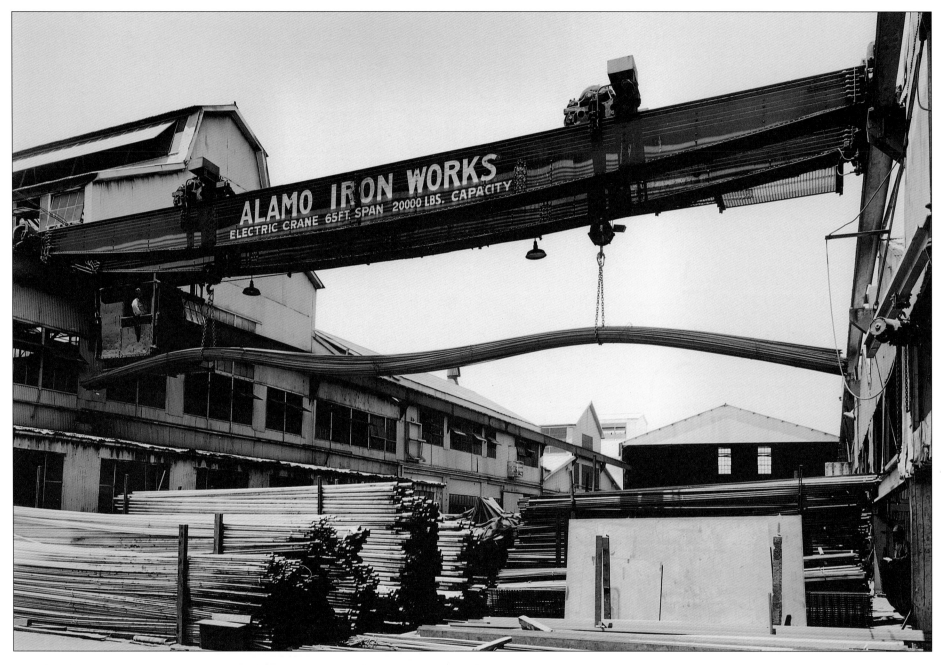

Proudly old-economy, Alamo Iron Works (AIW) was established in 1876 and became a major regional purveyor of heavy-metal objects (safes, jail cells, and shutters). By the 1920s, the company had moved its clangorous activities to the eastern edge of downtown, where headquarters included a machine store, foundry, and other buildings. AIW toughed out the Depression and regained prosperity during World War II. Flush with new business and new machinery, the company built more warehouses and fought competition by consolidating operations here. As the company grew, it required more space than its near-downtown property could provide. AIW moved to a new location near what is now the SBC Center, and the former ironworks was demolished for construction of the Alamodome.

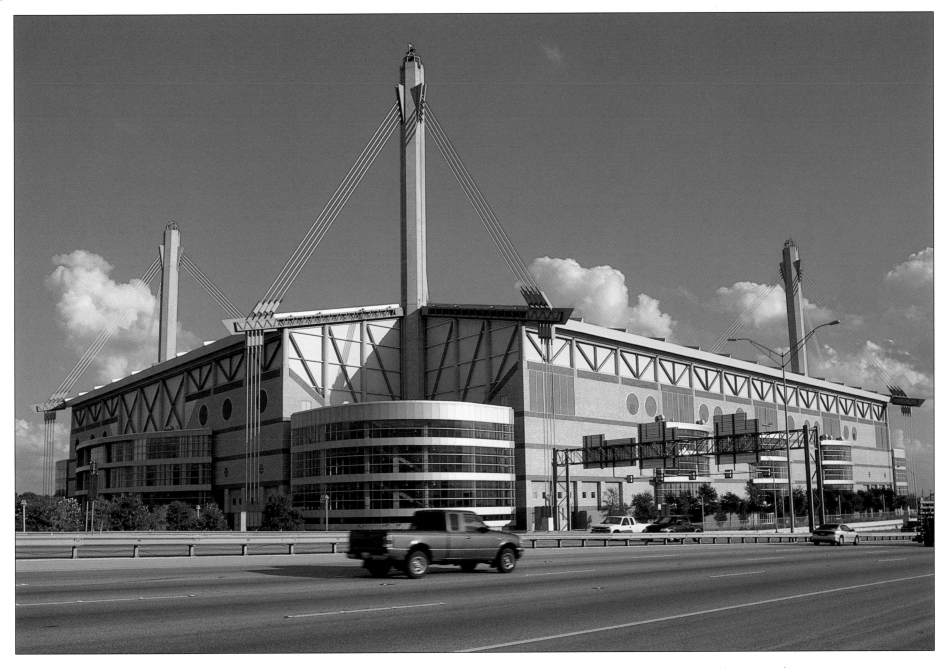

For fans of San Antonio Spurs basketball, the Alamodome (opened in 1993) was an improvement on the Convention Center Arena, with more seats and no view-obstructing columns. For everyone else, the city's first domed stadium offered a versatile space that could be reconfigured to suit football games, ice skating, rock concerts, and trade shows. The location would rehabilitate an ex-industrial site and promised economic benefits to its East Side neighborhood. From the beginning, however, there was controversy over the fish-out-of-water design (four towers were connected with cables and the windows has a nautical porthole shape), metal-contaminated "dome dirt," and a location cut off from downtown by an expressway. In 2002, the Spurs moved into the next big thing: the SBC Center.

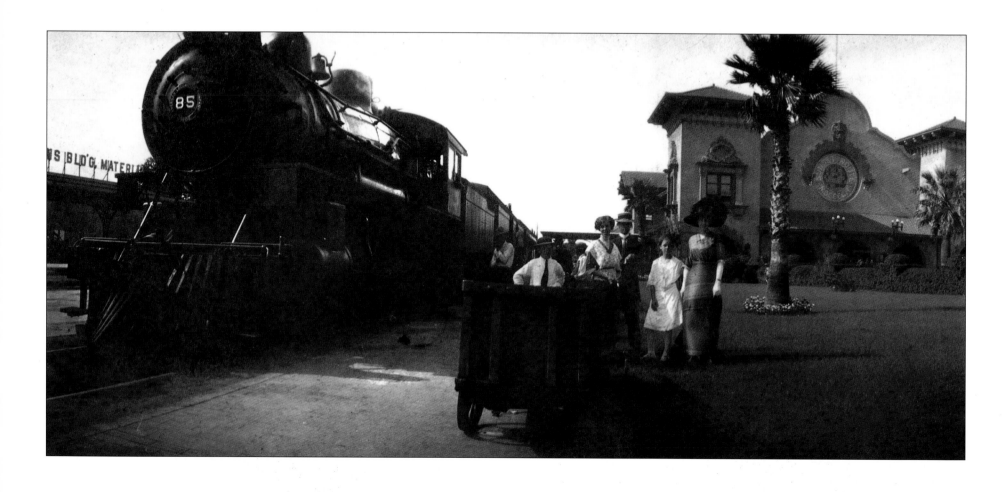

San Antonians were proud of the 1903 Sunset Depot, named by the Southern Pacific Railroad for its Sunset Route that stopped here between New Orleans and Los Angeles. Described by the railroad architect as an "adaptation of the Mission style . . . to modern requirements," the two-story station references the Alamo with its rounded gable and other mission churches with its twin towers. The Beaux Arts interior held separate waiting rooms for men, women, and "colored" passengers, as well as a ticket counter, newsstand, "dining room," and depot offices. Built of stucco-clad brick (exposed in archways), the exterior was painted ocher. Details such as a grand staircase, stained-glass rose windows, and a gold-leafed barrel ceiling lent dignity to the business of travel.

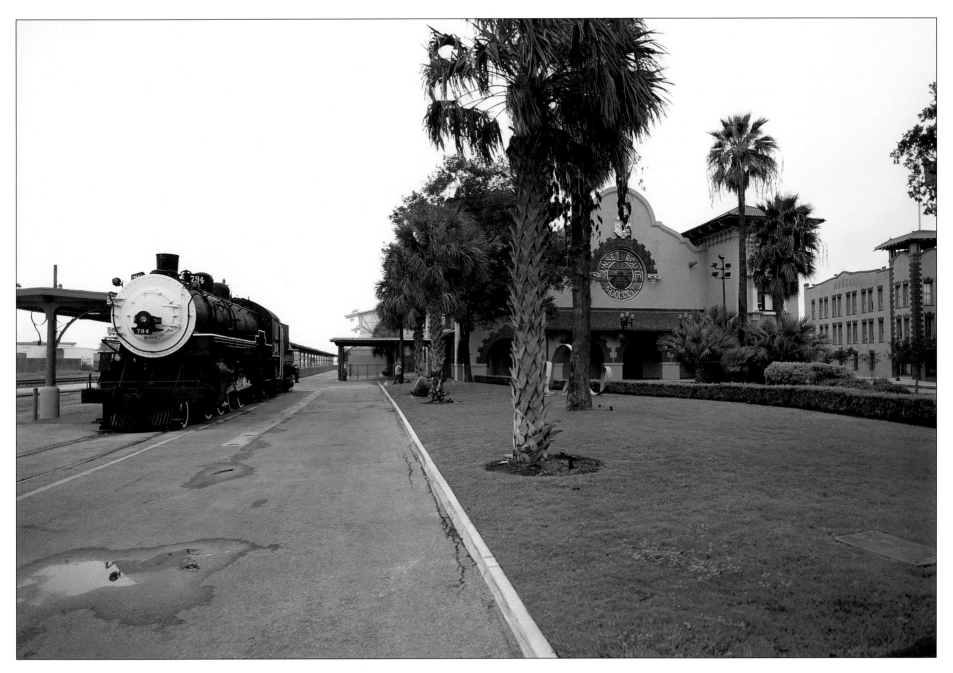

After the depot survived a 1907 fire, freight buildings were added. Passenger facilities were enlarged in 1942, and the building was painted pink around 1950. As railway use dwindled, Southern Pacific became the last independent railroad to run passenger trains to San Antonio before Amtrak's 1971 takeover. To cut costs, Amtrak moved in 1996 to an adjacent, smaller station, just two years before suspending its San Antonio service. The old depot's owner, since 1989, was the city's VIA Metropolitan Transit, which accepted a private proposal to rebuild the depot as an entertainment complex. After restoration of its decorative features and reconfiguration into restaurant and nightclub spaces, the depot reopened as Sunset Station, a popular venue for music and special events.

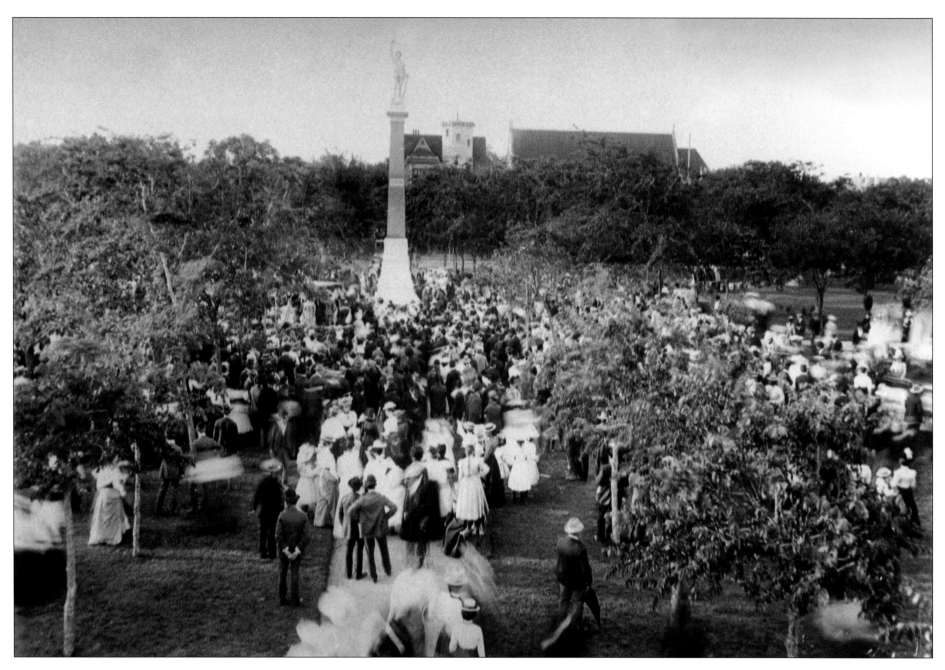

The former orchard of Samuel Maverick was willed to the city for a park around 1870 and named after Alamo hero William Barret Travis. This photo was taken on April 28, 1900, when a Confederate monument was dedicated. The local chapter of the United Daughters of the Confederacy—then the largest in the state—raised funds with teas, concerts, dances, and quilting bees. Said by the organization to be "the first monument ever erected in San Antonio," the statue (by local sculptor Frank Teich) represents a private soldier, atop a forty-foot shaft of native stone. When it was unveiled, to the cheers of the "largest outdoor assembly ever witnessed in the history of our city," Confederate veterans gave the rebel yell, and a band played "Dixie."

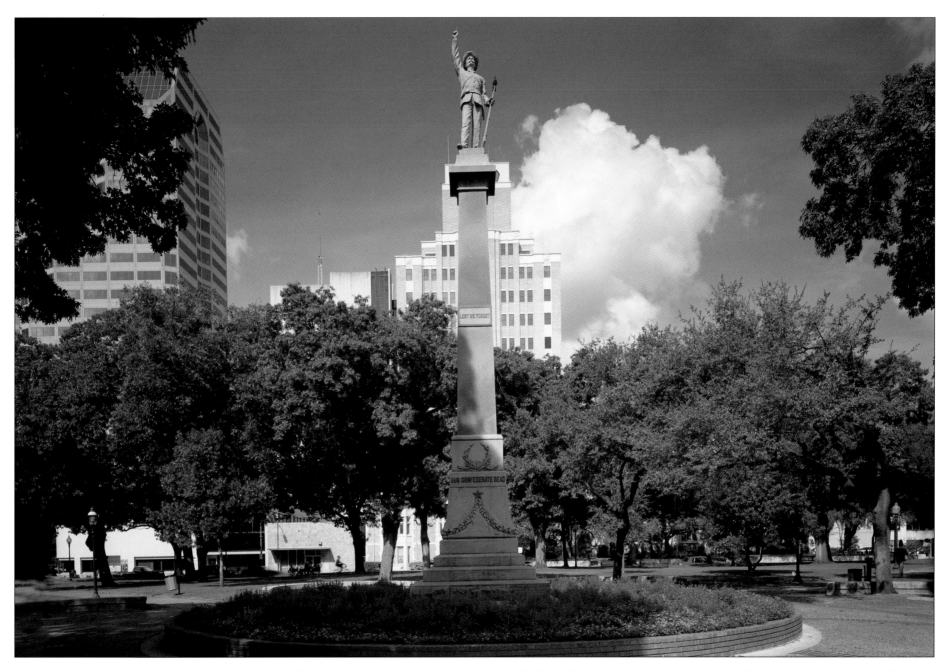

In the mid-1950s, there was a proposal to put underground parking garages under Travis Park, Alamo Plaza, and other public spaces. A plan by Smith-Young Tower architects Ayres and Ayres would have put the monument on a pedestal above escalators for the garage (and potential bomb shelter). The $3 million deal was quashed by preservationists led by Maverick heirs.

Instead, the park was renovated in 1956, emphasizing its beauty by replacing weedy hackberries with better-regarded trees. When Travis Park underwent a further renovation in 1984, new lighting, seating, and a low wall were added. Once a popular spot for patriotic and political speech-making, the park has been the scene of the annual Jazz'SAlive festival since 1983.

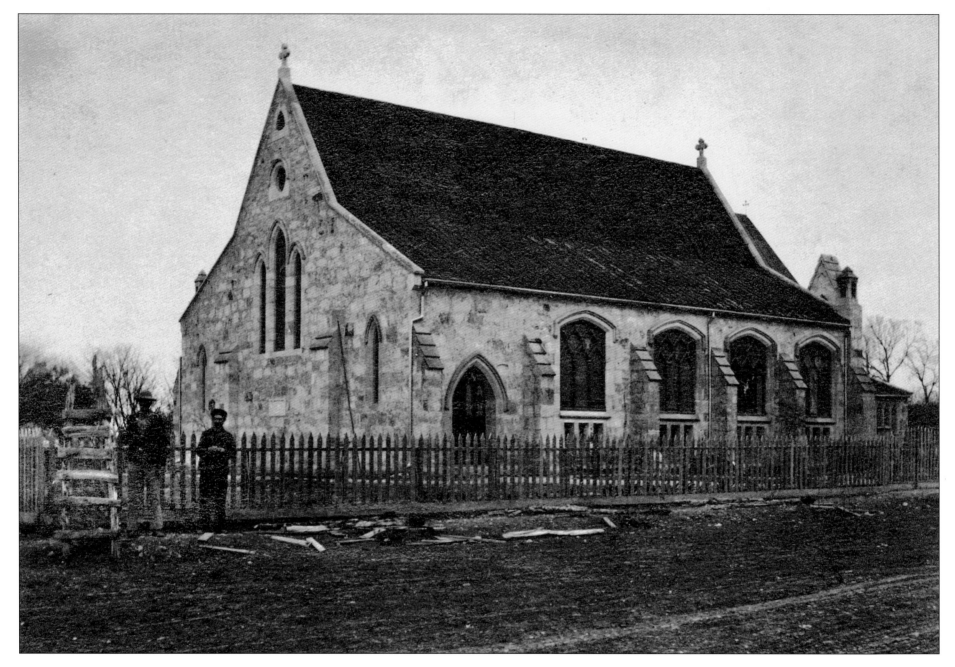

The oldest Episcopal parish in San Antonio, St. Mark's has links to three previous churches. It was built on former fields of Mission San Antonio de Valero (the Alamo), and descended from Trinity Church, the city's first Episcopal congregation. After secularization, mission lands were distributed to Native American residents, who sold it. When Trinity Church disbanded, two pioneer families donated lots for building a new church. U.S. Army Colonel Robert E. Lee, then stationed in San Antonio, was a member when construction started in 1859. The Civil War halted progress, and the half-built walls were abandoned. Stones were carted off during reconstruction, and this Gothic Revival church designed by Richard Upjohn (architect of New York's Trinity Church) was completed in 1875.

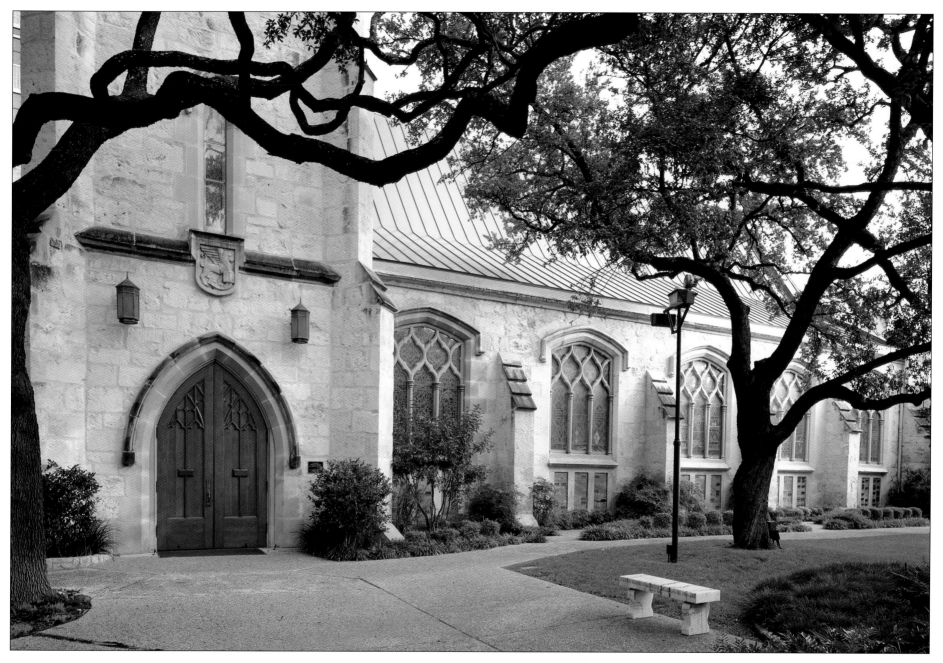

St. Mark's was the cathedral of the Episcopal Diocese of West Texas, until diocesan headquarters moved to Cathedral Park in Alamo Heights. The church has been called the "mother of bishops" because several rectors have attained that office. It was also the scene of a future president's wedding, when Lyndon Baines Johnson married Claudia "Lady Bird" Taylor in 1934. A cloister now connects the 1920s parish hall to the church, which includes a

1949 addition by local architect Henry Steinbomer. Contemporary St. Mark's stresses outreach, helping the city's homeless, hosting Alcoholics Anonymous meetings, and supporting medical missions. The parish plans a capital campaign to create a theology center, meditation garden, café, and bookstore in the area around the church.

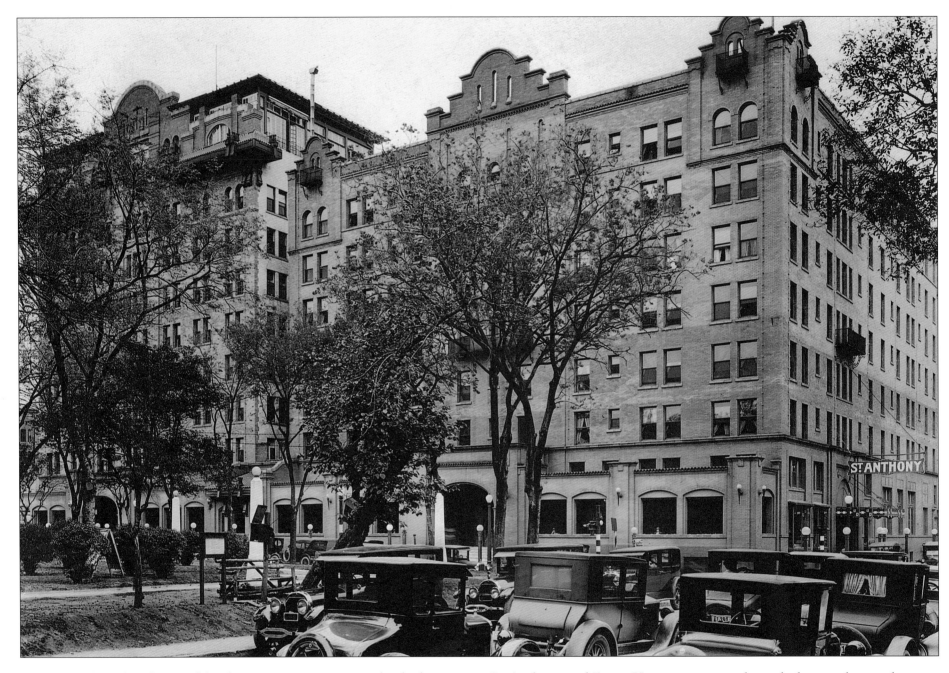

The St. Anthony hotel, named for the city's patron saint, was finished in 1909. It had two different-sized towers with rounded gables in Mission Revival style. Heralded by newspapers as the "big hotel, built by oil- and cattlemen for oil- and cattlemen," The St. Anthony has been a celebrity magnet for decades, as shown in lobby photos of movie stars from the era of touring stage shows. Robert Frost had dinner on Christmas 1936 in the St. Anthony, and Ernest Hemingway spent the night here on his way home from Mexico in 1941. An addition made to the facade in 1936 evened it up and toned down the Alamo detail. The renovation also introduced innovations such as central air-conditioning and the state's first "electric-eye" automatic doors, and the lobby was filled with works of art.

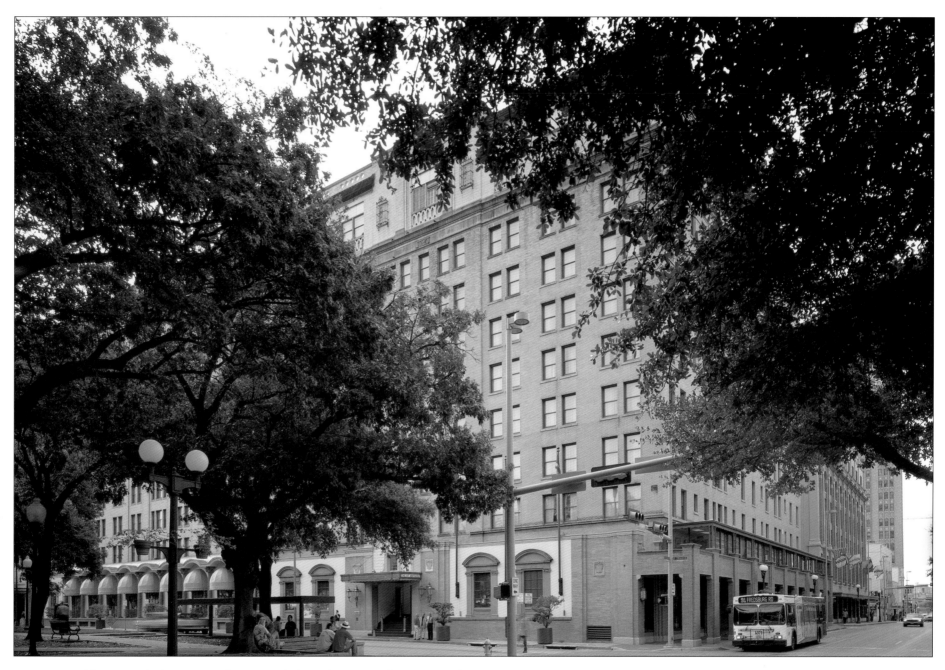

During World War II, dashing air cadets attended tea dances in the St. Anthony, and through the 1980s, wheeler-dealers commandeered the private St. Anthony Club for power lunches. Now it is a modern hotel catering to tourists and business travelers, but the St. Anthony still has its old-school elegance, thanks to a 1983 renovation that brought it back to its 1936 opulence. The Peacock Alley lobby, where Sunday brunch is served, has once again been made impressive with Oriental carpets on marble floors, original light fixtures, a wrought-iron staircase, and antique furniture. The Spanish-style roof garden (a cool dance floor in the 1920s and 1930s) has given way to an outdoor heated pool and Starlight Terrace celebration venue.

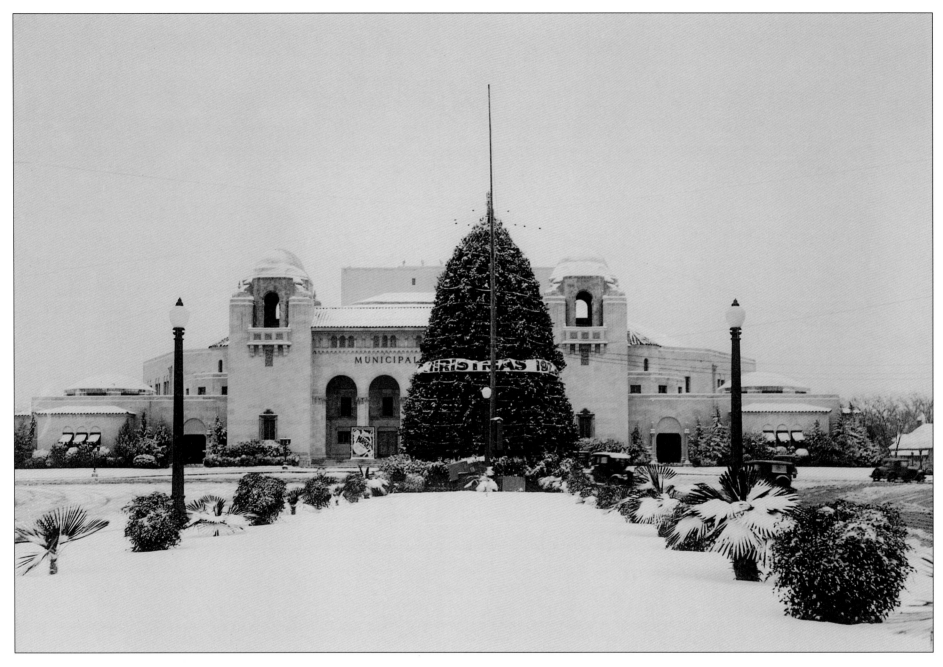

The Municipal Auditorium (finished in 1927) was constructed as interest in historic preservation was growing, and acknowledges the city's origins with Atlee Ayres's award-winning Spanish Colonial Revival design. Sometimes called the Memorial Auditorium, the $1.25 million project was intended to honor World War I veterans. A showy 6,500-seat interior—with decorative tile work, domed ceiling, and a curtain painted with scenes of Spanish conquest—made other theaters, such as the Alamo Plaza's Grand Opera House, seem passé. Grand opera and other prestigious entertainment moved to the auditorium, while more popular fare (such as auto shows and carnivals) occupied its capacious basement. Taken on December 22, 1929, this photo shows the auditorium's tropical landscaping (when San Antonio boasted "seven varieties of palms"), decked for a rare white Christmas.

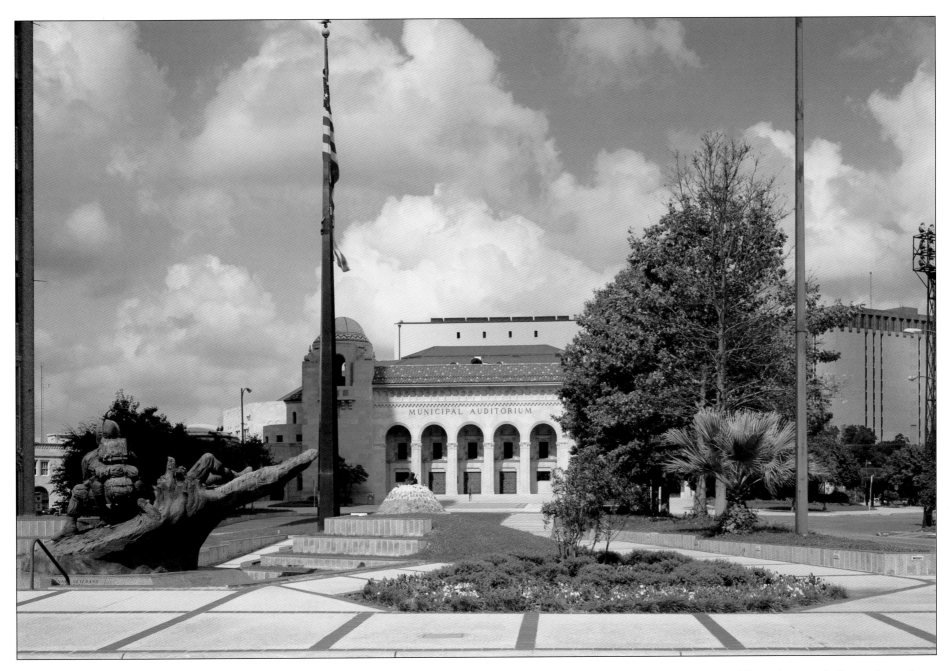

The Convention Center built for the HemisFair '68 eclipsed the deteriorating Municipal Auditorium's purpose. When a 1979 fire gutted the interior, city authorities debated its fate for years. Because of its architectural significance, the auditorium was restored and technical facilities updated for a 1986 reopening. The original stage, trod by celebrities such as Will Rogers, Elvis Presley, and Richard Nixon, survived. The decorative organ grilles flanking the stage were kept, although the organ itself was destroyed. Since then, the auditorium has been used for concerts, meetings, galas, graduations, and the annual Coronation of the Queen of the Order of the Alamo presenting Fiesta San Antonio "royalty." In front of Municipal Auditorium are two war memorials, one for the veterans of the Vietnam War, on the left, and the other for Korean War veterans. A World War I marker was added in 1938.

The first bridge across what is now Commerce Street was probably made of lashed wooden beams. This one was built in 1914, during the street-widening project that rendered its cast-iron predecessor obsolete. (Known as the "O. Henry Bridge" for its mention in a short story, the narrower bridge was moved to link a river-bisected street in the King William neighborhood.) This Commerce Street Bridge was constructed of "artistic concrete" and had Texas star motifs and a *First Inhabitant* Indian statue. It opened on November 21, 1924, when the street was rededicated. At left, the round-towered Clifford Building (1891) was designed for an attorney by courthouse architect James Riely Gordon. Its suavely curved masonry is exceptional; most riverside buildings were built with their disheveled backs facing the barely curbed and flood-prone stream.

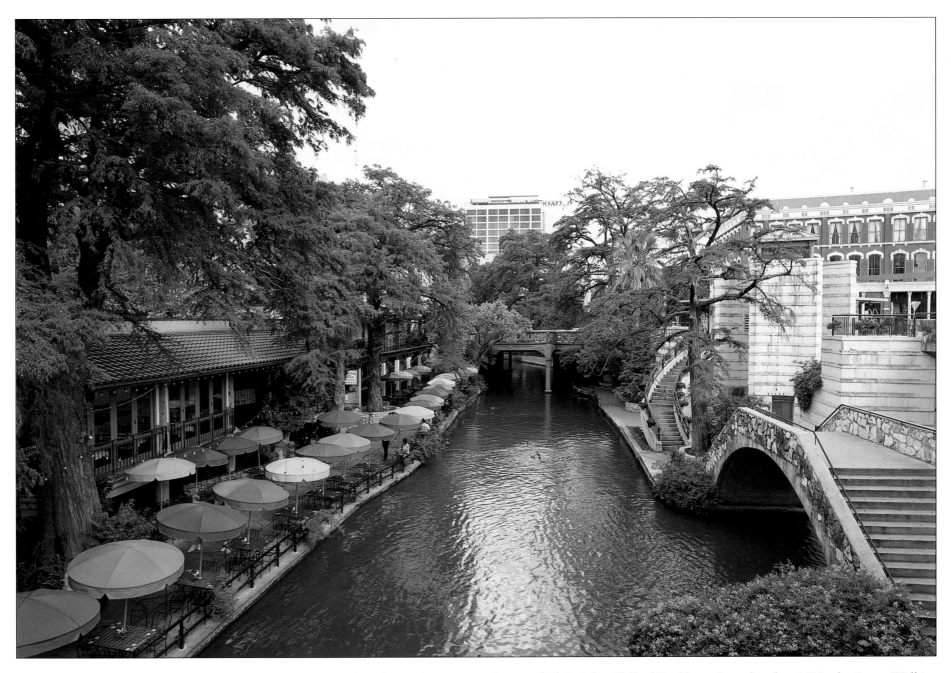

From missions to mills to tourism, the San Antonio River has changed course and purpose but has never lost its importance as the sinuous spine of the old city. San Antonio River Walk architect Robert Hugman, who imagined the "linear paradise" of waterside stores, sidewalk cafés, patios, and parklike seating areas, demonstrated his faith in flood control by locating his office on the river level of the Clifford Building. Completed in 1939, the River Walk's development was set back by World War II. When the Lung Jeu Chinese restaurant opened in 1959 in the turreted landmark, the River Walk was run-down and rather lonely. It was not until the HemisFair '68 development that the River Walk begin to realize the possibilities that Hugman foresaw.

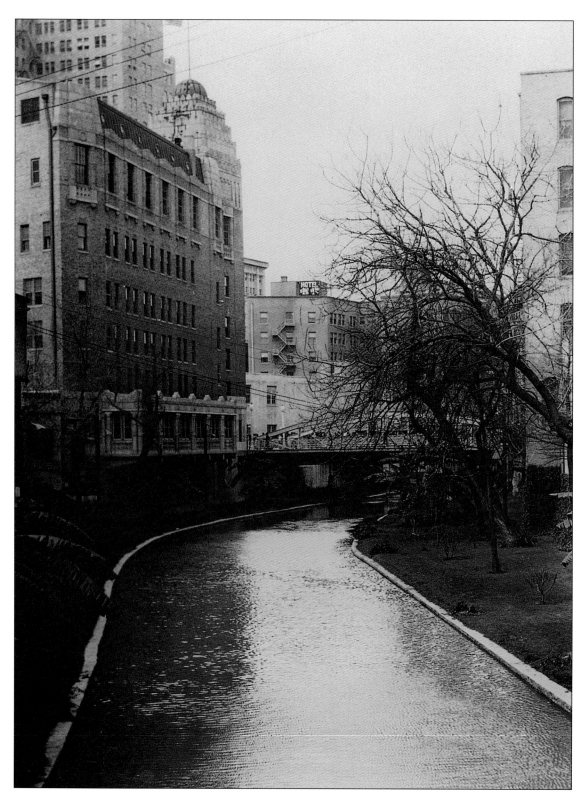

Though its Art Deco style is associated with the French, and its cast-stone details are Mayan motifs, this building recalls the city's German heritage. The Casino Association was founded in 1857 by 106 German American men as a social club and cultural outlet. Its Market Street headquarters served as their clubhouse, ballroom, and theater. Stock companies and classical artists played there, but so did minstrel shows. Illustrious guests include Civil War commanders Robert E. Lee and Ulysses S. Grant and Wild West impresario Buffalo Bill Cody. In 1925, the Casino Association merged with the San Antonio Club (established in the Grand Opera House); the allied groups became the San Antonio Casino Club, whose six-story Art Deco building was completed in 1927.

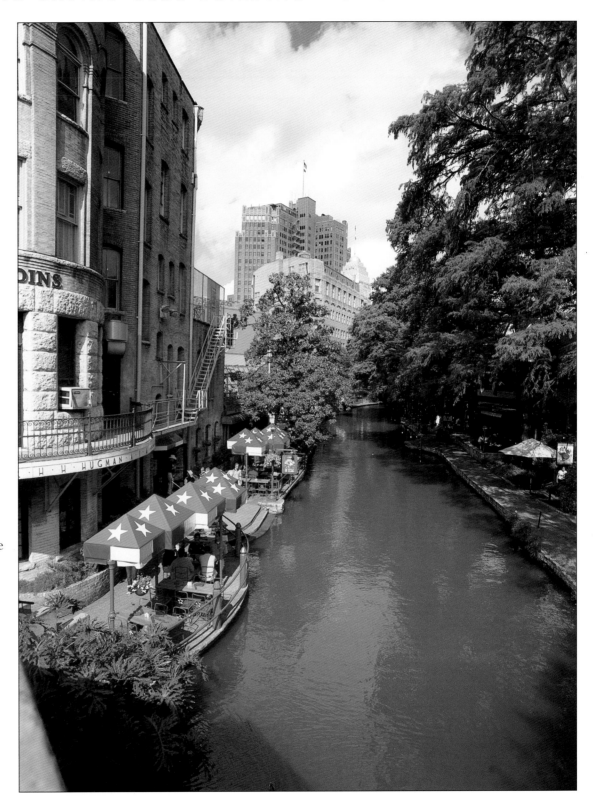

As assimilation into American culture made all-German groups less necessary, most of such institutions became more inclusive or waned altogether. Before joining forces with another exclusive men's club, the Casino Association sold its old Casino Hall in 1923 to the city's water board. The reorganized San Antonio Casino Club built this tower on a triangular lot bounded by river, bridge, and street. In 1942, the fading club sold its headquarters to Oklahoma oilman Thomas Gilcrease, after which it was known as the Gilcrease Building. From 1952 on, the building was sometimes vacant. Federal funding fueled a 1979 redevelopment of the upper-floor apartments and river-level retail space. *Roots* author Alex Haley was a tenant, and the lower level is now home to an Italian restaurant.

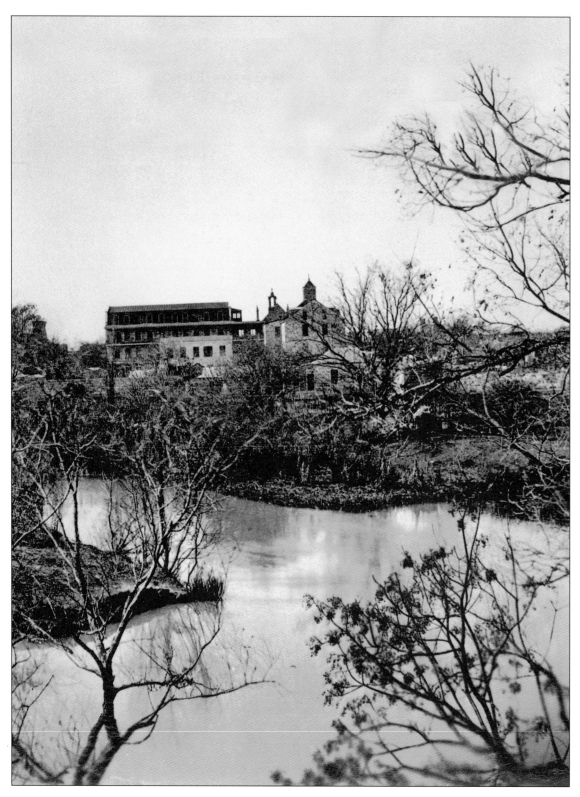

When poet Sidney Lanier visited San Antonio in 1872, he was charmed by its recurring river. "The stranger strolling on a mild summer day often finds himself suddenly on a bridge," he wrote for *Southern Magazine*, "and is half-startled with the winding vista of sweet lawns running down to the water, of the weeping-willows kissing the surface, of summer-houses on its banks, and of the swift yet smooth-shining stream meandering this way and that." Never highly industrialized, most of the stretch that winds through downtown was like a small-town neighborhood, with residences, businesses, and schools (St. Mary's Institute is at the top right) sharing the convenience of being on the water. The river at that time was left to flow its natural, sometimes tortuous course.

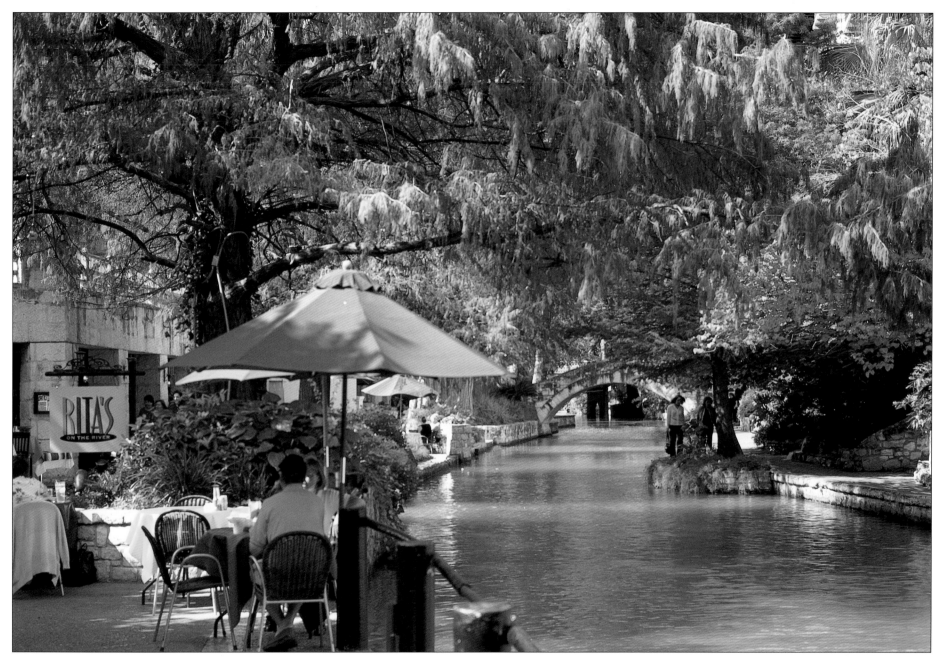

As the city grew, residential areas were moved to "streetcar suburbs," and commercial buildings replaced most riverside houses. After a 1921 "hundred-years flood" that killed fifty people and caused damages estimated at $10 million, the city approved construction of a cut-off channel, first in a series of flood-control measures. Though some advocated paving over the downtown river, the city accepted plans from a young local architect, Robert Hugman, for what has been called "the Venice of America," the San Antonio River Walk, completed in 1939. Its parklike plantings, ornamental bridges, and paved walkways with frequent stairs created a tourist-friendly district of stores and restaurants. Since HemisFair '68 boosted interest, the River Walk has become one of the state's top visitor attractions.

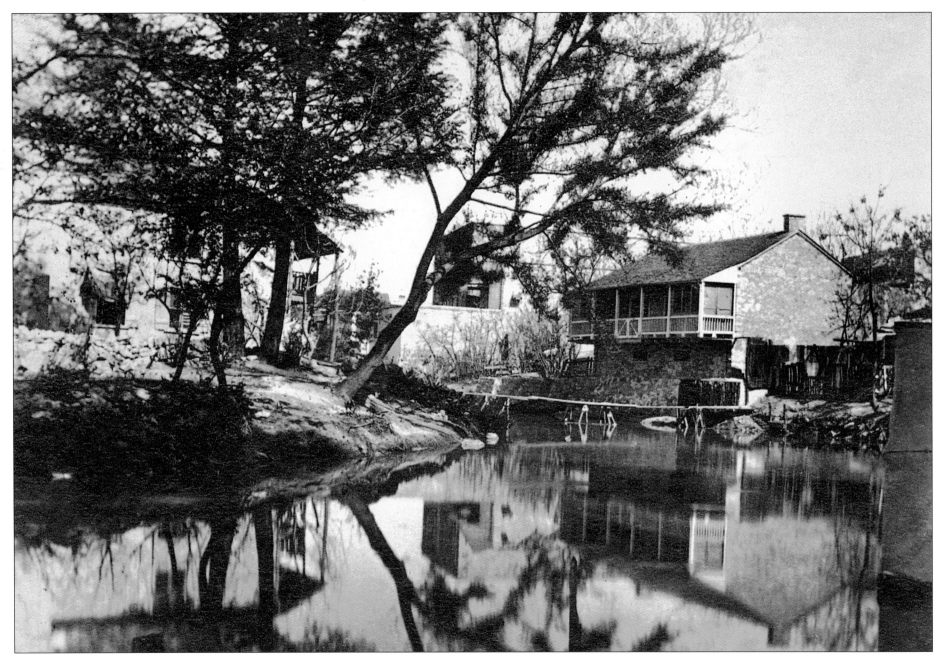

Irish-born merchant/banker John Twohig kept his office on the river. It was connected by a footbridge to his house (seen on the right), known as La Casa del Rio, where guests included such powerful military and political figures as Sam Houston, Zachary Taylor, Robert E. Lee, and Ulysses S. Grant. A veteran of the Texas Revolution, Twohig was one of the one hundred wealthiest men in Texas by 1870 and was known as the "breadline banker" for his charities to the poor. Built around 1840 on a site in the former garden of the Veramendi Palace, the house was moved in 1941 to the grounds of the Witte Museum, where it was furnished by the San Antonio Conservation Society and has since been used as office space.

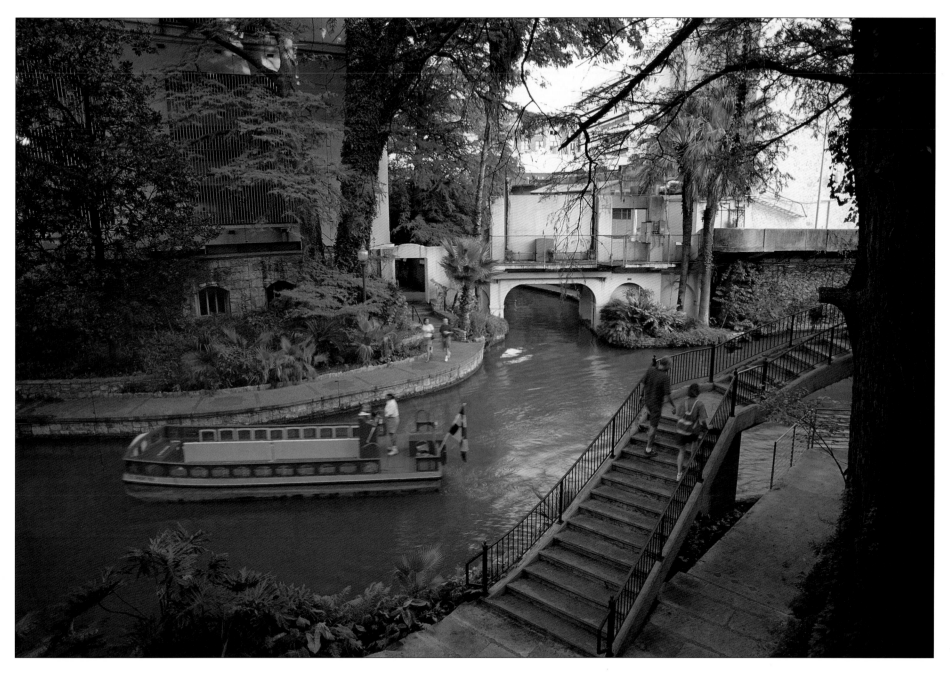

Motorized barges with operators providing narrative tours are an emblematic feature of the contemporary San Antonio River Walk. In earlier days, horses and even carriages forded the river at strategic spots, and rowboats were used for more extensive water travel. After the River Walk was developed, private parties rented canoes, and then, later, pontoon paddleboats (popular with soldiers and their dates). Experiments with more romantic-looking vessels, such as gondolas and swan boats like those used in the Boston Public Garden, were discouraged when the heavy craft toppled and sank in the comparatively shallow river. The wider barges accommodate more people, make regular stops at hotels, dining and shopping areas, and are even available for dinner cruises catered by River Walk restaurants.

Within blocks of several banks, the former de la Garza homestead may have been the city's first financial institution. Built in 1734 for a landowning family, the house was once much larger. Stone walls, as much as four feet thick, made it a fortress against banditry, and a stone closet inside was used as a safe. San Antonians stored valuables there before long journeys, marking their bags of silver or gold and paying an honorarium to Jose Antonio de la Garza. With government permission, minor silver coins were minted there in 1818. Before the Garza House was torn down in 1912, it had devolved into a saloon that sold Standard Beer for ten cents "if drank at bar."

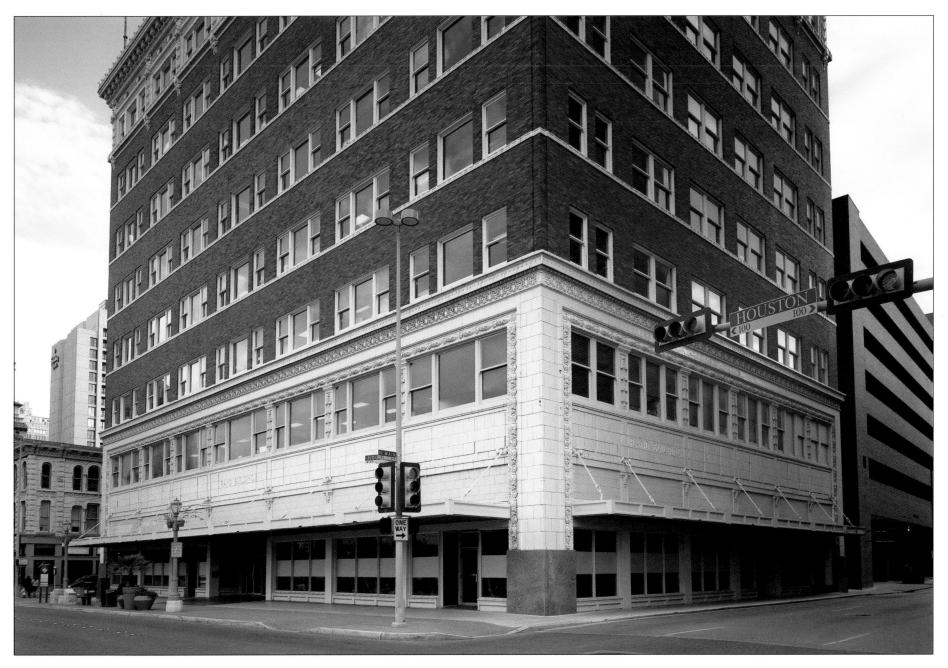

Fort Worth architects Sanguinet and Staats designed this 1913 "skyscraper" at the corner of Houston and Soledad streets. The eight-story building—then the city's tallest—became the home of the Wolff and Marx department store (founded in 1877). Its height would become a disadvantage, making it impractical to retrofit the building with fast-moving escalators (like rival Joske's), which bought Wolff and Marx in 1965 and sold its downtown store two years later. The renamed Rand Building's tenants included a steakhouse and USAA from 1968 to 1975, when the insurance company's Fredericksburg Road headquarters were completed. It was bought by the San Antonio Conservation Society in 1981 and soon resold to developers, who renovated the office building's interior around a central atrium.

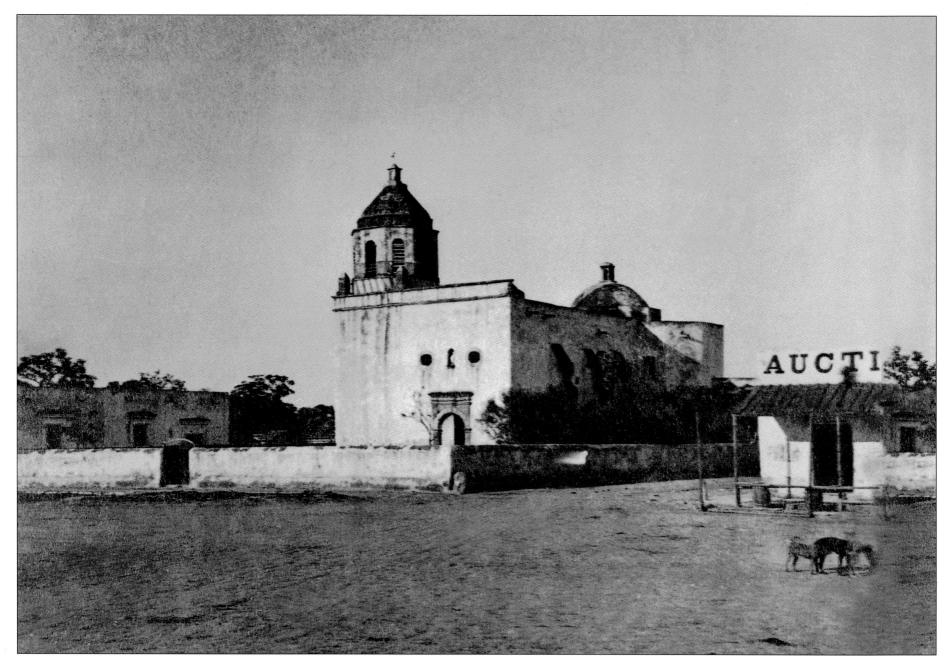

Founded for the city's first civilian settlers—fifteen families from Spain's Canary Islands—San Fernando is the oldest parish church in Texas. Begun in 1738, the first church building was completed in 1755; its dome is traditionally considered the geographic center of San Antonio. San Fernando was the scene of Alamo hero James Bowie's marriage in 1831 to Ursula de Veramendi, daughter of an influential local family. The signal that began the Alamo battle came when Mexican General Santa Anna ordered a "no quarter" flag hoisted to the tower of the church. Alamo defenders' remains may have been buried under its sanctuary railing, though historians' opinions differ. The front (eastern) wall and tower were removed for a French Gothic addition (1868–1873).

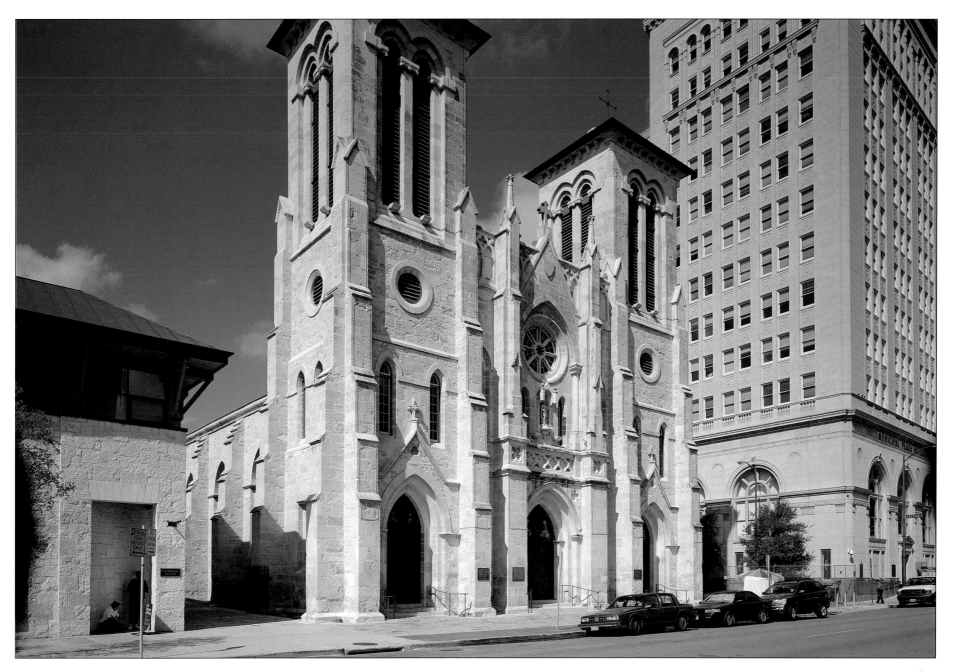

Walls from the original church (the city's oldest structure) form the sanctuary of the church, which became a cathedral when San Antonio was named a diocese in 1874. Among its treasures are carved-stone Stations of the Cross installed at that time, and a baptismal font that may have been a gift from King Charles III of Spain. The church added a pipe organ (the city's oldest) in 1884 and stained-glass windows in 1920; a marble sarcophagus contains what may be Alamo defenders' remains discovered in 1936. During a 2002 restoration, a new Cathedral Center (at left) replaced a rectory with a museum, gift shop, and other support facilities. More than 4,000 attend weekend Masses, and the cathedral receives hundreds of visitors daily.

This simple cottage, built in 1855 of caliche (earth rich in lime deposits) for German settler John Kush, was briefly the home of writer O. Henry. Born William Sydney Porter in North Carolina, Henry came to Texas in 1882 for his health and worked as a ranch hand, pharmacist, and bank clerk. As editor of the Austin-based *Rolling Stone*, he moved to San Antonio in 1895 at the urging of his publishing partner. Porter rented this house for six dollars a month and stayed for a year. When the satirical publication failed, he moved to Houston to write for a newspaper. A story set here ("A Fog in Santone") was published posthumously in 1912 in *Rolling Stone*.

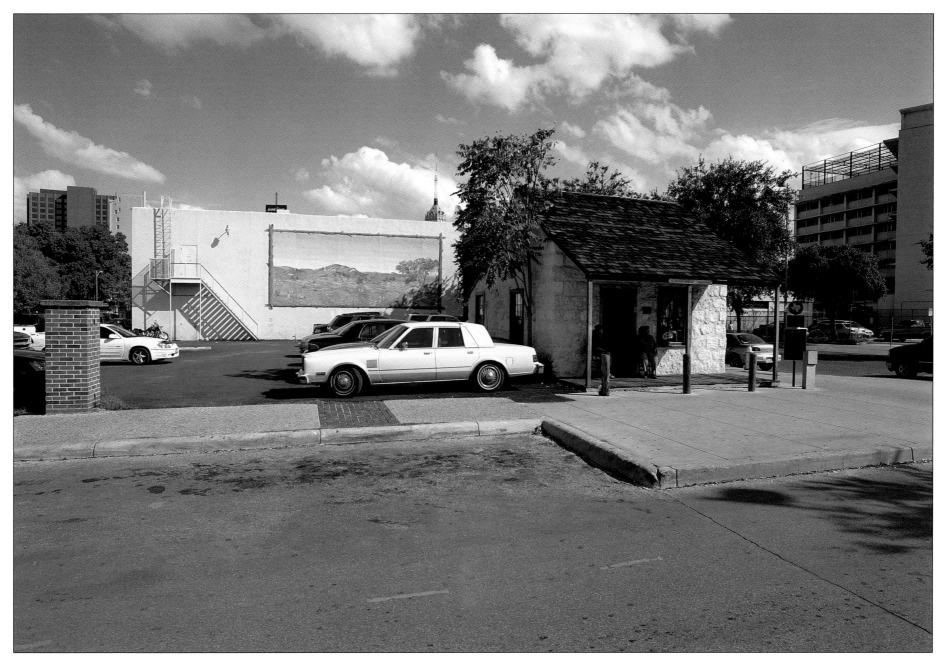

The O. Henry House has been something of a "rolling stone" too. At its original location on South Presa Street, it went from a residential house to a food stand, and the neglected building eventually was threatened with demolition. Bought by the San Antonio Conservation Society in 1959 for one dollar, it was sold for the same price to the Lone Star Brewing Co. The house was dismantled and replaced at the brewery's South Side museum, where it was furnished in period style with O. Henry artifacts, including a copy of his *Rolling Stone* magazine. After the brewery closed its San Antonio operation, the house was moved in 1999 to a site bordering a parking lot at Laredo and Dolorosa streets.

This building was part of a complex built around 1850 of local limestone, caliche, and adobe for landowner/merchant Jose Antonio Navarro, who served in public office under the governments of Mexico, the Republic of Texas, and the State of Texas. A signer of the Texas Declaration of Independence, he also helped frame the state's constitution. Navarro spoke out in defense of Tejano (Mexican American) rights and was the state's first Tejano historian. He died at home in 1871. From the 1860s through the 1870s, this building was a trading post, "perhaps the last in San Antonio where Indians traded wild game and blankets for white men's supplies," as Navarro grandson Colonel Tom Ross (at right) said in 1933.

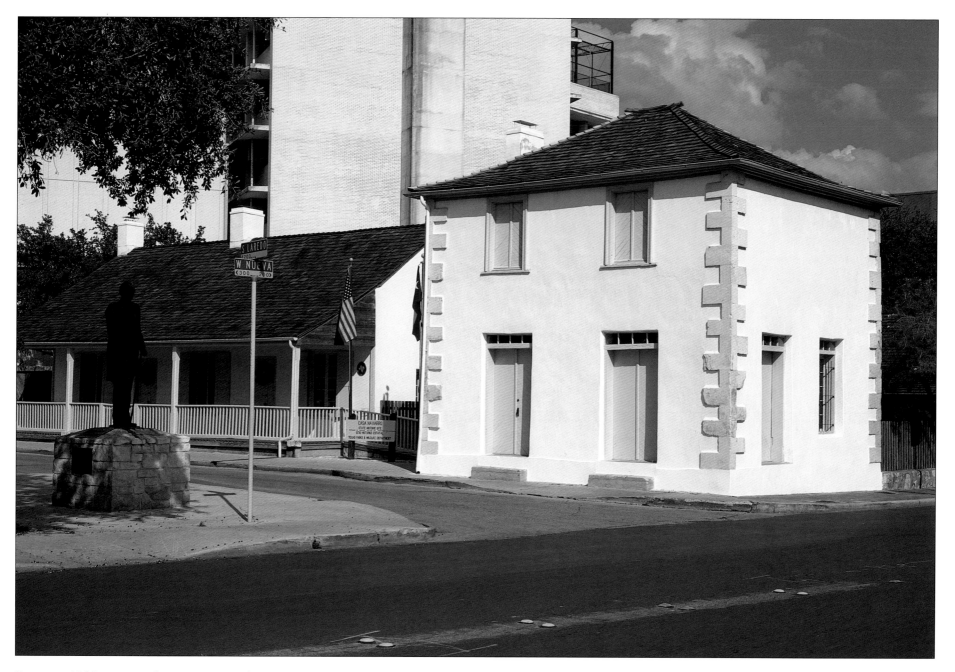

During a 1959 street-widening project, the San Antonio Conservation Society opposed proposals to move the Navarro buildings, then private property within an urban-renewal district. When the society bought the complex the following year, the former Navarro office and trading post was the Jacalito Inn, its walls painted with beer advertisements. After restoration, the complex, including the residence (at left) and its detached kitchen, opened in 1964 as a house museum, with the two-story building representing Jose Antonio Navarro's office. The complex was donated in 1975 to the Texas Department of Parks and Wildlife, which continues to operate it as the Casa Navarro State Historical Site, dedicated to the interpretation of Navarro's contributions in the context of his Mexican heritage.

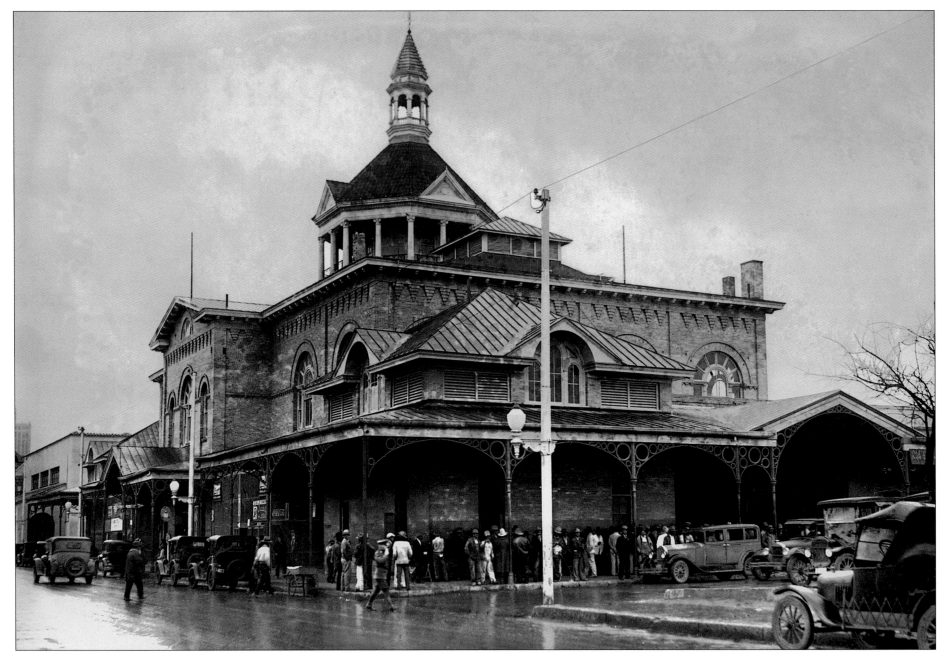

Another grand-scale public building designed by Alfred Giles, this city market house opened in 1900 as headquarters for the produce trade. Replacing an 1859 predecessor, the new facility was up-to-date, with a refrigeration plant that could chill "120 beeves" (butchered cattle). Vendors sold their wares from stalls, as a four-piece band played to entertain shoppers. Food-service professionals came as early as 2 a.m.; housewives came later, the thriftiest waiting for end-of-day bargains. Its 4,000-seat, second-floor auditorium was used as a concert and convention hall. Shown here in the early 1930s, the Victorian colossus was becoming anachronistic as suburban development and neighborhood groceries siphoned household trade. The market house was demolished in 1938 in favor of a modern farmers' market.

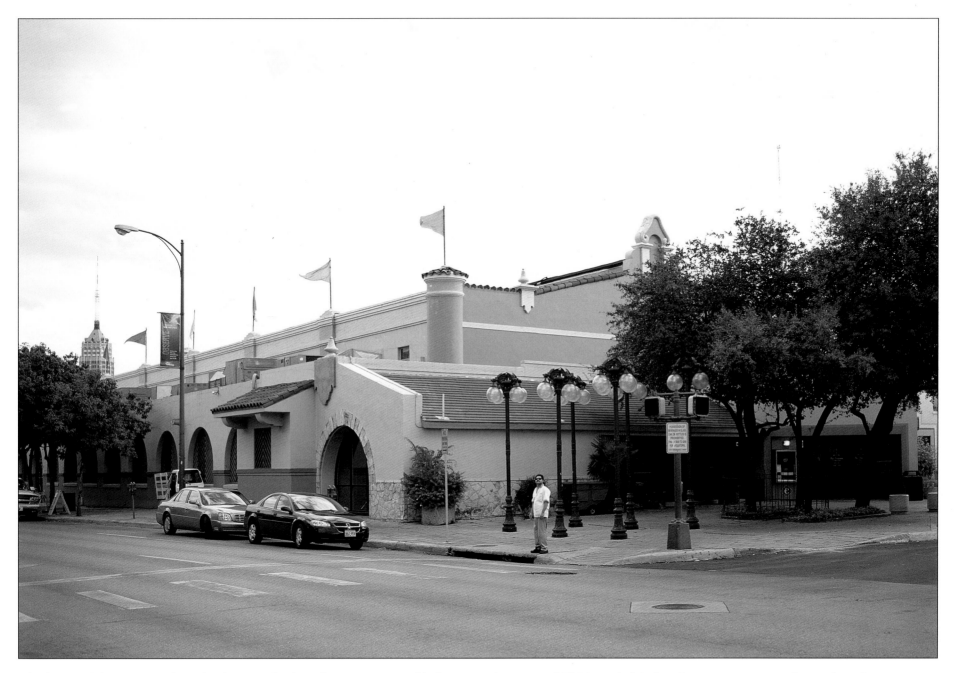

The latest of the municipal market houses, the low-slung, Mission-gabled Farmers' Market Building was painted white when it opened in 1938. A guidebook published that year praised its "modern and sanitary" interior, along with its "atmosphere . . . of a Mexican mart." After a new produce terminal on the city's West Side took over much of its former purpose, the building became a centerpiece of the 1970s urban-renewal project that created El Mercado/Market Square, a city-owned complex of stores, restaurants, and plazas used for frequent festivals and outdoor performances. Nearby, a former market annex built in 1923 is under renovation to house the Museo Americano—a Smithsonian Institution affiliate that focuses on Latino culture.

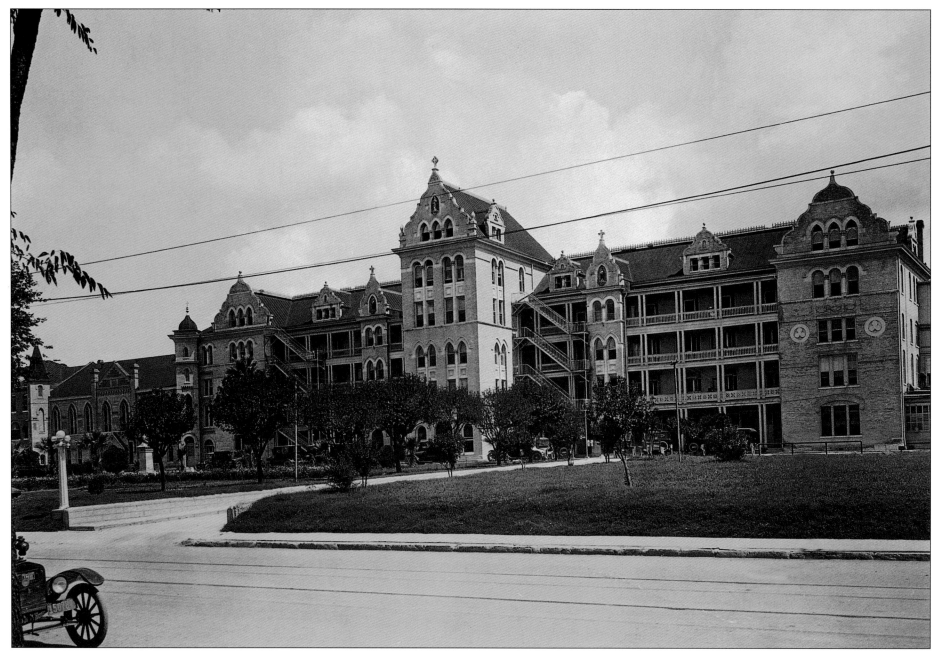

Soon after a severe cholera epidemic, San Antonio's first private hospital was founded in 1869 by three French Sisters of Charity of the Incarnate Word, who announced that the facility would be open to "all persons, without distinction of nationality or creed." Santa Rosa Infirmary (most likely named for St. Rose of Lima, the first new world saint to be canonized) started with nine beds in a small frame structure. Renamed Santa Rosa Hospital in 1930, the institution has grown steadily ever since, adding a pathology laboratory in 1910 and a unit for the care of crippled children in 1918.

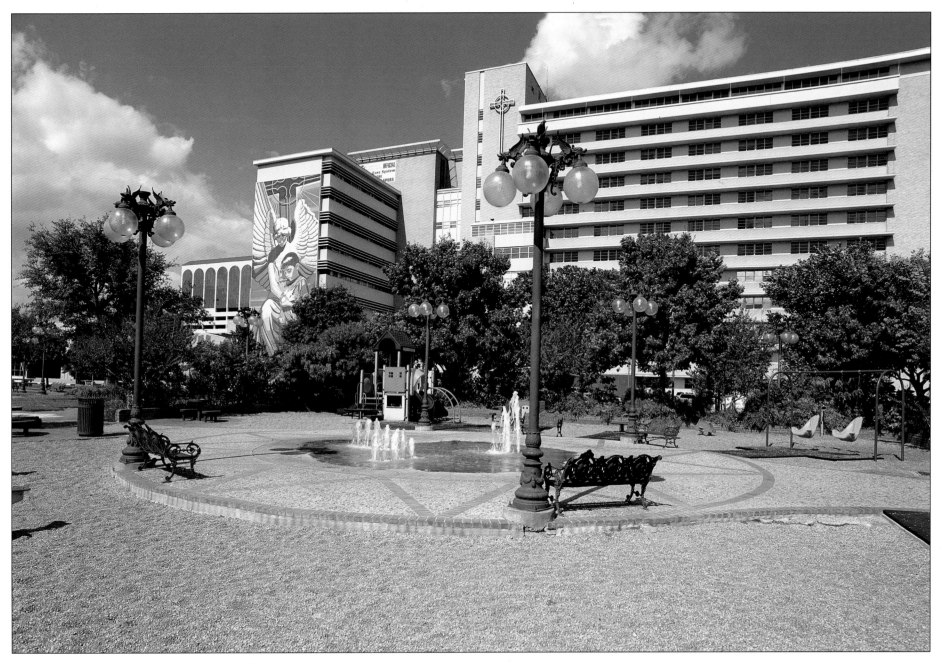

In 1935, the Santa Rosa Hospital was first in Texas to be air-conditioned, and in 1959, Santa Rosa opened the city's first children's hospital. An early-1900s building is still part of the campus, named after the hospital's founder, Mother Madeleine. The tile mural (at left, on Christus Santa Rosa Children's Hospital) is by San Antonio artist Jesse Trevino, who based *The Spirit of Healing* on an old cemetery memorial. Both hospital complex and neighboring Milam Park (foreground) are sited on the city's former Campo Santo burial ground (remains having been reinterred elsewhere). The park, established in 1885, underwent extensive renovations during the early 1990s. Along with its sister hospitals, the original Santa Rosa Hospital is now part of the nationwide Christus Health System.

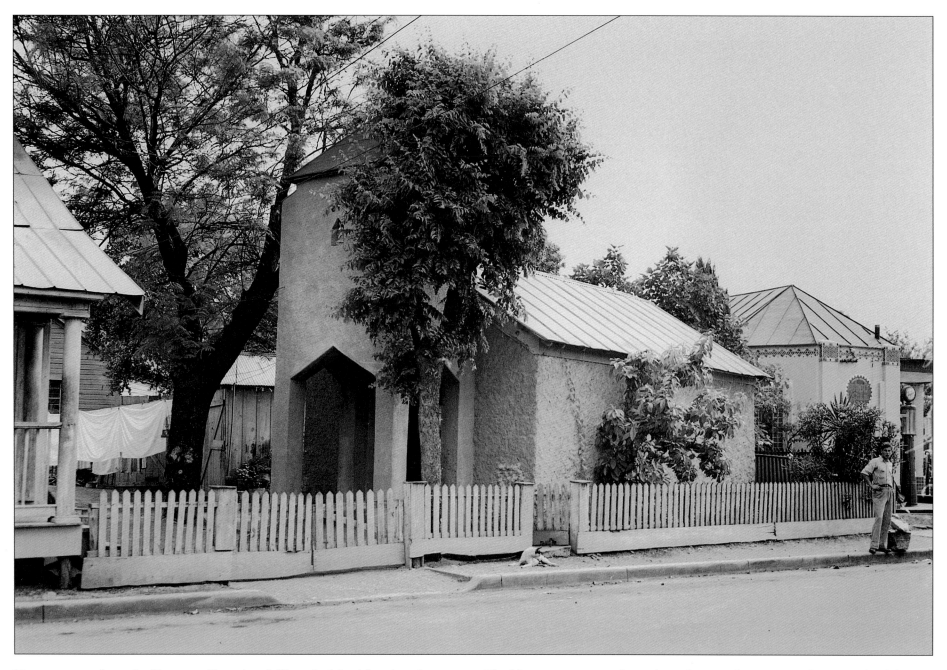

Known variously as the Ximenes Chapel and Chapel of the Miracles, this plastered stone chapel is thought by architectural historians to have been built around 1850 to 1870. (The tower was added during an early-1940s renovation.) Its original owner was Juan Ximenes, a veteran of the Texas Revolution who fought with Ben Milam's company in the Siege of Bexar.

The Ximenes compound may have been within or near the grounds of the first site of the Alamo mission. Inside the chapel hangs a large Spanish Colonial crucifix with a nearly life-size corpus, said to have hung in the Alamo and San Fernando churches. Family caretakers kept the chapel open to the public, and it has acquired a reputation for miraculous cures.

The Chapel of the Miracles has remained in the Ximenes-Rodriguez family by tradition. One of the women of each generation acts as caretaker, with headquarters in the adjacent house (at left). Still private property, the Ximenes buildings are enclosed at one end of the city's Eduardo S. Garcia Park, with a sign identifying the chapel as *Senor de los Milagros* (Our Lord of the Miracles). Urban-renewal projects and interstate highway construction have chopped and changed this formerly residential neighborhood west of downtown. Now surrounded by public land and buildings, the chapel remains open to visitors, who pray, light candles, and leave *milagros* (miraculous medals) that symbolize their petitions for deliverance from illness and ill fortune.

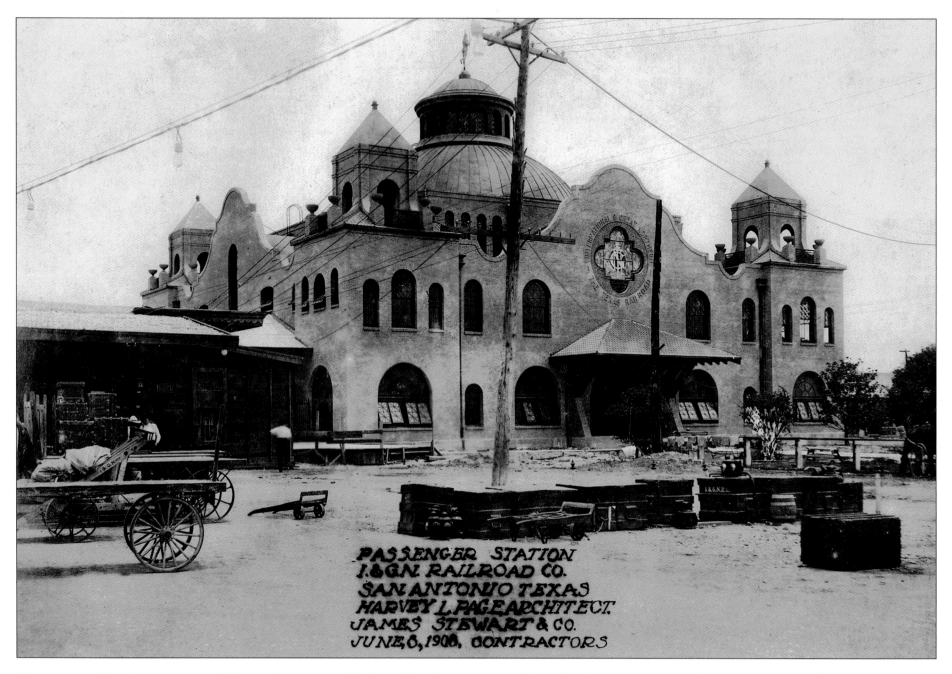

PASSENGER STATION
I.&G.N. RAILROAD CO.
SAN ANTONIO TEXAS
HARVEY L. PAGE ARCHITECT.
JAMES STEWART & CO.
JUNE 6, 1908, CONTRACTORS

Having served San Antonio since 1881, the International & Great Northern Railroad (I&GN) built this "cathedral of commerce" to replace its modest frame depot. Architect Harvey L. Page called it his "Taj Mahal," and it was completed in 1908 for about $142,000. Once owned by railroad robber baron Jay Gould, the I&GN had an eventful history marked by foreclosures and ownership changes. Its relationship with the Missouri Pacific (MoPac) extended its San Antonio service with connections to Dallas, Fort Worth, St. Louis, Memphis, and Chicago. The depot was down to a single passenger train a day in 1965, and MoPac closed the station in 1970. Amtrak briefly stopped at the boarded-up depot, but passengers had to buy tickets at the Southern Pacific station.

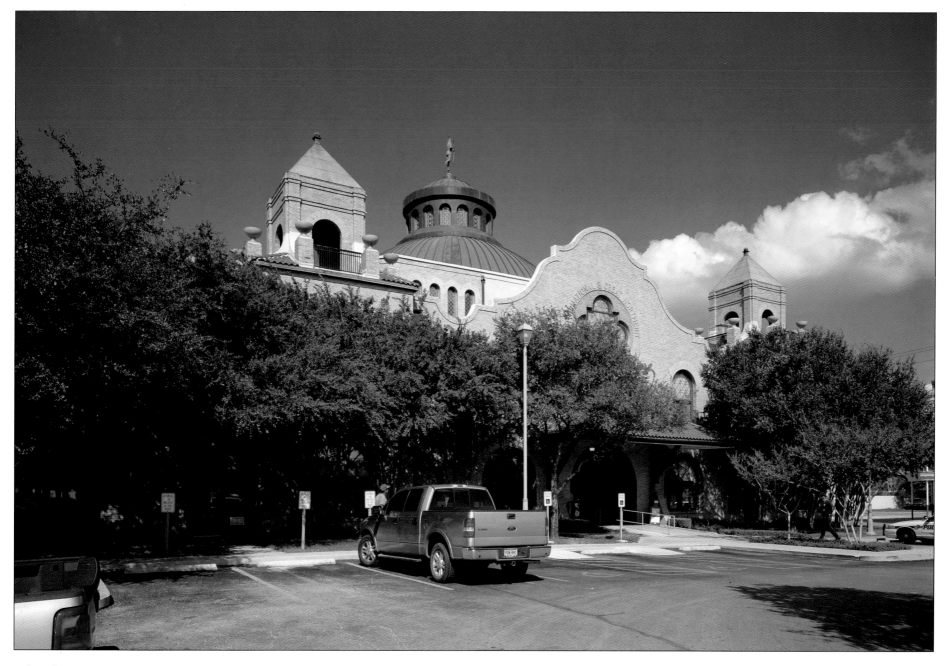

After the Missouri Pacific sold its former depot in 1972, the building stood empty while private owners considered redevelopment plans. Meanwhile, vandals shattered its original I&GN stained-glass windows, and thieves stripped protective copper from the dome. Squatters left trash inside and may have started a 1982 fire that did further damage. The building was nearly unsalvageable by the time San Antonio City Employees Credit Union

(SACECU)—a nonprofit, financial cooperative founded in 1940—bought it in 1988 and committed to a $3.1 million renovation. The award-winning project restored the windows, replaced the dome's Indian statue (stolen in 1982 and recovered in a vacant lot), and built a compatible addition. Trains still run on the tracks near the credit union's main office.

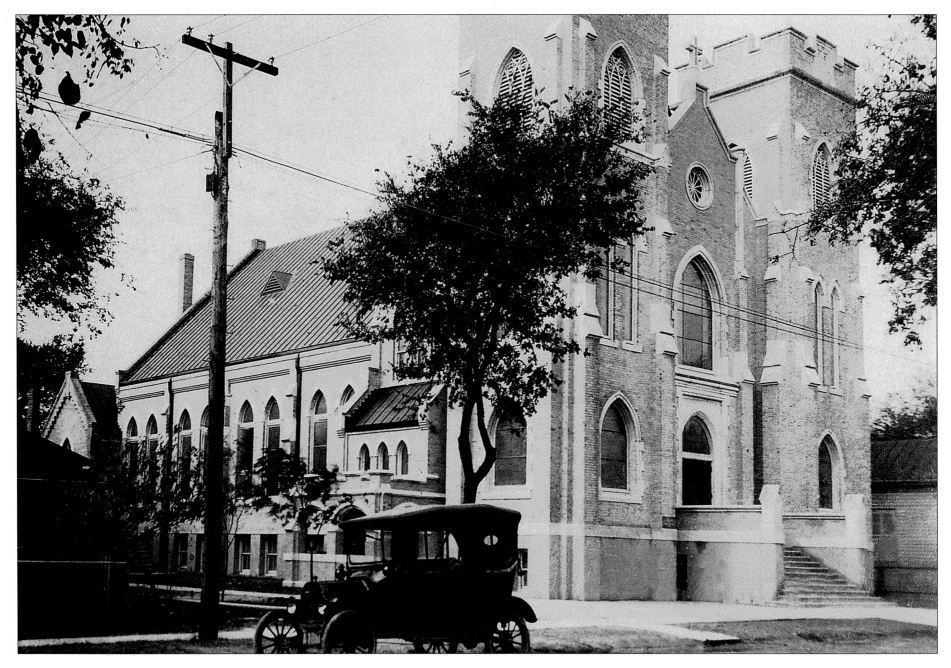

The third oldest parish in San Antonio, St. Michael's was organized in 1866 to serve Polish Americans. The parish celebrated Masses in San Fernando Church and in a rented building until its first stone church was completed in 1868. Damaged in the flood of 1921, it was replaced the following year by this larger, white-brick Gothic Revival church. By mid-century, St. Michael's served 900 families, with facilities including a dramatic club, rectory, school, parish hall, and nuns' residence. Within the site chosen for HemisFair '68, all church property was bought in 1965 by the Urban Renewal Agency for $370,000. St. Michael's built a contemporary-style church on the East Side; its stained-glass windows were reinstalled in Immaculate Heart of Mary Catholic Church.

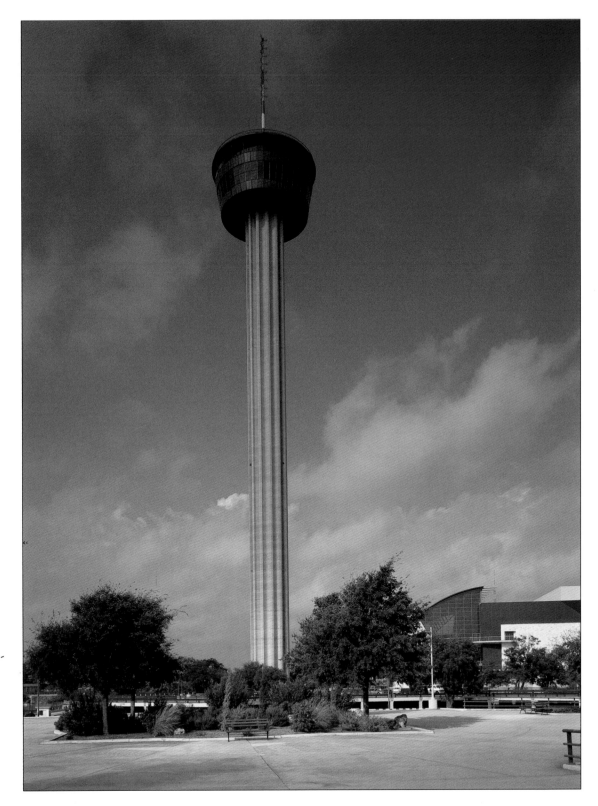

Under the supervision of architect O'Neil Ford, thirty-five historic buildings in the former mixed-use neighborhood were preserved for HemisFair '68, while more than 750 other homes, business, and public buildings were demolished. The city-owned Tower of the Americas is 750 feet tall. Its revolving top house was built on the ground, then hoisted in place. The concrete shaft has glass-walled elevators to a restaurant and observation deck. It is situated just south of the center of the former fairgrounds (now HemisFair Park). After renovation, the Tower of the Americas will reopen with new restaurants, a ground-level theater, gift shop, and indoor/outdoor café.

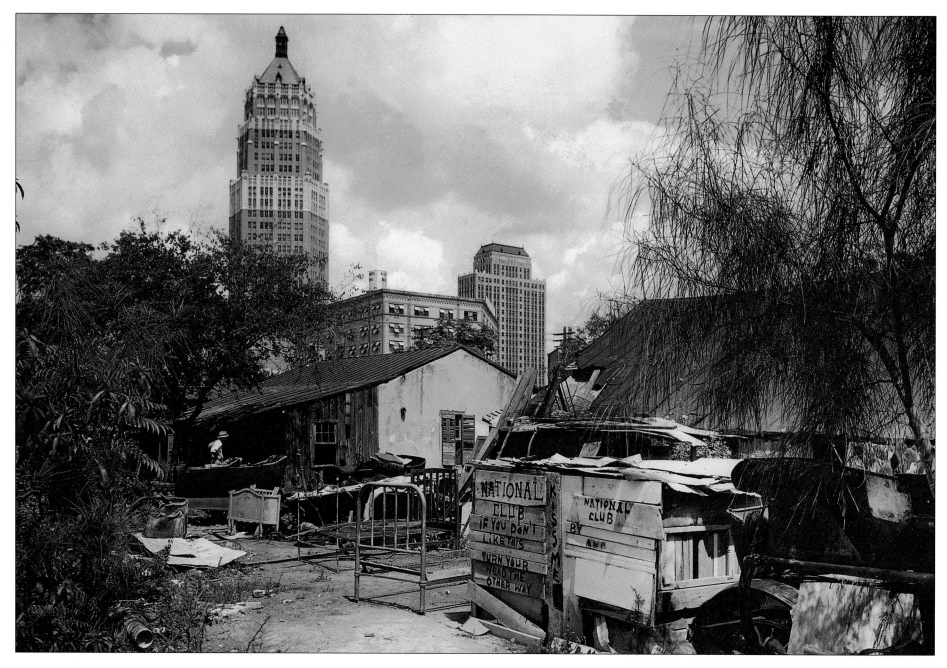

Sometimes called San Antonio's first suburb, La Villita (the Little Village) began as temporary quarters for Spanish soldiers at the mission now known as the Alamo. The village clung to its river bluff, and by the late nineteenth century was settled by European immigrants. The neighborhood later deteriorated into what architect O'Neil Ford called "the worst slum you ever saw . . . in the middle of town." For an urban-renewal project in 1939, Ford identified buildings sound enough to save; 119 residents whose dwellings didn't make the cut were relocated in what a WPA report calls "eviction-by-convenience." Remaining houses were restored, plazas paved, and a headquarters building, Bolivar Hall, was erected. Re-created as a city-owned arts-and-crafts community, La Villita was dedicated in 1941.

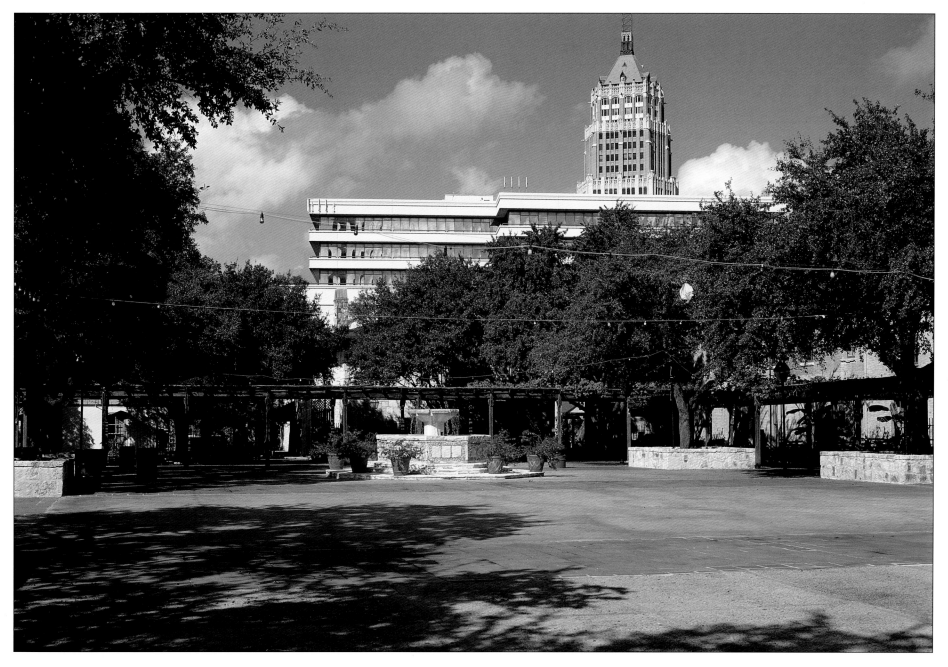

Now one of the city's historic districts, present-day La Villita's boundaries extend past the 1939 project area, with other significant buildings purchased later and additional plazas used for private parties and festivals. Best-known among the latter is the San Antonio Conservation Society's Night in Old San Antonio (NIOSA), a four-day Fiesta San Antonio event that celebrates the city's multicultural heritage and has been the organization's chief fundraiser. Built in 1958, Villita Assembly Hall (now a meeting facility) was designed by original restoration architect O'Neil Ford, who also supervised a 1981 renovation of La Villita. Tenants of the complex still include art galleries and artisans' shops, and the Arneson River Theater (an outdoor amphitheater) connects La Villita with the River Walk.

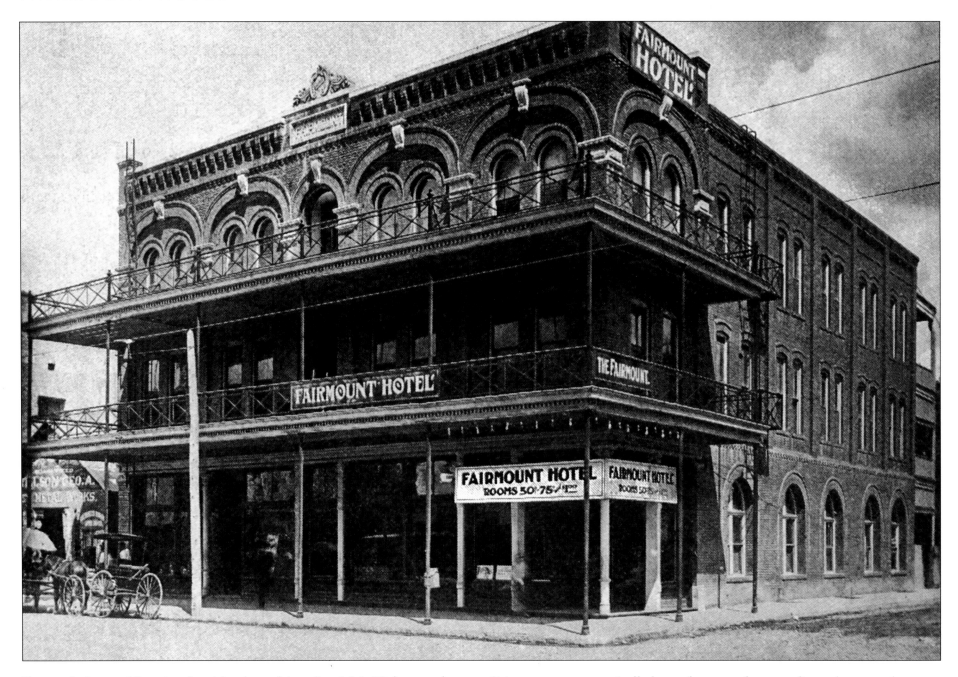

Despite Italianate Victorian flourishes by architect Leo M. J. Dielmann, the thirty-room Fairmount Hotel wasn't supposed to be anything special when it was built in 1906 of red brick, limestone, and wood. Originally on Commerce Street between Alamo Plaza and the Southern Pacific train station, the Fairmount was strategically located to appeal to traveling salesmen, who could walk or take a cab from the depot. The ground floor was rented to various businesses, while hotel guests walked up to the advertised "Rooms, 50¢–75¢" on the building's second and third floors.

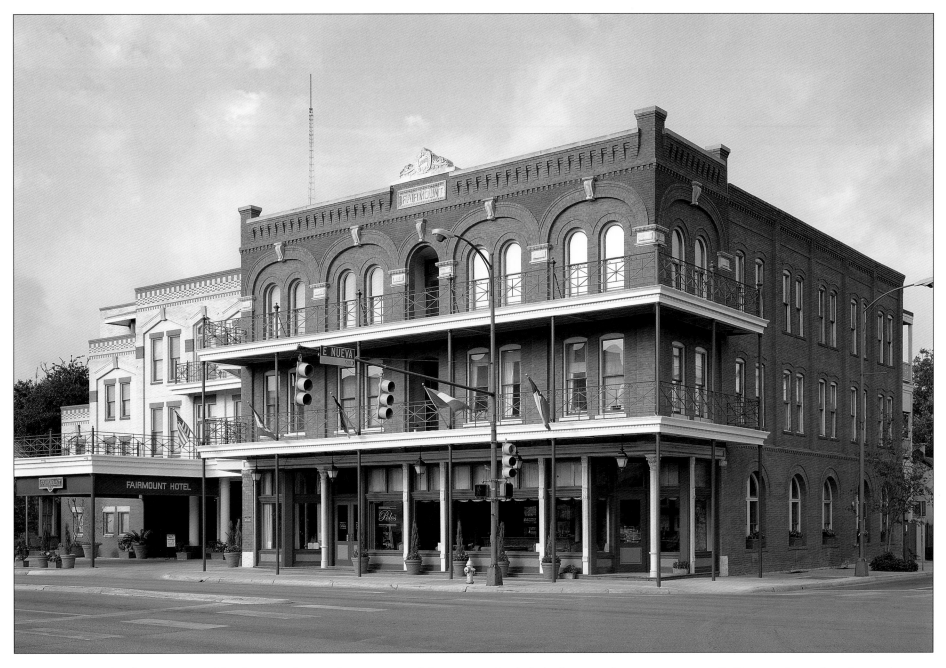

Vacant since 1968, the Fairmount Hotel was at the southeast corner of the site of what became Rivercenter Mall. Unwanted by mall developers, the 1,600-ton building was moved in 1985 to a former city parking lot on South Alamo Street. In a record-setting operation that made worldwide news, the Fairmount was lifted onto beams supported by railroad ties and set atop wheeled platforms with pneumatic tires. Rolling no faster than four miles an hour along its four-block route, the old hotel crossed a bridge over the San Antonio River and made two turns. Private investors renovated the building as a thirty-seven-room luxury hotel, opened in 1986. With an addition (at left), it is now the Fairmount—a Wyndham Historic Hotel.

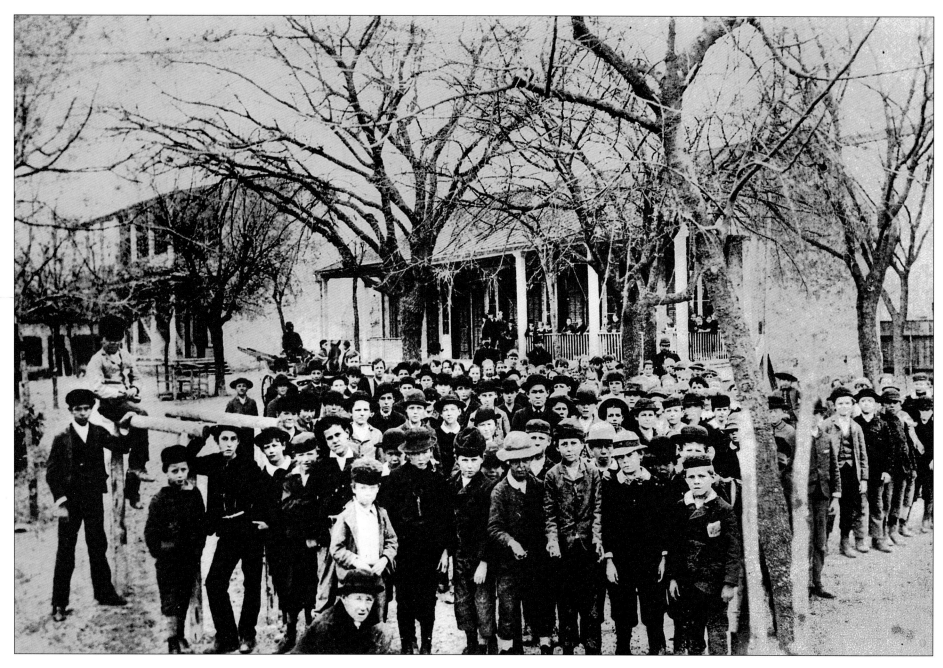

Founded in 1858 by Casino Club members, the German-English School met in hotel rooms as funds were raised for a permanent campus. The first building, in the heart of the German American community along South Alamo Street, was completed in 1860, and two more had been added by 1875. Dedicated to poet Friedrich von Schiller, the school offered an ambitious program, with instruction alternating between German and English. During an eleven-month term, gender-segregated students spent six days a week learning algebra, geography, writing, history, Spanish, astronomy, poetry, and singing, with optional art and swimming lessons. As public schools improved and new generations of German Americans entered the cultural mainstream, the German-English School became obsolete. Its buildings were sold to pay off debts in 1897.

In 1903, the San Antonio Board of Education established George W. Brackenridge grammar school in the former German-English School buildings. Yet another new school moved into the old buildings in 1926, when University Junior College—a two-year public institution founded in 1925 at Main Avenue High School—needed its own space. The renamed San Antonio College was outgrowing its downtown premises when it moved in 1951 to a new campus near San Pedro Park. Protected by the San Antonio Conservation Society, the German-English buildings were restored in 1964 for use as HemisFair '68 headquarters. The complex is now the Marriott Plaza San Antonio Hotel Conference Center, where the North American Free Trade Agreement (NAFTA) was signed in 1992.

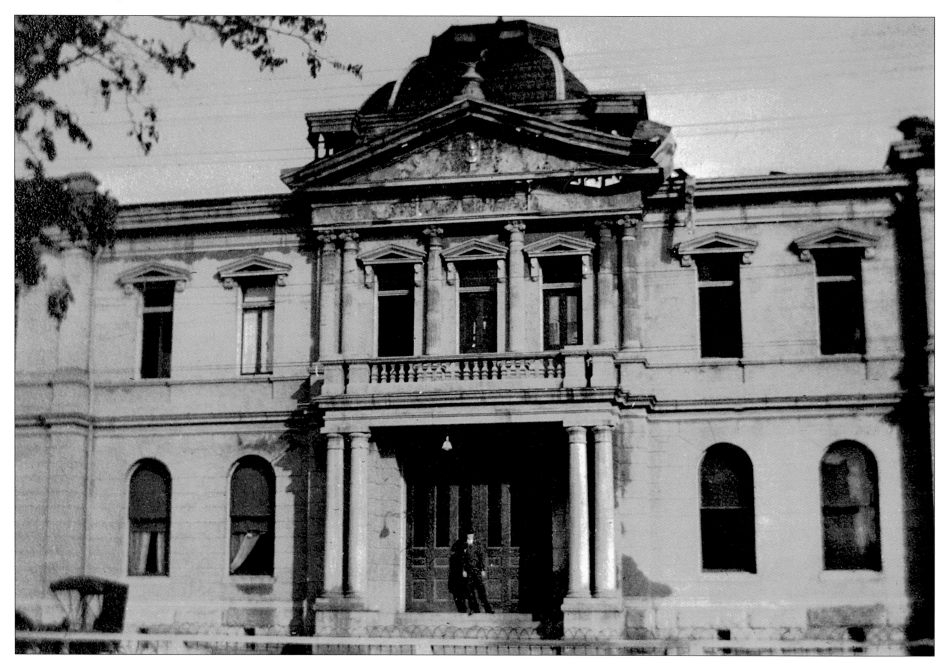

Founded in 1867, San Antonio's Beethoven Maennerchor (Men's Chorus) may have been the first organized musical group in San Antonio and remains the oldest German American singing society in Texas. Visiting poet Sidney Lanier played his flute for the group in 1873 and wrote favorably of the quality of its music. With funds raised by twenty-dollar subscriptions, the Maennerchor bought land on South Alamo Street and built this 1,200-seat, brick-and-ironclad hall for about $25,000. Completed in 1895, Beethoven Maennerchor Hall was used for performances by its namesake organization as well as for the city's first symphony orchestra, other amateur and professional concerts, in addition to theatricals. Shown here after the October 31, 1913, fire, the hall was rebuilt the following year.

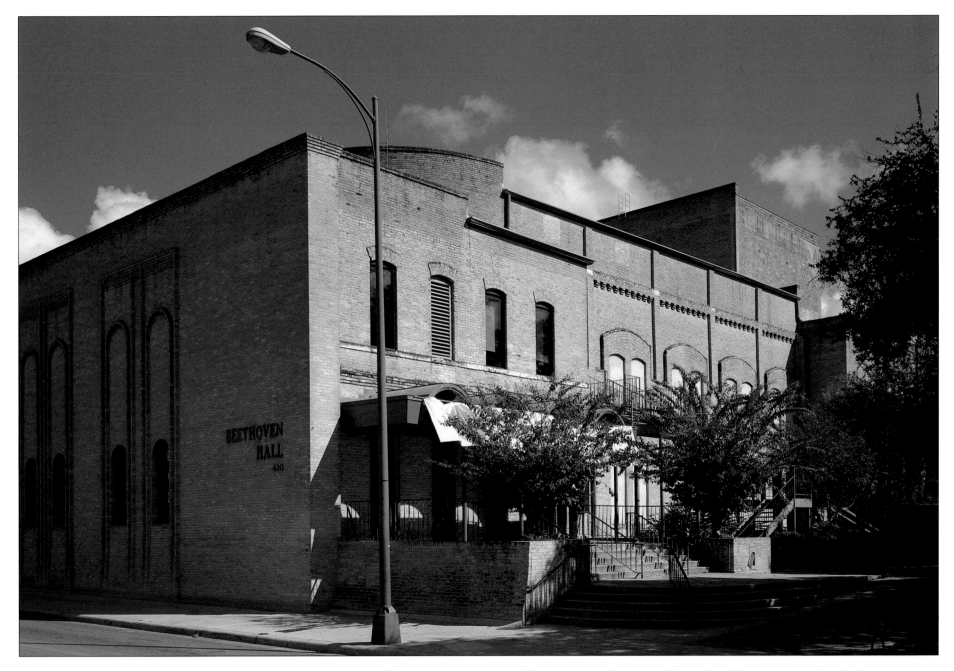

Architect Leo M. J. Dielmann designed the new Beethoven Hall with a neoclassical facade like its predecessor's, with added fireproofing features, a bowling alley, and a saloon that helped support the hall until Prohibition (1919) closed it down. Despite improvements, World War I anti-German feeling and the influenza epidemic of 1918 depressed attendance, and the Beethoven Maennerchor sold the hall in 1920. It housed a dance hall, prizefight arena, warehouse, and Ku Klux Klan meeting place before it was bought by the city in 1950. During a HemisFair '68 street-widening project, the hall's facade was sheared off, and its entrance was moved. Often empty after the world's fair, Beethoven Hall hosted occasional performances until the Magik Children's Theater became the resident company in 1997.

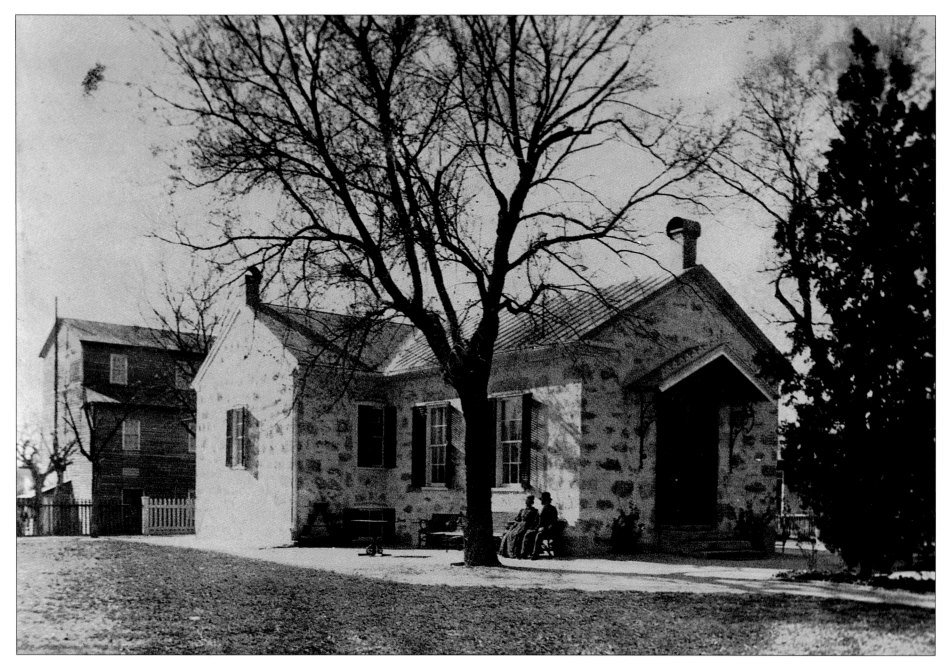

German-born miller Carl Hilmar Guenther built an enduring business and his family home on a seven-acre site along the San Antonio River, south of downtown. In 1859, he founded a water-powered mill to grind grain, with a millstone imported from France. The one-story house was built the next year, out of stone quarried in what later became Brackenridge Park and joined by mortar made from river rocks. There, the Guenthers reared seven children; youngest son Erhard became president of the renamed, modernized, and expanded Pioneer Flour Mills in 1902. Guenther Street, in the adjacent historically German-American King William Historic District, is named for the family, who once owned all four houses in a single block.

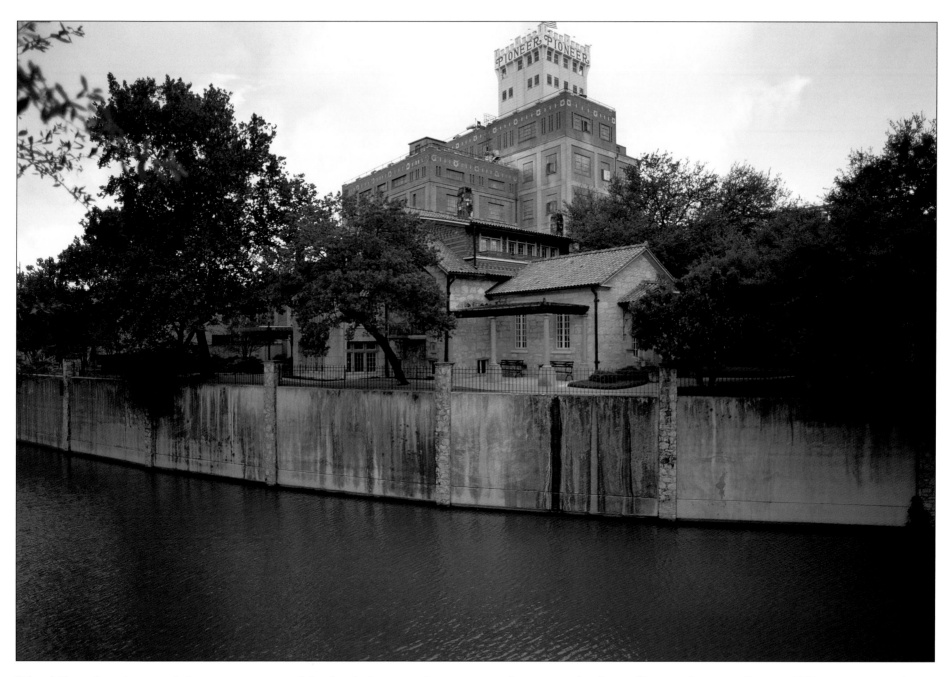

Erhard Guenther also presided over renovation of the family home in the 1910s. Two stories—including a third-floor ballroom, a balcony, and side veranda—were added to the original six-room structure, and the entrance was moved. Green tiles replaced metal roofing, while porcelain tile floors, a crystal chandelier, and other luxurious fittings were installed inside. Family members occupied the house until the 1940s, after which Pioneer Flour Mills used it as a test kitchen, offices, and storage. Since a 1988 restoration, it has been the Guenther House restaurant, with museum rooms including mill and family memorabilia, such as Erhard's Casino Club bowling trophy. Pioneer Flour Mills, still active on the site, may be the oldest family-owned business in Texas.

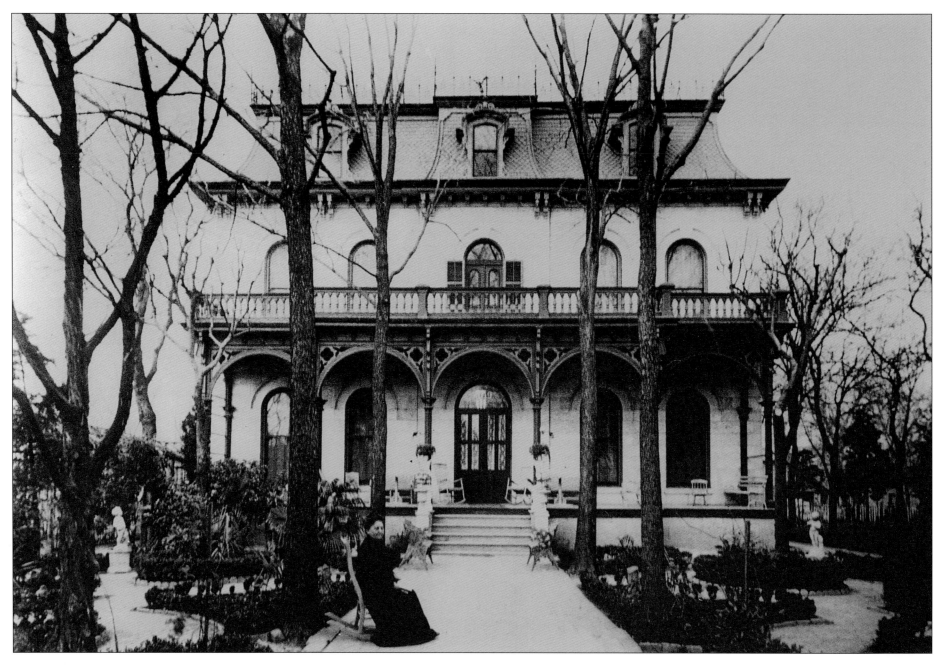

The riverside home of Edward and Johanna Steves was built in 1876, of limestone with lots of wood trim as befitting a lumberman's residence. The German-born couple moved in 1866 to San Antonio, where Edward started his trade in wood, from fine hardwoods to the mesquite blocks used as street pavers. While this house was built (for $12,000, reputedly from plans by Alfred Giles), the couple visited the Philadelphia Centennial Exhibition, where they bought a cast-iron fountain, and shipped it by wagon to their new home. Inside, the house was a woodwork sampler, with grooved banisters, pocket doors, and elaborate cornice boards. The separate, enclosed "natatorium" was the city's first private swimming pool, where Mrs. Steves (shown seated) swam each afternoon, first ringing a bell for privacy.

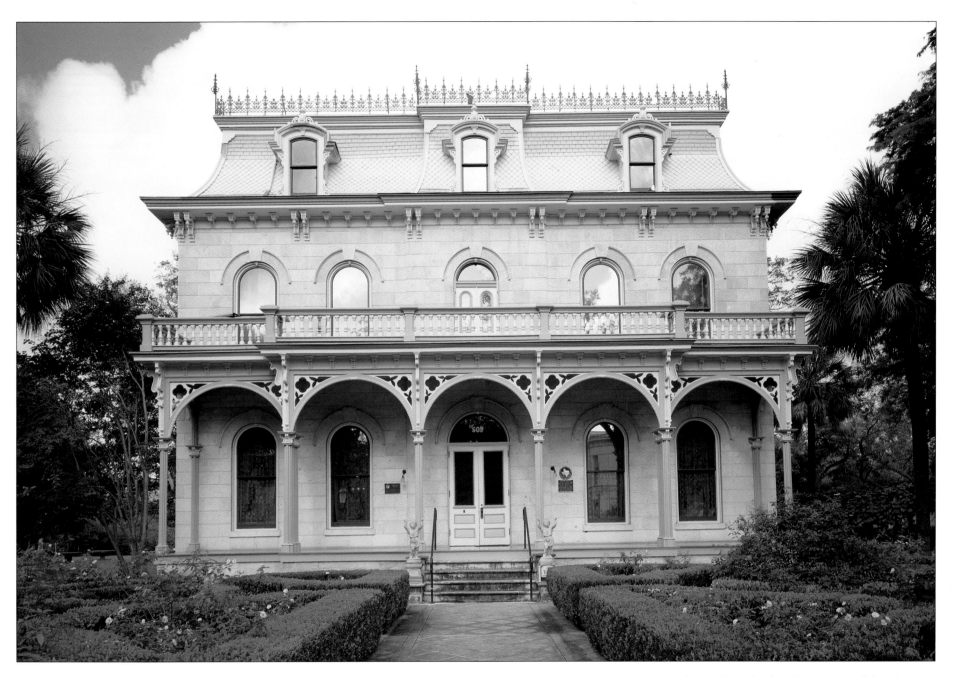

The Steves mansion was donated to the San Antonio Conservation Society in 1952 by a granddaughter of the original owners, with tenants at that time staying on as caretakers. After a general sprucing-up of the house and grounds, the Steves Homestead opened in 1954 as a house museum—still the only one open daily to the public in the King William Historic District.

Rooms configured in Victorian style are furnished with period and family pieces, including a parquetry table presented to Edward Steves by employees who made it from "day's end" scraps of twenty-six different woods. The former natatorium (with the swimming pool closed off) is now the River House, used as a Conservation Society meeting place.

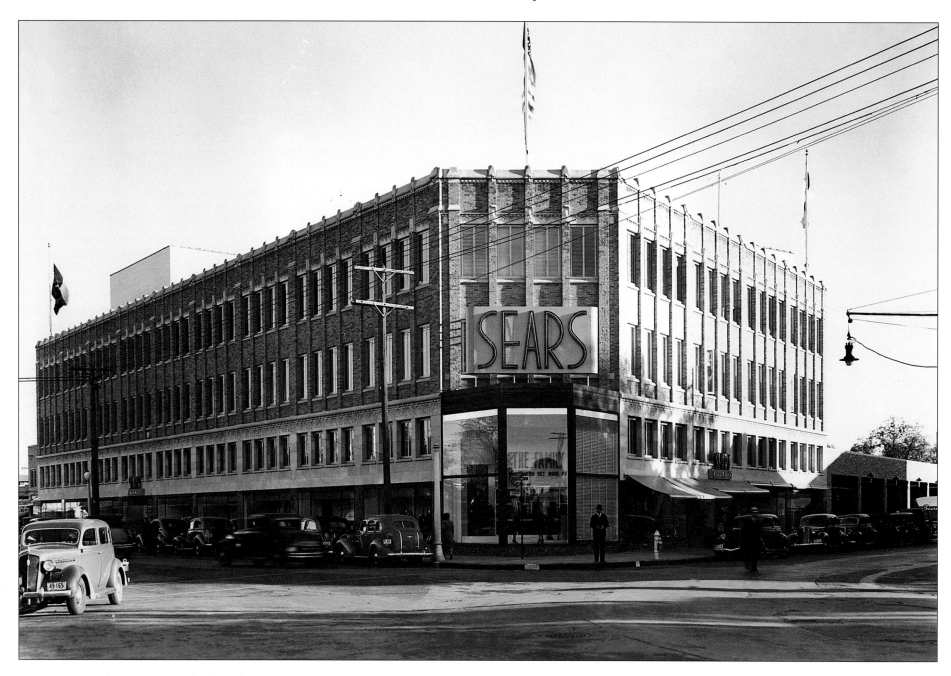

San Antonio's first Sears, Roebuck and Co. store was an original tenant of the Smith-Young Tower (now Tower-Life Building), occupying several lower floors when the thirty-two-story skyscraper opened in 1929. The mail-order catalog giant had been opening retail stores since 1925 to attract city shoppers to its wares. Display windows were built into the ground floor for the store's use, and special express elevators with liveried operators ferried shoppers between Sears's many departments. When the store outgrew its vertical premises in the late 1930s, Sears moved to a building of its own on Romana Plaza on the northern edge of downtown. In turn, this store building was left behind when Sears moved on to suburban mall locations.

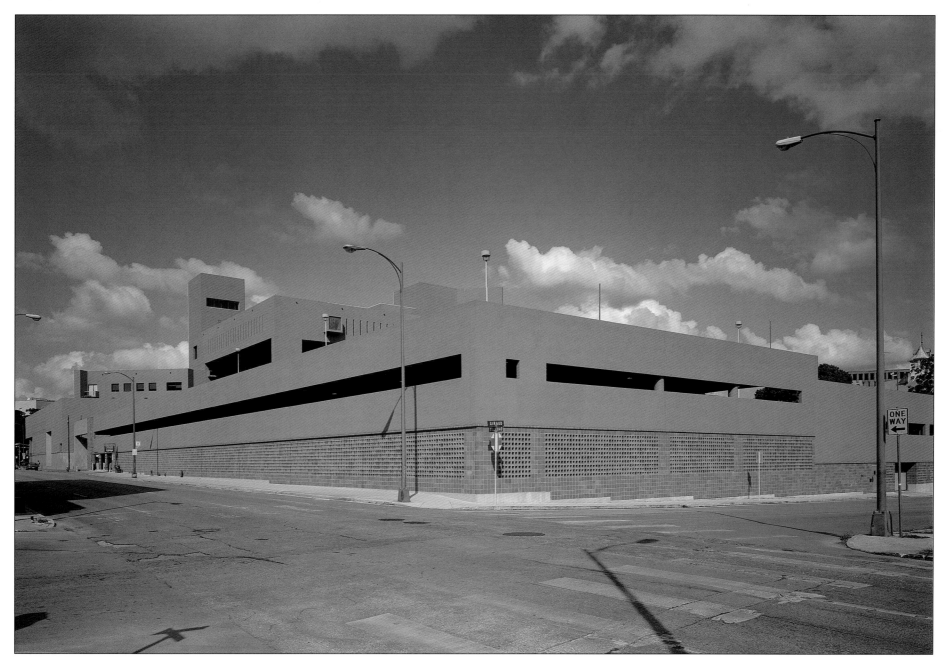

Opened in 1995, this six-story, 240,000-square-foot building is the fourth main library in the city's history, a descendant of the 1903 Carnegie Library on Market Street. Designed by Mexico City architect Ricardo Legorreta in association with local firms, this is the central branch of the San Antonio Public Library system, housing its largest collection, administrative offices, a Texana/Genealogy research department, and an auditorium. A thirty-six-foot foyer mural by Jesse Treviño gives an impression of walking through downtown streets during the World War II era, depicting actual stores and theaters. The library's "enchilada red" exterior, with purple details and a sunny yellow atrium inside, has sparked the use of similar masses of strong color in renovations of several other downtown buildings.

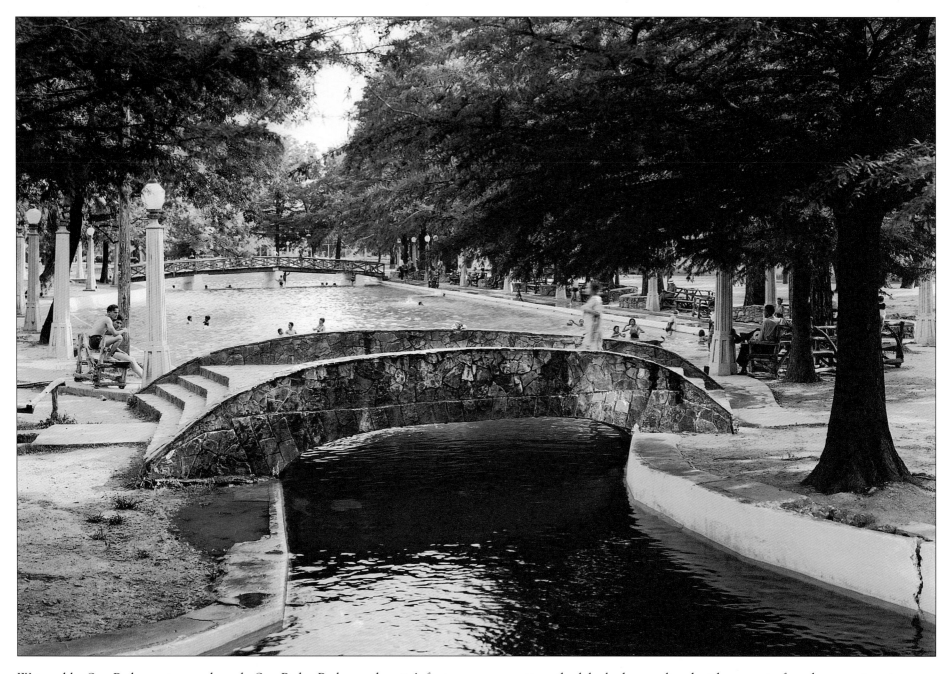

Watered by San Pedro springs and creek, San Pedro Park was the city's first swimming pool, decreed as public land by the Spanish colonial government. Camels for a U.S. Army experiment were kept here, as were Union prisoners during the Civil War. Developed as a public resort during the late nineteenth century, the park included a swan-stocked boating lake. During a 1922 renovation, the lake bed was relined with concrete for a larger swimming pool, with the old wooden bridge (at rear) left in place. Dams at each end allowed for cleaning and drainage; the springs could refill the pool within eight hours. Mixed bathing was permitted, and races in which contestants swam to retrieve greased watermelons added to summer fun.

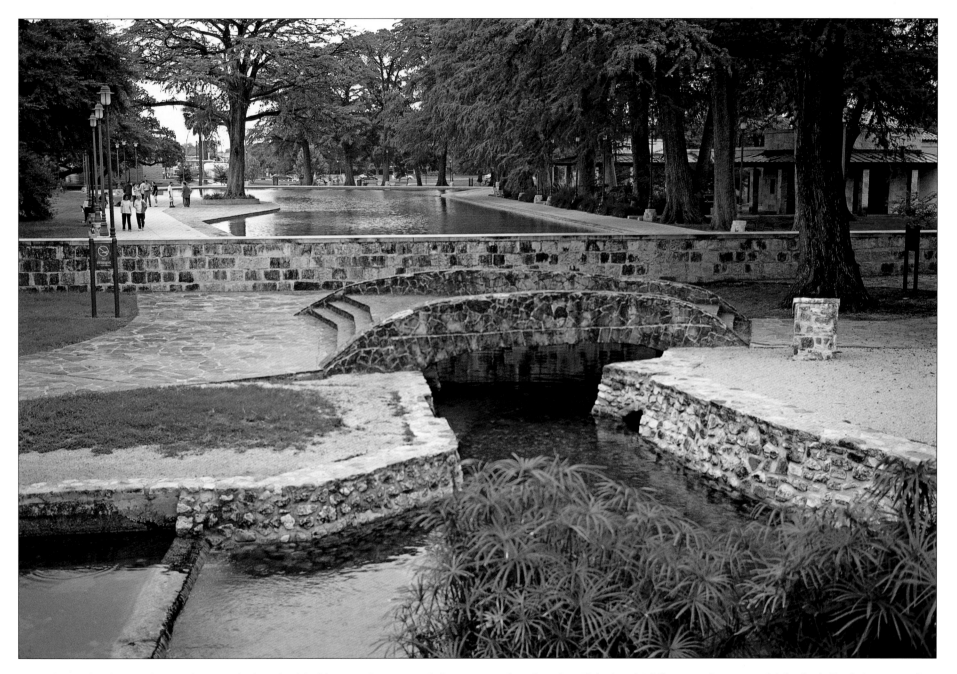

Drought and polio epidemic closures dealt a double blow to the spring-fed swimming pool that followed the long, natural lines of the old lake bed. In 1954, the city replaced it with a rectangular pool filled with chlorinated well water. After years of deterioration, a renovation of San Pedro Park focused on restoring its historically important water features. The latest old pool was replaced with a "lake/pool" following the original lake bed. Dark lining and a limestone surround give the newest pool a real-lake look; large cypress trees (like those along the River Walk) flank the water, and a removable fence encloses it through the summer swimming season. With a ceremony including Native American observances, this pool opened May 20, 2000.

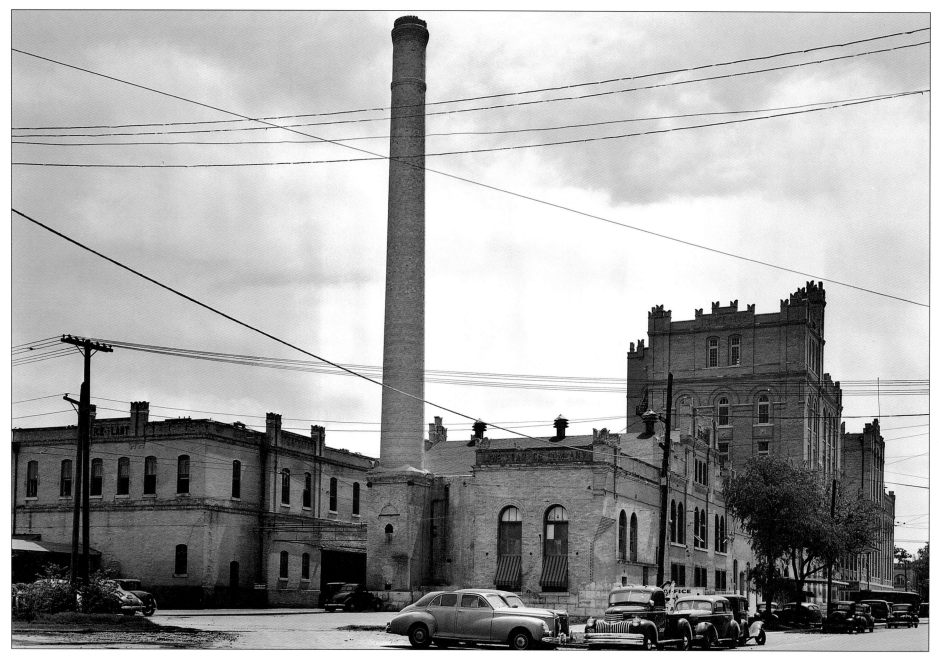

Beer was big business in San Antonio as German brewmasters immigrated to run New World operations. This complex—with buildings used for different stages of production—belonged to Lone Star Brewing, founded in 1884 near the Sunset Depot and expanded from 1895 to 1904 on a riverside site north of downtown. By then it was owned by the Anheuser-Busch Brewing Association and was the company's first factory outside St. Louis. With labels such as Pilsner, Select, and low-alcohol Alamo ("the favorite beer of gentlemen"), Lone Star was a medium-size brewery, rolling out 60,000 barrels a year. After Prohibition, the factory turned to soft drinks before converting to a short-lived cotton mill. Its buildings later were used for auto repair, ice distribution, storage, and offices.

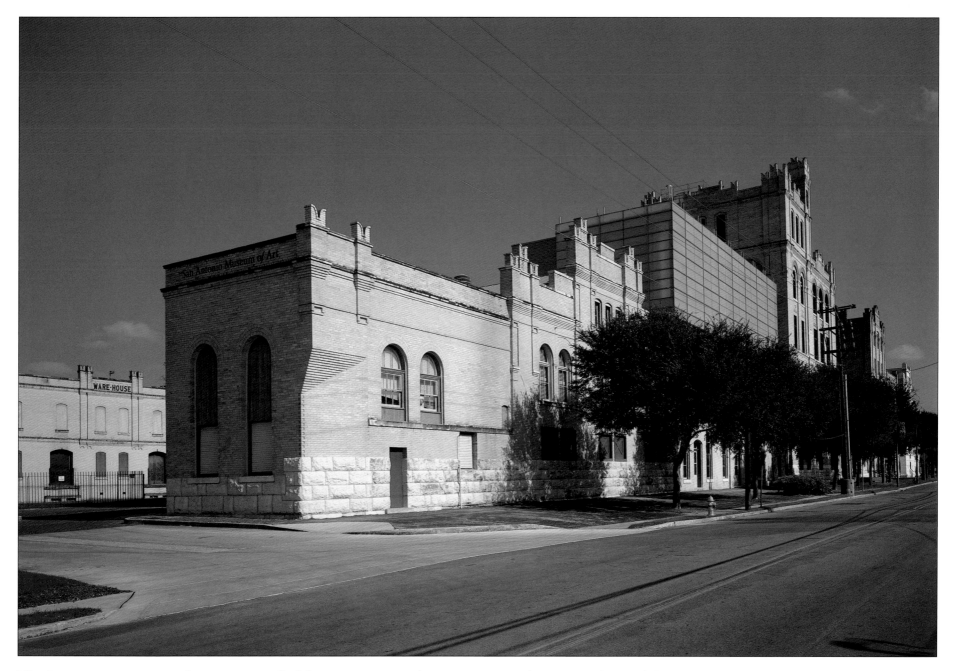

The San Antonio Museum of Art is a spin-off of the Witte Museum, begun when a director of the latter advocated establishing a separate art museum in the old brick brewery buildings. The San Antonio Museum Association bought the property in 1972 and launched the project that created eight galleries in two brewery towers connected by a neon-iced walkway. The restoration was christened in 1977 with a bottle of beer; the new museum opened in 1981 with an exhibit on American realism. Permanent collections cover a continuum from classical antiquities through Latin American and contemporary art. In 1991, a former warehouse was renovated in 1990 to expand exhibit space. Family art classes are conducted in the brewery's onetime Hops House.

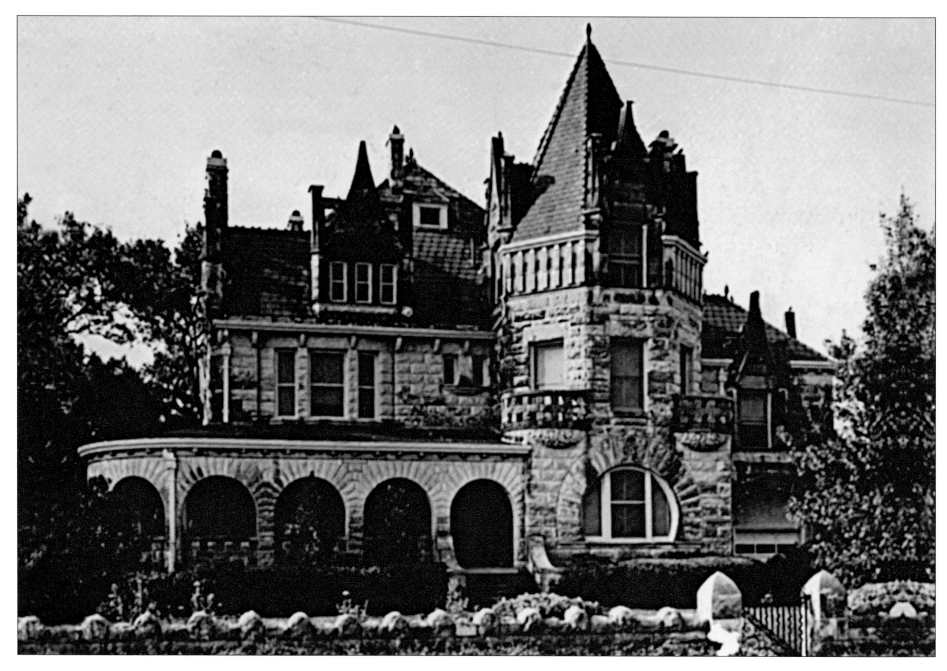

A residential project of Alfred Giles, Lambermont was built in 1894 for Indiana-born Edwin Holland Terrell, a San Antonio businessman and state Republican Party leader. Terrell, a Harvard Law School graduate who had studied at the Sorbonne, was a San Antonio Gas Company executive and promoter of the city's first railroad. He was serving as U.S. minister to Belgium when his first wife, Mary, daughter of pioneer Samuel Maverick, died in 1891. Lambermont (named for a Belgian village) was planned as a bridal gift for Terrell's second wife, Lois Lasater. The limestone-block house recalls elements of French châteaus and other European architecture. After Terrell's death in 1910, his widow moved to Paris, and the house was sold.

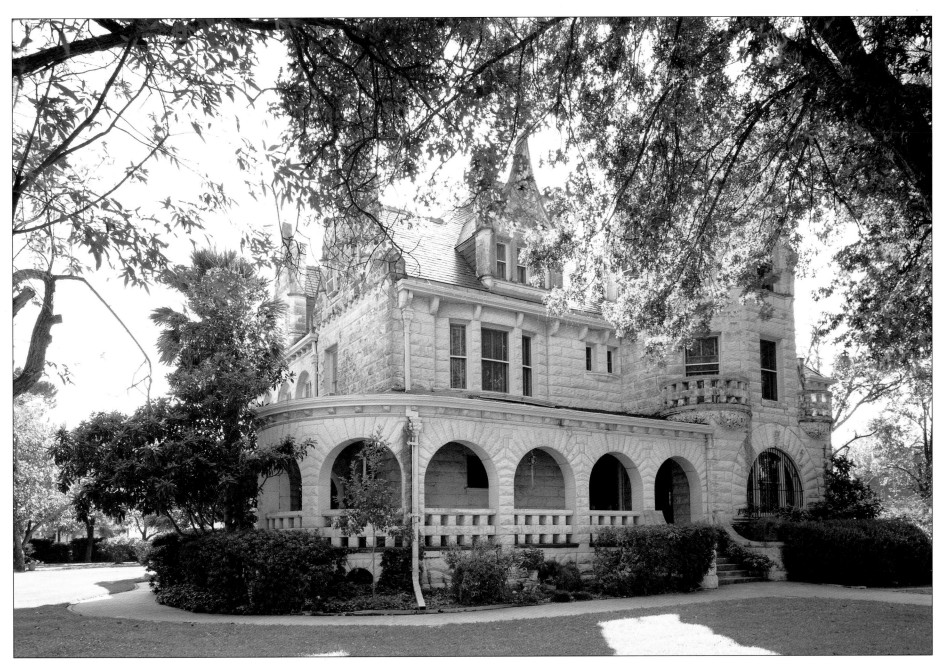

After the Terrells's tenure, Lambermont had several owners. During the 1930s, a spiritualist held séances in the large central reception hall. Later it became a boardinghouse, and then the mansion was divided into apartments in the 1970s. The still-majestic building was renamed Terrell Castle in 1986, when it was converted to a bed-and-breakfast inn. Some suites include one of the house's original nine fireplaces. A restoration preserved distinctive woodwork, such as a staircase with harp-shaped newel posts, cabinetwork with adjustable shelving, inlaid borders, and parquet floors. While most such establishments in San Antonio are in the King William Historic District or other downtown areas, Terrell Castle's one-acre site is on the southern edge of Fort Sam Houston, a historic U.S. Army post.

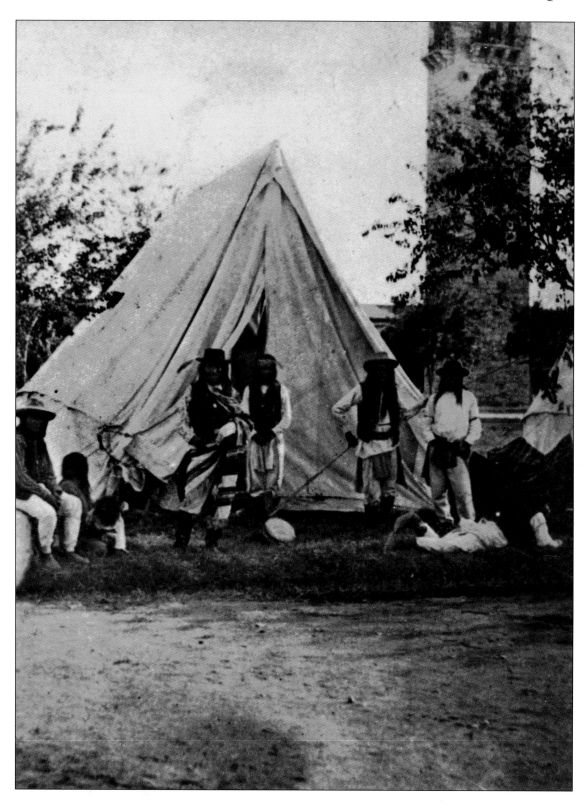

Still called the Post at San Antonio, this installation was less than a decade old in 1886 when members of the Chiricahua (Apache) tribe were held captive for six weeks in the Quadrangle. War chief Geronimo had surrendered to General Nelson Miles in Arizona after escaping from a reservation. Put on a train as a condition of surrender, the Chiricahua members were stopped and held in San Antonio, while officials decided to treat them as prisoners of war. Since the post's guardhouse was unfinished, they camped in tents. The eighty-eight-foot "water and watch tower" (at right) was completed in 1877. Geronimo was taken up the tower but refused to step out onto the balcony, fearing soldiers would throw him off it.

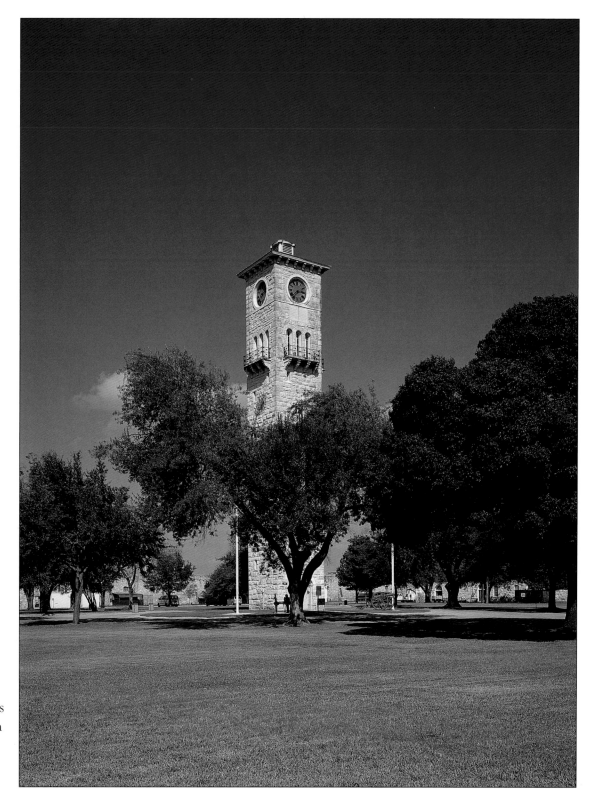

For more than a hundred years, deer, peafowl, and guinea hens have lived in the Quadrangle courtyard, where it is a tradition for tourists to feed them. Legend has it that the grassy area was stocked with game for Geronimo's men to hunt during their 1886 stay here, but no evidence supports this. The surrounding Quadrangle is the oldest building on this historic post, founded in 1876 as a successor to downtown military buildings (such as the Arsenal and Quartermaster Depot in the Alamo church). In 1890, it was renamed for Sam Houston, general in the Texas Revolution and president of the Republic of Texas. Built as a supply depot, the Quadrangle buildings now are headquarters for the Fifth U.S. Army.

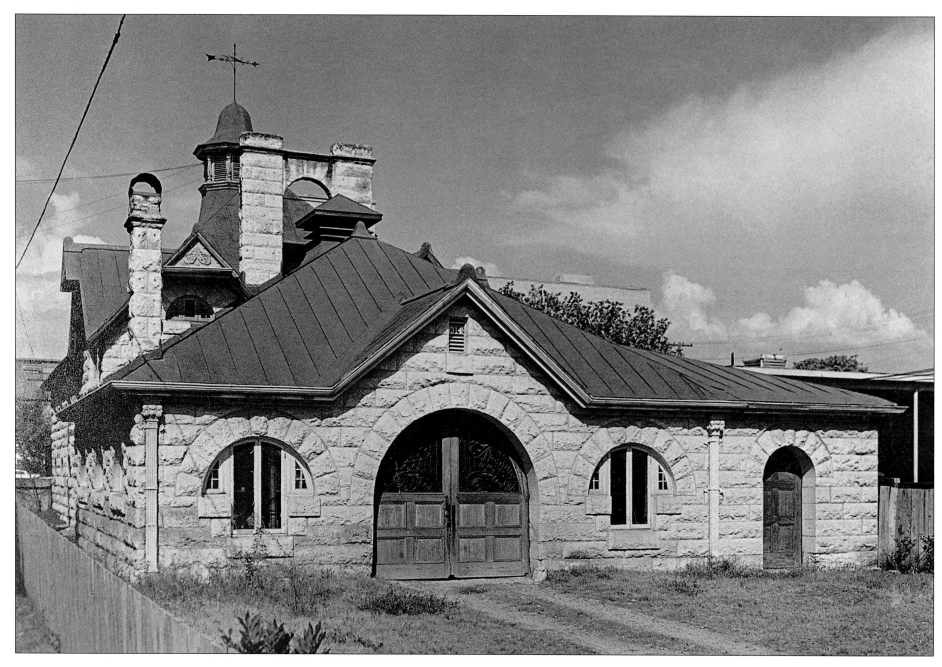

Grand houses used to line downtown streets, the Alfred Giles–designed mansion of banker Daniel J. Sullivan was one of them until it was demolished in 1971. This carriage house, built in 1886 of rusticated limestone, was a cupola-topped *chateau des chevaux* in the Richardsonian-Romanesque style of the main house (demolished in 1971 to make way for a parking lot). Its owner, the Hearst Corporation, used it for storage, then donated it to the Witte Museum for removal to its grounds. When funds raised proved insufficient, the museum passed the gift to the San Antonio Botanical Society, which sponsored the dismantling—stone by cleaned and numbered stone—and rebuilding of the carriage house at what was then the San Antonio Botanical Center. Reassembled at the entrance to the gardens, it was dedicated in 1988.

After an interior renovation, the Sullivan Carriage House opened in 1995 as the entrance building to the San Antonio Botanical Center, which comprises the city-run San Antonio Botanical Garden and San Antonio Garden Center, operated by a nonprofit organization with roots in the 1940s. The garden's gift shop, café, and Botanical Society offices are all contained in the building. Opened in 1980, the thirty-three-acre site now includes a Texas Native Trail and conservatory, as well as formal and specialty gardens. At an annual Walk Across Texas event, costumed guides and reenactors take visitors around regional plant exhibits and replicas of pioneer dwellings.

Science teacher Ellen Quillin started what became the Witte Museum with natural-history exhibits in a classroom at Main Avenue High School. Backed by civic organizations, she led an effort to raise funds for a museum. Local businessman Alfred G. Witte bequeathed $65,000, on condition that the museum be named in memory of his parents. Operated by the newly formed San Antonio Museum Association, the museum in Brackenridge Park opened in 1926, known as the Witte Memorial (sometimes Municipal) Museum. The early museum had a diverse mission, with exhibits on science and local history, an art collection, classes, and sponsorship of archaeological digs. During the Depression, rattlesnakes earned the museum's keep in demonstrations (including "snake fries") in an outdoor reptile garden.

After the San Antonio Museum of Art opened in 1981, the Witte refocused on regional history, with permanent collections on natural science, cultural anthropology, and historical art. Since 1994, the Witte and the art museum have been separate institutions. The Witte frequently hosts major national traveling exhibits, while the museum's educational programs include family workshops, theater performances, lectures, and frontier-life demonstrations.

In 1997, a Science Treehouse building (sponsored by H-E-B Grocery Co.) opened behind the museum. Overlooking the river, the glass-walled structure is filled with stations for hands-on science activities. The Witte acquired much of the Hertzberg Circus Museum's collection when the latter closed in 2001 and, after a climate-control upgrade, the Witte mounted its first exhibit of "Circusana" in 2004.

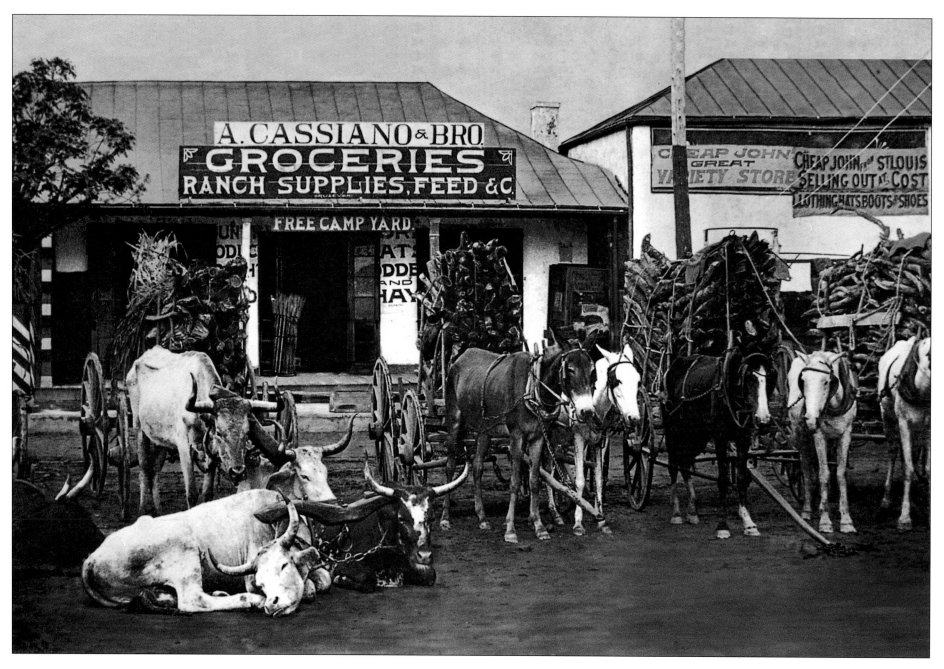

Built around 1745, the building at left was owned by Juan Manuel Ruiz and passed to his son, José Francisco Ruiz. The house—at what is now 420 Dolorosa, across from City Hall—was the city's first public school, with the younger Ruiz appointed schoolmaster in 1803. A military officer and city official, Ruiz supported the Texas Revolution; his son Francisco was alcalde (mayor) of the city during the Alamo battle. With his nephew, José Antonio Navarro, Ruiz was one of only two Tejano signers of the Texas Declaration of Independence and later served in the Republic of Texas Congress before his death in 1840. The house was later used as a commercial building in the Military Plaza market area (shown here).

Valued as an example of Spanish colonial construction, the Ruiz House seemed endangered when it was damaged by the hurricane of 1942. Made of plastered rubble, it was sound enough to dismantle the following year for a move to the grounds of the Witte Museum. The house was reassembled behind the museum, where it joined another relocated historic building—the former home of banker John Twohig, moved a few miles upriver. The Ruiz House move cost about $6,000, defrayed by donations of money and materials from museum supporters. The rebuilt house was used as a ceramics studio by potter Harding Black, who taught his craft in the museum's art school. It is still used for educational programs.

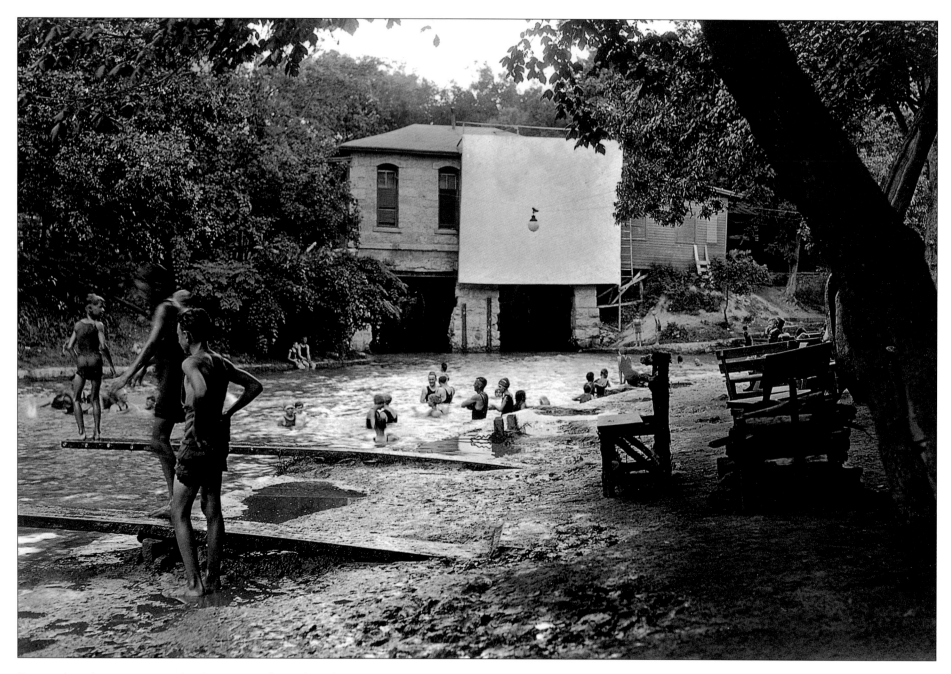

Donated to the city in 1899 by George Brackenridge, the river-crossed park that bears his name was formerly the site of the private waterworks he headed. Parks Commissioner Ray Lambert oversaw many improvements to Brackenridge Park, including the construction of the city's first swimming pool. Known as Lambert Beach, this was a seminatural pool built in 1915 around a bend in the river—where mud was replaced with gravel—near an 1877 Water Works Co. pump house. Free to the public, the pool was so successful that it was enlarged about a decade later, with separate, concrete-lined adults' and children's areas. After dusk, movies were projected on an outdoor screen (at rear) to be watched in cool comfort in the days before air-conditioning.

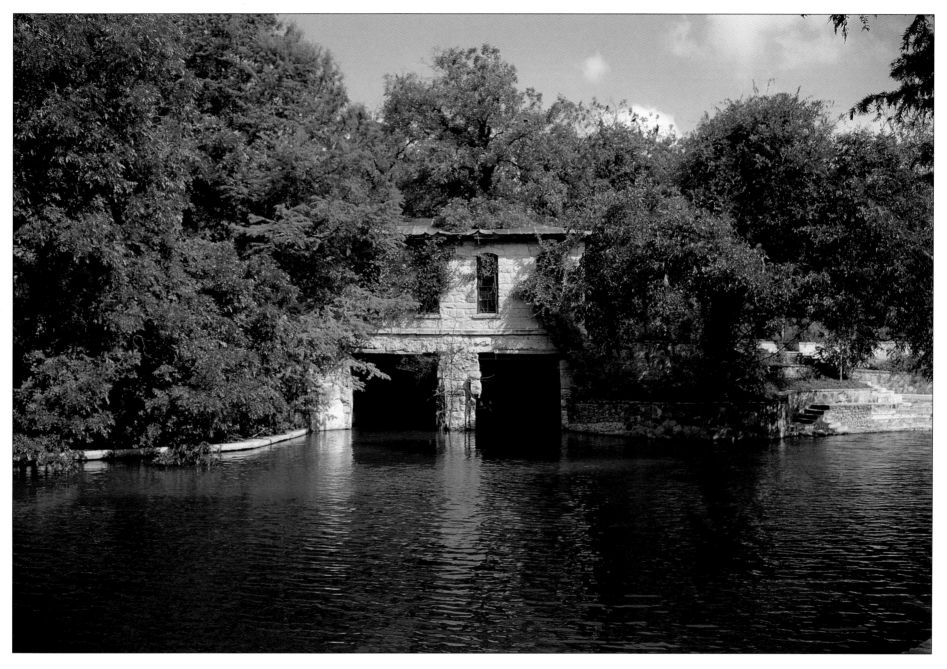

From the mid-1920s into the 1930s, the once-simple Lambert Beach kept getting fancier, as a forty-room bathhouse and concession stand was built, benches and street lights were added, and the riverbank "beach" was paved. The Depression and World War II dried up resources for further improvements, and persistent problems with pollution necessitated closing the pool in 1950. Long abandoned, the former bathhouse with its riverstone-clad walls was reopened in 1997 after a $350,000 renovation in which the old structure was converted into an innovative, mazelike playscape.

When Brackenridge Park opened in 1901, a city-owned quarry was still active there. After the last operator, Alamo Cement, moved to a new plant in 1908, a half-century of quarrying had carved a jagged pit. It was parks commissioner Ray Lambert's idea to fill that cavity with an Asian-themed lily pond. To raise funds for realizing his "half-remembered boyhood dream," Lambert toured the park with local businessmen—including the cement company president—and persuaded them to create his garden plan. With their contributions, as well as bulbs donated by citizens and labor provided by jail inmates, the garden was built for around $7,000. Completed in 1918, the Japanese garden had an island with a palm-thatched pagoda, arched stone bridges, and walkways for contemplative strolling.

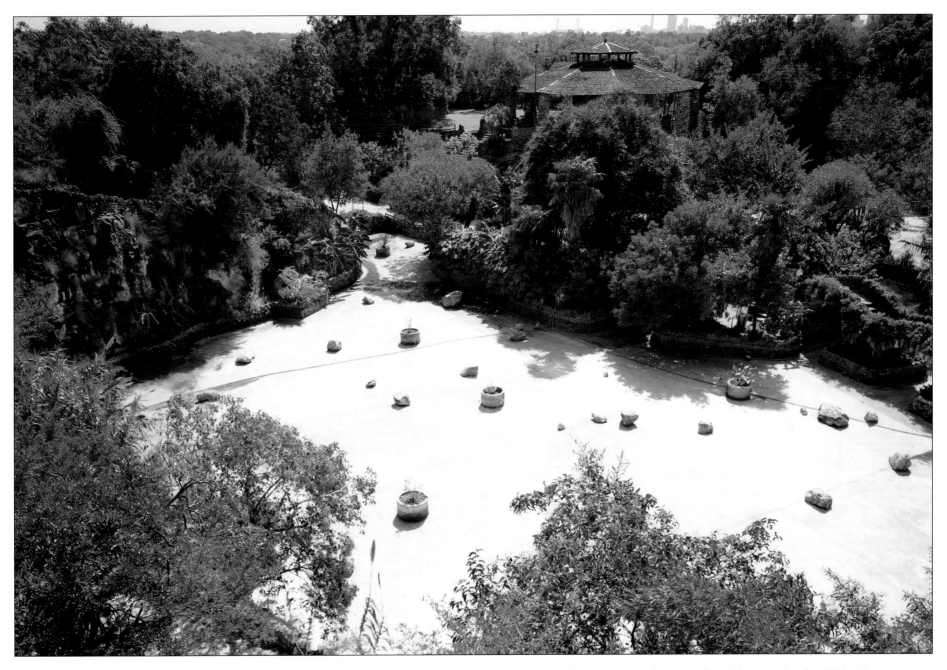

From the late 1920s, the garden had a Japanese family as live-in custodians and the Bamboo Room restaurant opened, serving tea and light refreshments. This family was expelled at the start of World War II and replaced with Chinese caretakers. Sculptor Dionicio Rodriguez was commissioned in 1942 to fashion a concrete-wood entrance gate in the style of a Japanese temple, with Chinese characters proclaiming the "Chinese Garden." The Japanese Garden name was officially restored in 1984, but most still call the area the "Sunken Garden," after the nearby amphitheater. A major renovation has been proposed to restore the pagoda and water features, with funds to be raised by groups such as Friends of the Park and the Japan-America Society.

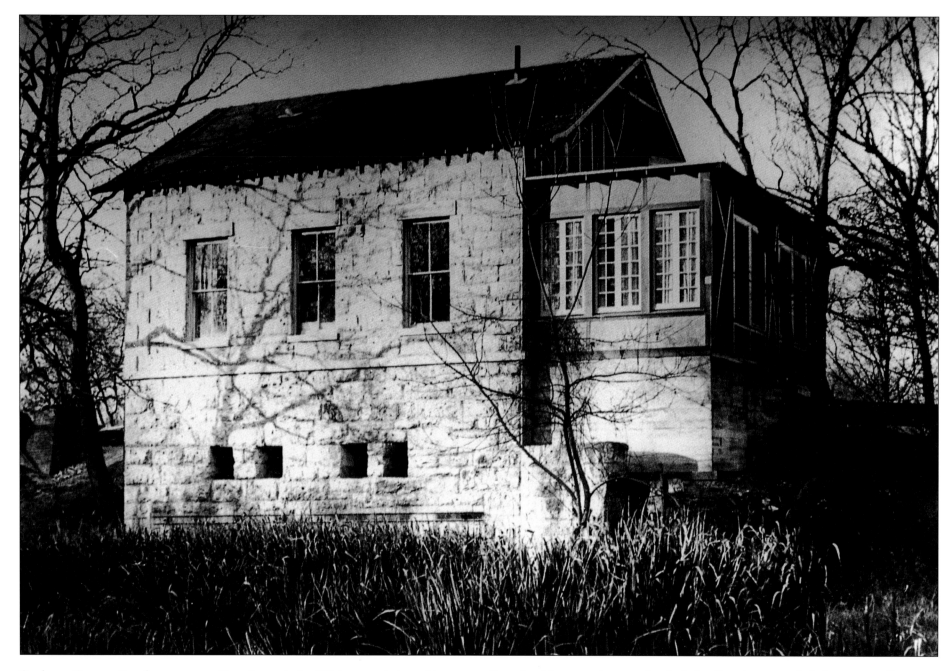

Sculptor Gutzon Borglum came to San Antonio in 1924, commissioned by the Trail Drivers Association to create a monument to the great northward cattle drives of the late 1800s. Borglum and his family first stayed in the Menger Hotel, where he may have done some preliminary work before setting up a workspace in a warehouse. Later, he rented this city-owned former pumphouse in Brackenridge Park, under which the old millrace stream still flowed, adding windows and a skylight. Borglum traveled the state, talking to ranchers and cowboys for research and helping to raise funds for the monument. In this studio, he designed and sculpted various projects, including models for his most famous work, the colossal Mount Rushmore Memorial in South Dakota.

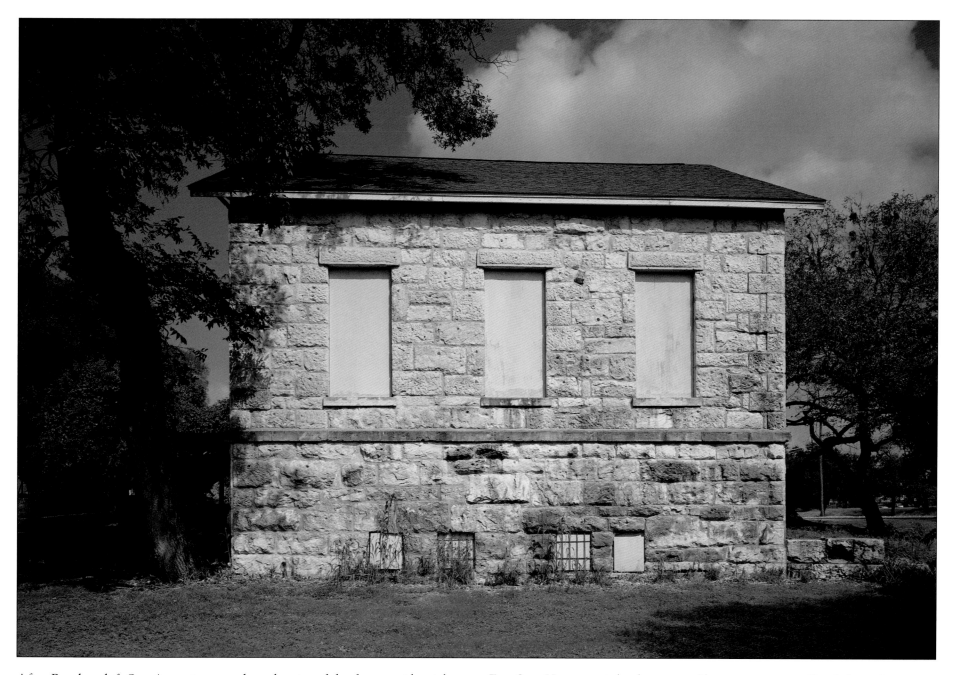

After Borglum left San Antonio to work at the site of the four presidential heads carved into Mount Rushmore, South Dakota, the city turned the renovated pumphouse over to the Witte Museum. For many years, the building—renamed the Borglum (later Mill Race) Studio—was used for art classes sponsored by the museum. During World War II, soldiers stationed at Fort Sam Houston took advantage of low-cost courses offered there; later, it became a night school, and it hosted children's art classes. The building was renovated in 1985 by an architecture firm noted for its restoration work. Still owned by the city, this historic structure is located close to the Brackenridge Park Golf Course parking lot.

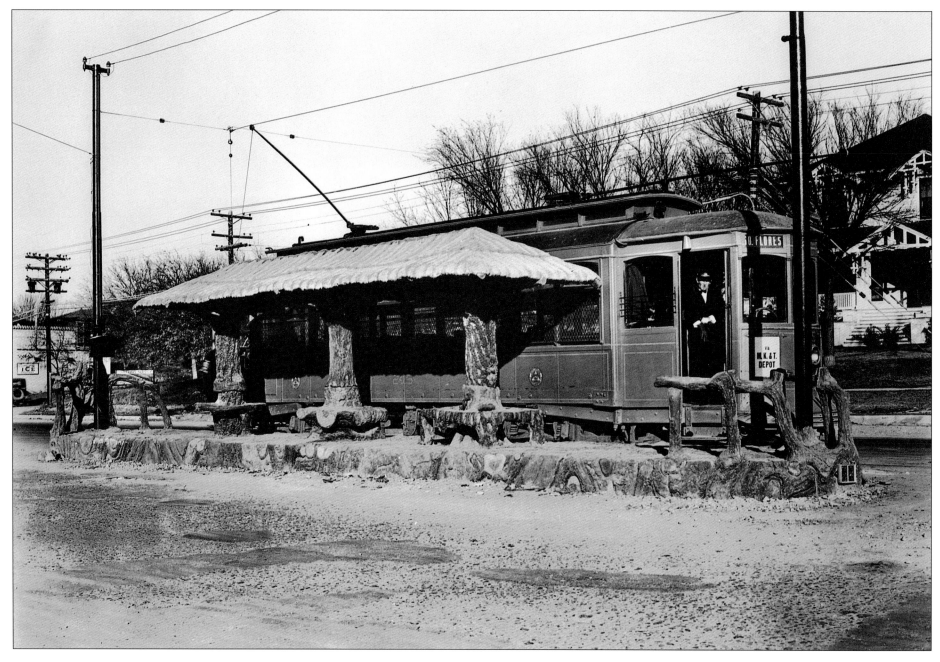

The *faux-bois* (false wood) concrete sculptures of Mexican-born artist Dionicio Rodriguez are known for their rustic realism. Rodriguez arrived in San Antonio around 1924 and primarily worked here for the rest of his life. This streetcar shelter on Broadway in Alamo Heights is typical of his work in tinted concrete formed over a metal framework. Several of his San Antonio works are said to have been commissioned by Alamo Cement president Charles Baumberger, who may have wanted to promote the artistic possibilities of his product. Rodriguez disguised function in his natural-looking bridges, benches, drinking fountains, and trash receptacles, some of which were installed in public spaces such as the Alamo Plaza, the Spanish Governor's Palace, and Brackenridge Park.

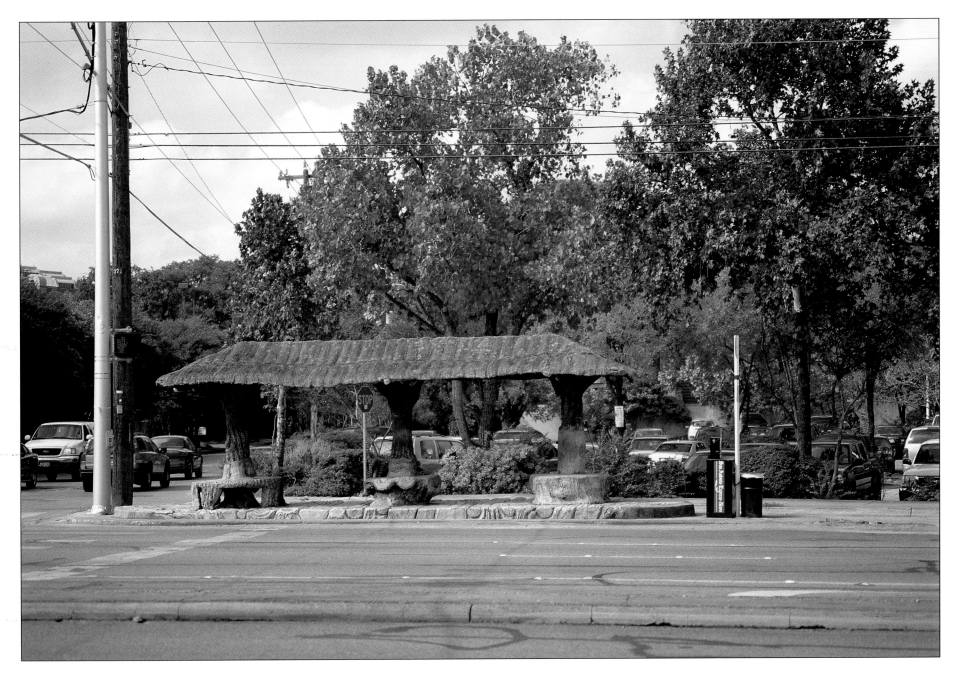

When streetcar services were discontinued in 1933, San Antonio was the first large U.S. city to convert completely to buses. It was also the first (in 1946) to air-condition its entire bus fleet. Although municipal VIA buses have replaced Public Service Company streetcars, and this Broadway block has changed from residential to commercial, this covered seating area is still a bus stop, and its concrete-wood trunks and thatch appear untouched by time. While many works by Rodriguez have been moved and subsequently lost, several may still be seen, including a footbridge in Brackenridge Park and a fence and fountain at a café near Quarry Market (a shopping complex developed on another former site of the Alamo Cement Company).

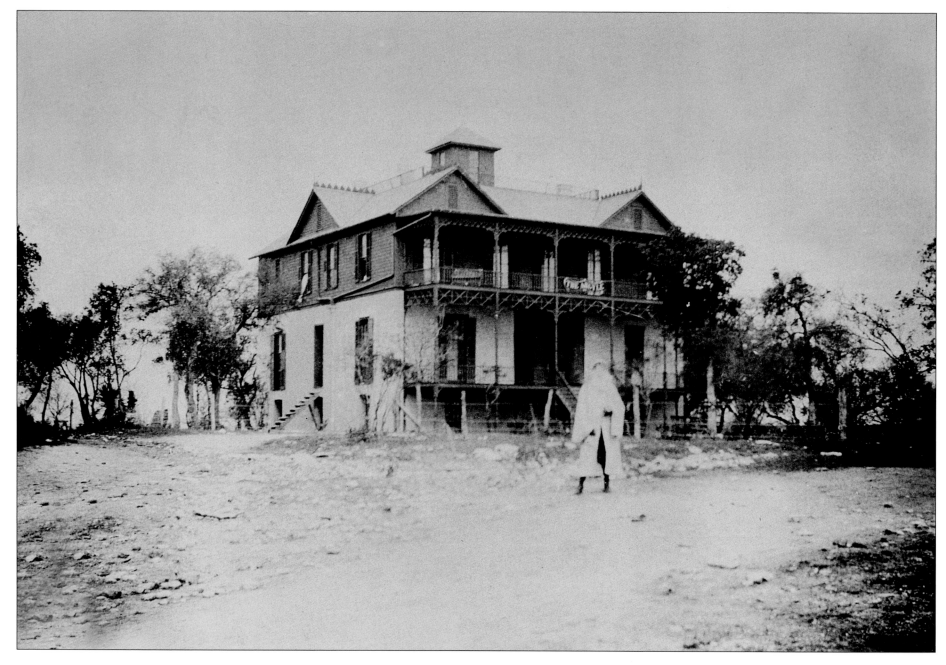

Well-worn copies of *The Argyle Cookbook* are treasured in many San Antonio kitchens for its rich, Southern recipes from the long-defunct inn. The plantation-style house it occupied was built in 1859 for Charles Anderson, a Union sympathizer who fled Texas early in the Civil War. The next owner sold the house to the out-of-state developers of Alamo Heights, an elite suburban community. A partnership described as "two Scotsmen named Patterson" bought the house, added a third story, and named it the Argyle Hotel. Two Irish-Americans named O'Grady took over in 1893, decorated the twenty-one guest rooms with European furnishings, and created the cuisine immortalized in the cookbook.

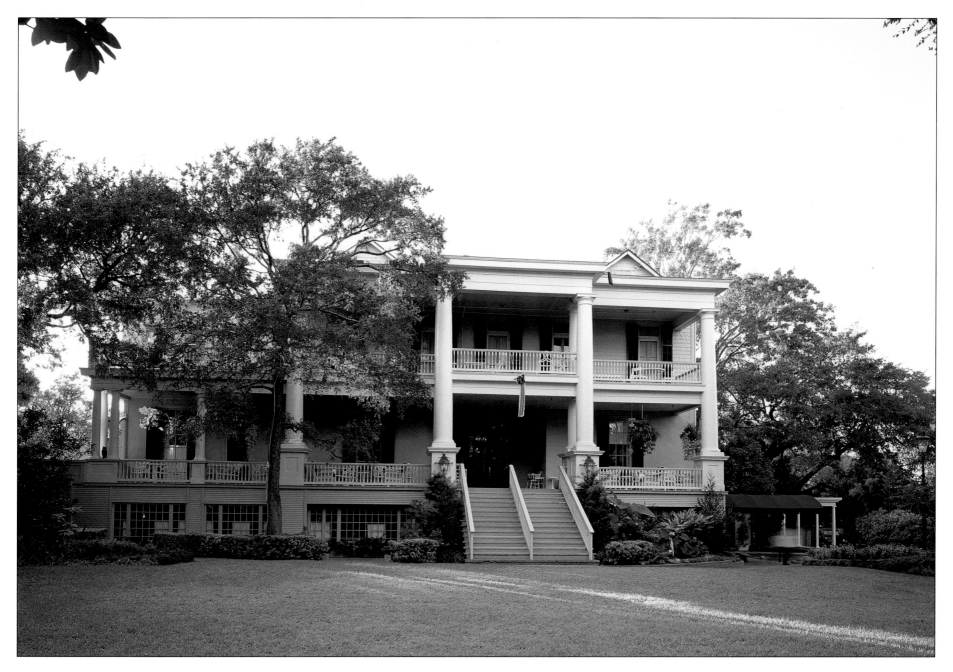

"Miss Alice" O'Grady—assisted by her brother "Mr. Bob" and other siblings—kept the Argyle Hotel for nearly fifty years. Reared in the family stagecoach station in Boerne, northwest of San Antonio, Alice O'Grady collected recipes most of her life, tweaked them if necessary, and served only the best, in antebellum extravagance. Prized for their spun-sugar decorations, O'Grady's tiered cakes graced weddings all over South Texas, riding the rails in their own Pullman berths. Miss Alice retired in 1941 and the hotel was converted to a private club in the 1950s. The Argyle's membership supports the work of the Southwest Foundation for Biomedical Research, an independent institution that has sponsored important research in heart disease and other areas of study.

While the first military flight took place at Fort Sam Houston, Stinson Field was the birthplace of civilian aviation in San Antonio. The city's first airport was established in 1915 off Mission Road on the city's South Side and named for a family of pioneer aviators. Siblings Eddie, Katherine, and Marjorie Stinson conducted a flying school there until 1918, training many pilots who served in World War I. Renamed Winburn Field in 1928 after a reporter killed in a crash, the airport received the city's first airmail delivery that year. Before this WPA-funded administration building was completed in 1937, the airport reverted to its original name, in memory of the pilot and aircraft manufacturer Eddie Stinson, who died in a 1932 plane crash.

In 1942, large passenger airlines such as Braniff and Eastern moved out of Stinson Airport into the newly created San Antonio Municipal (now International) Airport. The new facility on the city's North Side was built on former farmland with greater expansion potential. Still headquartered in this 1930s administration building, Stinson remains an active, city-run airport, serving individuals and companies using light aircraft. It is second only to the College Park (Maryland) Airport as the oldest in continuous operation in the United States. Two hangars at this historic field house the Texas Air Museum, Stinson Chapter, with a collection including an engine used in a plane flown by Katherine Stinson, early flight instructor and member of the namesake flying family.

The Mission Drive-in Theatre was not San Antonio's first—that was the Fredericksburg Drive-in, opened in 1940—but the Mission Drive-in has lasted the longest. The Mission opened on March 27, 1948, with *Pirates of Monterey*, a Western starring Maria Montez and Rod Cameron. From the years just after World War II through the mid-1980s, there were more than twenty outdoor theaters on the city's outskirts. Called "Texas' most beautiful drive-in," the state had nearly 400 drive-ins by the late 1950s. The Mission's neon sign (with moving bell) was a reference to the church facade at nearby Mission San José; through the 1950s, the Mission held drive-in church services on Easter Sunday.

As rivals fell by the roadside, the Mission stayed lit, luring carloads of patrons with promotions such as all-night "dusk-to-dawn" movie marathons. But from the 1960s on, outdoor theaters were challenged. Daylight saving time cut into showtime, cable television and video kept audiences at home, and indoor multiplexes offered more choices. The Mission countered with added screens, lower prices, and a now-nostalgic experience. Threatened with closure at the turn of this century, the Mission was sold and reopened in 2001. With double features (including some first-run movies) on each of its four screens, the refurbished theater made a comeback. Since 1996, the Mission has been the only outdoor theater in the San Antonio area and is one of fewer than twenty in Texas.

Long before HemisFair '68, the city hosted fairs linking it with its Latin American neighbors. The first San Antonio International Exposition opened in 1888, at the signal of a telegraph key pressed in Mexico City by Mexican president Porfirio Diaz. Held annually through 1910, the event gathered manufacturing exhibits, home-crafts competitions, rides, and celebrities such as Buffalo Bill Cody, boxer John L. Sullivan, and racing driver Barney

Oldfield. In May 1898, Theodore Roosevelt's Rough Riders trained here for the Spanish-American War, sleeping in Exposition Hall or on bleachers. After racetrack betting was outlawed in 1907, crowds dwindled. The fairgrounds became a private amusement park, sold to the city, which developed most of the exposition area into what is now Riverside Park.

Across the street from Riverside Park (best-known for its golf course with eponymous water hazards), this building houses the local offices of the National Park Service, which administers the San Antonio Missions National Historic Park. At the time of the old San Antonio International Exposition, the South Side's four Spanish Colonial missions were ruins. Author Stephen Crane observed in 1895 that "these portentous monuments" were "besieged . . . by indomitable thickets of mesquite," defaced by relic hunters, and under "general . . . attack by nature." The combined efforts of the San Antonio Conservation Society, the Catholic Archdiocese of San Antonio, and others led to the restoration of mission buildings and brought them to the attention of the Park Service, who established the historic park in 1978.

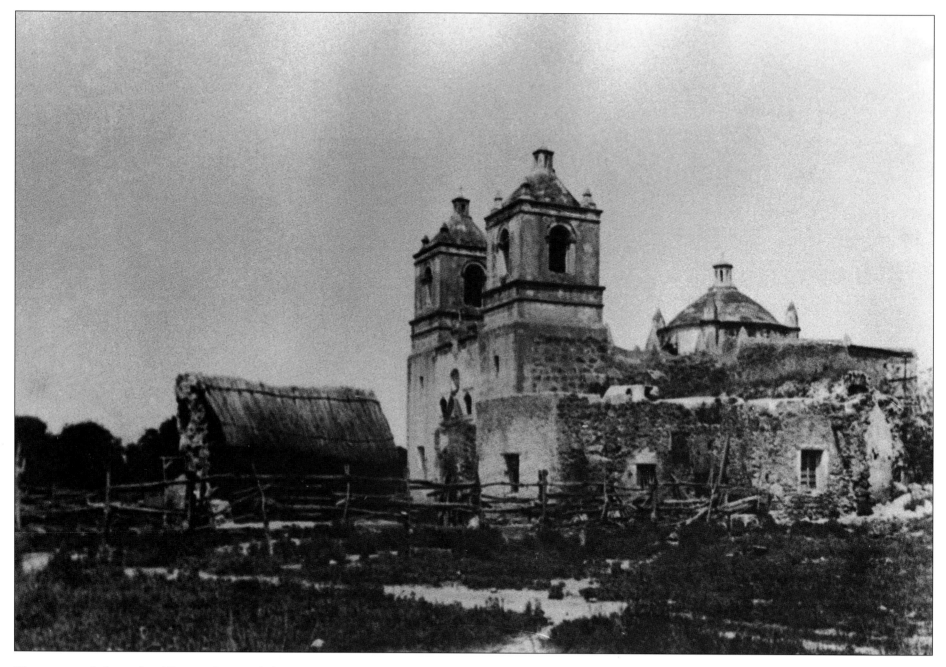

The mission dedicated to Nuestra Señora de la Purisma Concepcion (Our Lady of the Immaculate Conception) is one of the best-preserved of San Antonio's Spanish Colonial missions. It is second in a chain of five established along the San Antonio River—the first in line and oldest is Mission San Antonio de Valero, now the Alamo. Moved from East Texas, Concepcion was founded here in 1731 by Spanish Franciscans. Until the church was finished in 1755, the mission was a humble settlement of grass-roofed wooden structures. Like other missions, Concepcion attracted Native Americans with the promise of sufficient food and protection from raiding bands. By the 1790s, disease and other problems were bringing an end to mission life; Concepcion and others were secularized in 1824.

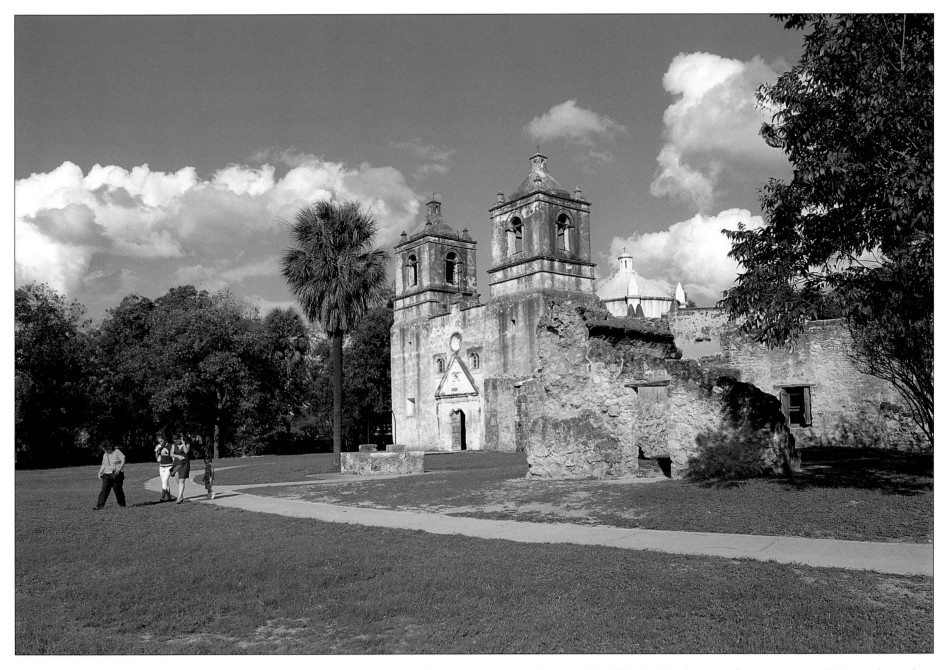

The church at Mission Concepcion is a near miracle of endurance, with twin towers that have never toppled and forty-five-inch-thick walls that remain standing. During the Texas Revolution, Concepcion was the scene of a thirty-minute battle; it was later used as a barn before becoming an attraction for sketchers and tourists. While other missions fell to "stark piles of rubble," Concepcion "was beautiful, firm and scarcely touched by time and abuse," wrote architect O'Neil Ford, who first saw the missions in 1924. In the early 1990s, restorers who had worked on the Sistine Chapel cleaned the interior decorations, including an *Eye of God* face. The church is still in use, and a recent archaeological dig just outside its walls uncovered evidence of other mission structures.

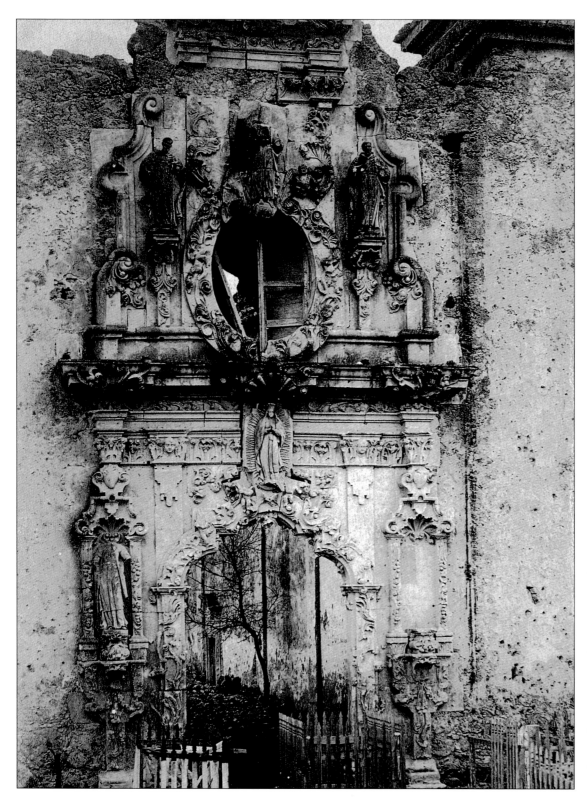

Once called "Queen of the Missions," with "the most beautiful church [in] New Spain," Mission San José was largest of the eighteenth century Franciscan missions, but was also the most spectacularly devastated in abandonment. Oscar Wilde, who visited San Antonio in 1885, pronounced the "window of the San José mission the finest [he] had seen in America," referring to the rose window on the church's south side. The facade (shown here in 1886), however, had been shot up, chipped off, and sold in bits to tourists. Massive carved-cedar doors had been stolen, and the church (completed in 1782) lost its roof, dome, and most of one wall before its tower tumbled in 1928. Compound walls had crumbled, though a much-dilapidated granary still stood.

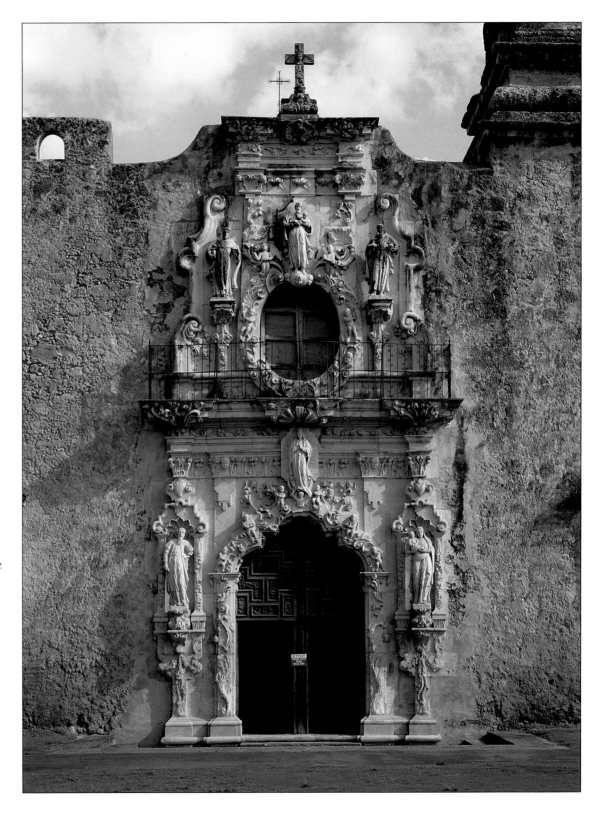

The Catholic Archdiocese of San Antonio repaired San José's fallen church tower, and the San Antonio Conservation Society led a community effort to restore the rest of the mission through the 1930s. Harvey P. Smith, restoration architect of the Spanish Governor's Palace, supervised rebuilding of the rubbled granary, first used as an arts-and-craft store and now as an exhibit space. An amphitheater was built on the grounds, the longtime setting of a yearly Los Pastores (The Shepherds) play, used to teach Christian lessons to mission residents. The compound now includes restorations of the Native American living quarters and a working grist mill. A visitors' center was built in the late 1990s, and San José church once again houses an active Catholic parish.

Access to water beyond the banks of the San Antonio River was a must for expanding the missions, as well as developing other Spanish Colonial settlements. The acequia (irrigation ditch) system started where the city did: at the missions. True to its Roman roots, Espada Aqueduct—part of seven acequia systems in the mission area—carries water from the San Antonio River across Piedras Creek to irrigate nearby fields. Built around 1745 of "lime and stone" (with mortar mixed with goat's milk), this bridge is the oldest Spanish aqueduct in North America and the only one in continuous operation. A *mayordomo* (ditch master) used floodgates to control the amount of water sent forth for irrigation and other household and industrial uses.

Farms still use water from the Spanish acequia system, including the Espada aqueduct and dam. Since the mid-1800s, the aqueduct has been owned by the Espada Ditch Company, which organized owners of former mission farmlands into shareholders in a company that retains water rights and maintains the system. A ditch boss schedules water use, and members are responsible for keeping up the part of the acequia that runs through their property. When a

1950s river-rechanneling project threatened to disable the last two working acequia systems (serving neighborhoods around missions Espada and San Juan), landowners sued to protect their water access and won in the Texas Supreme Court. Repairs in 2001 ensured that water continues to flow freely through the aqueduct.

INDEX